McSWEENEY'S 60

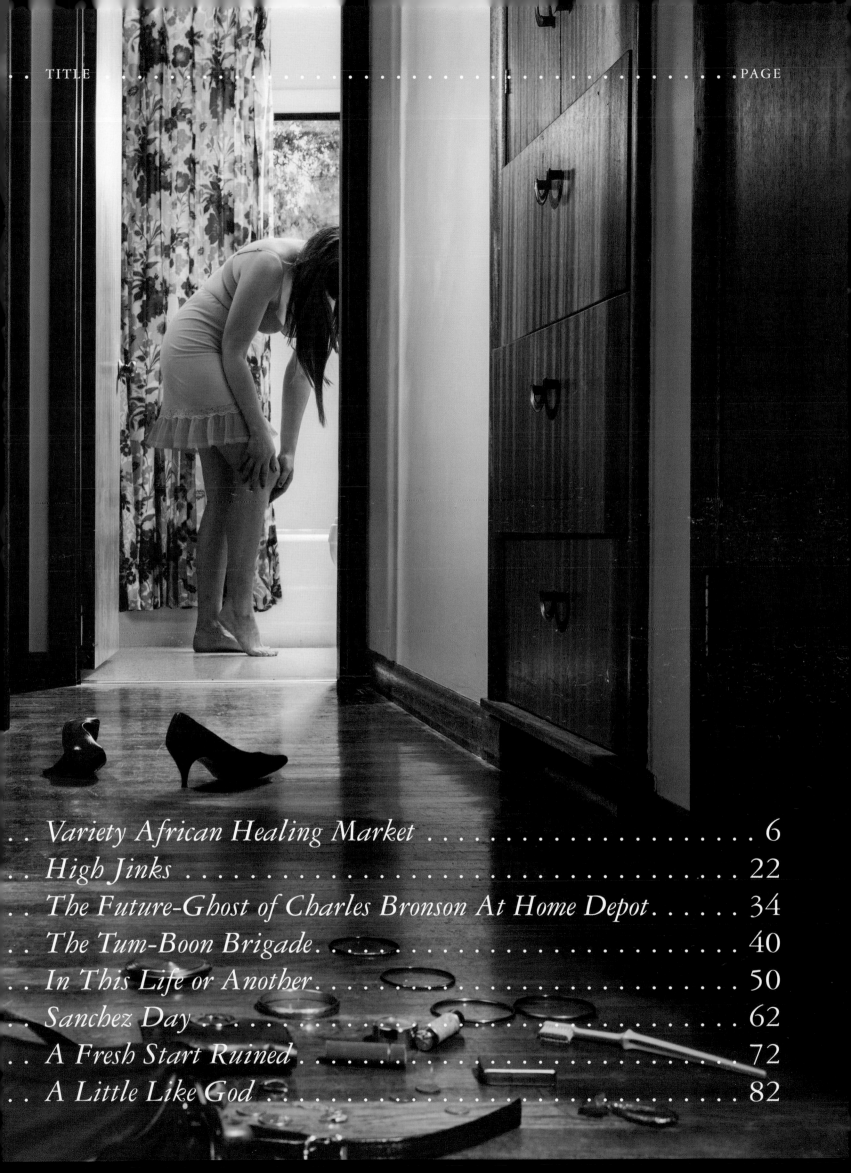

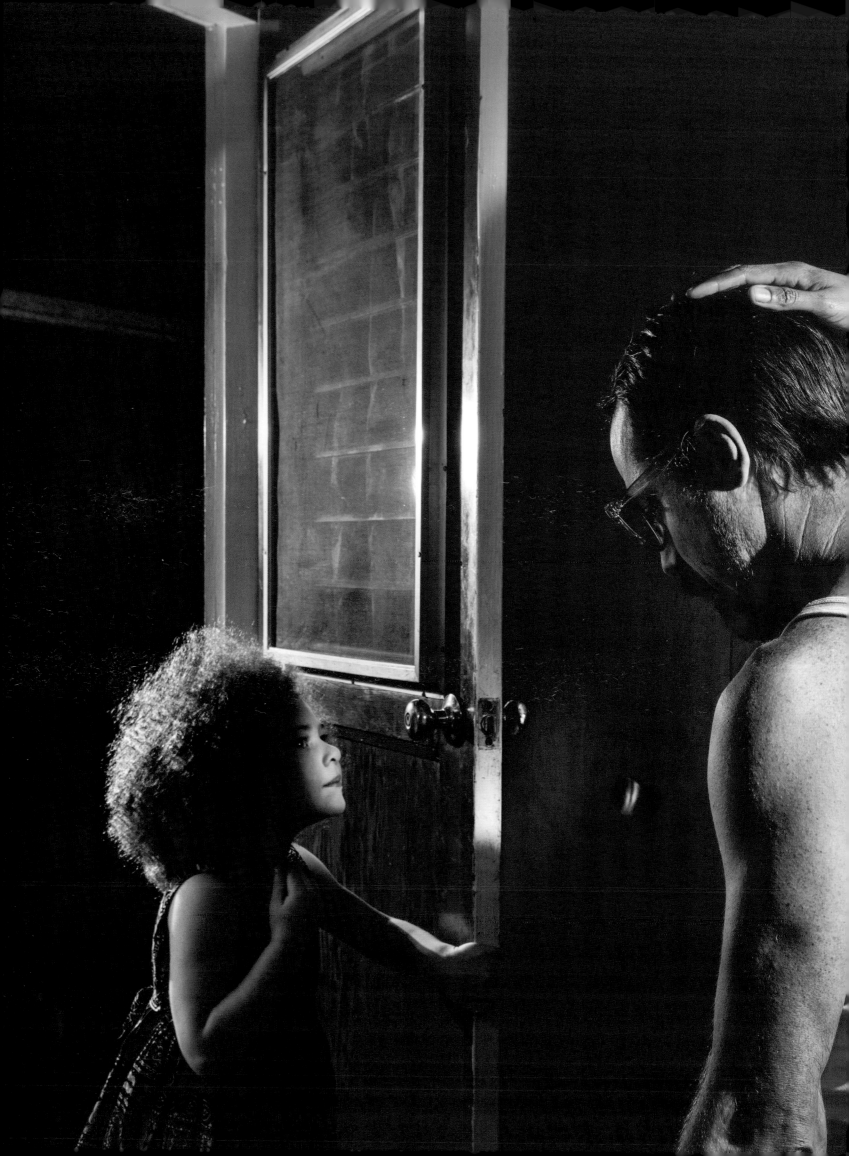

VARIETY AFRICAN HEALING MARKET

by Afabwaje Kurian

Behind the dried stockfish were the packets of bitter leaf, and in the next aisle over were the silver-red cans of sardines, and underneath the cans of sardines were the bags of Ola-Ola pounded yam. Every other Tuesday, around six in the evening, about an hour before closing, Aunty-Mrs. asked Emeka to take her to the same aisle to purchase a bag of pounded yam flour. Aunty-Mrs. was called Aunty-Mrs. because Emeka had gone to call her Aunty one evening and realized she had forgotten her first name, and when she thought to call her Mrs., she realized she did not know her last name. She could have just called her Aunty, since this was what she called any African woman her mother's age, but she had liked how Aunty-Mrs. sounded in her head, so she called her this to herself.

This Tuesday evening, the bell above the door clanged to signal Aunty-Mrs.'s entrance, right as Emeka was sweeping the floor, thinking that she ought to destroy the Bébé Manga cassette that a Cameroonian customer had given her parents and replace "Amio"—a song they played relentlessly—with Fuse ODG's "Dangerous Love." This was the song that she had danced to in Souks last Friday night with Grandfather, one of Souks's patrons. Souks Club was located on the other side of Urbana, Illinois, and Grandfather was a constant presence there. Each time a favorite song of his blasted from the speakers, he jabbed a fist in the air and muscled his way to the dance floor. He could have been forty or sixty. It was impossible to tell, because of the retro-square sunglasses that shielded his eyes and those veneers that gleamed unnaturally white. He had a rough little mustache obscuring his upper lip, and his skin was dark as coffee beans, and taut, like material stretched over a drum. Toots, the only one of Emeka's friends who had not yet escaped Urbana, said that under that dreadful taupe suit, Grandfather probably had skin as pruned and rough as an alligator's and ballooned veins worming up his nimble legs.

Once, Emeka had asked Grandfather his age, and he had not answered her. He had rocked his hips closer to hers and thrown his head back in laughter so that his silver fillings caught the blue strobe lights. He had said, what did it matter how old he was? Emeka had to agree. She and Toots were twenty, and Grandfather danced

better than they did. He had learned the moves to Azonto, surprising them all one night with his limber gyrations. He usually bought Toots and Emeka a drink or two after a few dances, and he would say in a voice that was far too loud and loose, "For you, my lady, what would you like?" But Emeka and Toots had gone to Souks long enough to know not to take him too seriously with his "my lady" this and "my lady" that, because every woman in Souks— tall or short, buxom or skinny, flat-chested or busty, expensively wigged or sporting a DIY— was "my lady" to Grandfather if she allowed his hands to roam freely across her bottom.

This is what Emeka was thinking when Aunty-Mrs. walked into the store for her yam flour. With the cart jangling behind her, Emeka led Aunty-Mrs. past the bins of plantains, onions, and cassavas. Aunty-Mrs. could not keep pace. She moved as if someone had bound her legs with Saran wrap, and it took some time before she reached Emeka.

Wheeling her cart into the aisle, Aunty-Mrs. clapped her hands. "Glory be to God!" she said, which was what she declared whenever she saw the yam flour stacked on the shelf.

With all her "glory be to God"s, Aunty-Mrs. often just stood and watched, not even offering to help Emeka hoist the twenty-pound bag into the cart. Emeka was grateful that she was built like her father, broad-shouldered and sturdy as a shot put thrower.

Later, when Aunty-Mrs. unloaded her groceries onto the counter, Emeka's mother emerged from the back room, waving a new roll of receipt paper.

"Bunmi, how you dey?" Her mother tapped the receipt printer. "Emeka, open the thing."

"Pain come enter my body," Aunty-Mrs. said, sliding two cans of custard toward Emeka.

"Isn't that what we must deal with every day?" her mother said.

"Mama Emeka, have you seen pain like this one before?" Aunty-Mrs. hiked up her wrapper. Behind her right knee was a grotesque protrusion, the size and contour of four fused kola nuts.

Emeka winced, and her mother said in alarm, "Bunmi, did something bite you?"

"I woke up one morning and the thing was just there, greeting me."

"You've seen a doctor?" her mother asked.

"Doctors, keh? The doctor said it's one kind

by
AFABWAJE
KURIAN

tumor. She wan stick me with needle. That's all doctors do these days. If you have cold, they wan give you needle. If you have headache, needle. I said, 'Not for me. That will not be my portion.' I put Neosporin, but the thing is still here disturbing me."

Emeka's mother said, "Ointment isn't going to do anything—"

"Just be praying for me."

"Let's do it now," her mother said.

Emeka groaned and tossed the empty receipt roll. Her mother did this often. She prayed in any situation or location—at home, the bank, or a dentist's office. Emeka leaned an elbow on the register and looked over at her mother, who had crouched like an umpire next to Aunty-Mrs.

Aunty-Mrs. delivered instructions. "Mama Emeka, you must stretch your hand."

"Bunmi, it's the same whether I stretch my hand or not."

"No, it's not the same, Susan."

Her mother extended her hand close to the misshapen bulge and after a few seconds said, "It's as if power is flowing from my hands. Can you feel it, Bunmi?" She sounded as if she was in a trance.

"Yes, o, I feel it," Aunty-Mrs. said. "Like wind is blowing on me."

Emeka looked up at the ceiling. "It's the fan—"

"Emeka, shut your mouth," her mother said. "Bunmi, concentrate on your leg."

Aunty-Mrs.'s eyes were shut tight, fingers clenching a jug of palm oil that she had not yet set down.

Finally, her mother said, "By the blood of Jesus, I declare that you are healed."

"Yes, I receive it," Aunty-Mrs. said, blinking her eyes open. "Thank you, Mama Emeka. Am feeling something in my leg already, like claws pinching me."

Emeka went over to the butcher counter after Aunty-Mrs. left. She was struck again by Robby's handsomeness, with his thick black hair gelled into a low pompadour, as he stood in a white apron and T-shirt, doing something as unappealing as repositioning chicken thighs on beds of lettuce. He always maintained a friendly, distant smile and had never asked her out. "You're potent," Toots had said. "He can't handle your spice." But that was not the reason. It was because Robby was married, which

Emeka had learned weeks ago when a woman with sunburned arms and a distrustful smirk breezed through the door with three kids in tow. One of the kids, a bald infant of indiscernible sex and with warring blue eyes, had sucked on a pacifier. The woman had said she was Molly, Robby Delgado's wife, and she was there for her husband's paycheck.

When Emeka told Toots, Toots had picked her nails. "Well, tête-à-tête," said Toots, who never used the right expression, though her mother was Togolese and French-speaking.

Robby was nodding toward the front. "Did I just see your mom praying?"

"Yeah," Emeka said, sighing. "She's strange, right?"

"Remember when I got that cut?" He peeled off his latex gloves and lifted his hand to show Emeka the pale pink line cleaving his palm. "No stitches. Your mom prayed for it."

"Oh. Really?" She did not remember, but what did it matter? It was a gateway to some type of conversation, even if it was about as unromantic a subject as one could choose.

"It healed faster," he said.

"Listen," Emeka said, ready to abandon talk of her mother's peculiarity. "Toots and I are going to Souks this Friday. Come out with us."

Toots had also told Emeka that this was the way to wear down a man. Just keep asking and asking, Toots said, and one day he won't be able to resist you. Toots was also saving up for breast implants and a move to Vegas, so Emeka had to sift through her advice.

"Molly's working Friday," Robby said apologetically. "I've got to stay home with my kids. Ask Goodwin, though."

"Goodwin?" Emeka said. Goodwin worked the weekend shift at the butcher counter. He was a terse and dour-faced man in his forties, recently emigrated from Lagos. Any time Emeka asked him a question, he looked at her as if she were a piece of tripe that had acquired vocal cords.

"Maybe he'd go," Robby said.

"Sure," Emeka said, and wondered self-pityingly why this was her lot in life. Spending summer days cooped up in her parents' store, bearing witness to the lunacy between her mother and Aunty-Mrs., and watching the petering out of a summer romance when it was only May.

* * *

A few days later, Emeka had just finished explaining to her father that they could partner with Sonya, the owner of Caribbean Delights—one of the three businesses left in their strip mall—and host a food-tasting event to increase traffic, when Aunty-Mrs. entered the store, feverish and bright-eyed.

"Baba Emeka, where's your wife?" Aunty-Mrs. said.

"What's happened?" Emeka asked, a bit annoyed because her father had dismissed her suggestion yet had given no other recommendations for how to keep the store afloat. Once, she had suggested that they repaint their sign like Cooper's Flower Shop, but he had refused, calling it a waste of money.

Aunty-Mrs. waved her hands at Emeka's question. "Take me to her now—"

"She's in the back," her father said.

"Baba Emeka, please. I'm begging you."

Emeka and her father weren't quick enough to respond, and Aunty-Mrs. wide-strode down the cleaning supplies aisle, passing the swinging metal doors that led to the back room.

Her mother rose when the three of them entered. "What is this, Bunmi?"

"You won't believe what I'm about to tell you," Aunty-Mrs. said.

"Should I send Emeka out?" Her mother removed her glasses, resting them on some invoices. She had the strained, anxious look that came from tallying numbers and worrying about figures.

"No, let the girl stay. Make am hear me. All the three of you must see this."

Her father said, "Who's going to manage the store with us in here?"

"Please, Baba Emeka. This is of far more importance. Mama Emeka, you remember that tumor that was giving me trouble, and I was having difficulty walking?"

Her mother said, "I remember, o."

"You touched my leg and wetin happen? Glory be to God. The thing disappeared."

"You're not serious. It's gone?"

"Gone, my sister." Aunty-Mrs. bunched up her skirt. "Come and see, o."

They all bent their heads to study Aunty-Mrs.'s leg. To Emeka's surprise, the skin was completely smooth, as if nothing had ever grown there, and the swelling was gone. She had thought Aunty-Mrs. was exaggerating.

"It's really gone," Emeka said, before she could stop herself.

"What's this nonsense?" Her father crossed his arms. "What's gone?"

"It's vanquished, o. Your wife healed my cancer."

"How do you know it was cancer, Aunty?" Emeka chuckled at Aunty-Mrs.'s overstatement. "How do you know it wasn't a spider bite?"

Aunty-Mrs. turned sharply. "I know what it was, Emeka. Have I not lived long enough? If I said that my cancer is gone, then believe me, your mother has healed me."

"Bunmi," her mother said, "I didn't heal you."

"Mama Emeka, this is one kind miracle. You cannot squander your gift, o. You must use it."

Her father, who had posted himself against the wall, laughed. "We have work to do. We don't have time to be wasting on this—"

"How can you explain this thing that was paining me? How is it that the thing has vanished?"

"Bunmi, I'm not a healer," her mother said. "It must have gone on its own."

Aunty-Mrs. was undeterred. "I have one friend. She's gone and seen so many doctors, one after another, because of pain in her stomach. Was it not the other day that I saw her looking poorly? Abeg, let me just bring the woman here so you can heal her too. She said she is willing to pay."

Her father straightened. "Pay? For my wife to pray for her?"

"I don't want anybody's money," her mother said.

"Abeg, listen to me," Aunty-Mrs. said. "You're a healer. Those hands of yours have power. I would not have asked you if I was not the one seeing my friend in so much pain. The medicine they gave her has not worked. If you pray for her and nothing happens, then I will leave you alone."

Aunty-Mrs. was cracked in the head, Emeka thought. Her mother praying for people and them becoming better was one thing, but her mother the healer? Emeka looked at Aunty-Mrs. and her mother, such similar physiques that they could have come from the same family, both thin and firm like river reeds. Her mother seemed to be nodding in agreement, looking down at her

by
AFABWAJE
KURIAN

hands as if seeing them for the first time. The back room was too warm; the air conditioner did not work, and there was no portable fan. Emeka decided that the heat must have gotten to her mother.

Emeka laughed. "Ma, you're not going to do this—"

"Leave her, Emeka." Aunty-Mrs. said. "Will you do it, Mama Emeka?"

"I won't take your friend's money," her mother said, finally.

"We won't?" her father said.

Aunty-Mrs. raised her hands and clapped. "So she can come?"

"Bring her tomorrow, after the store closes."

The woman that Aunty-Mrs. brought was much younger than Emeka had expected. She was solidly built, in her mid-to-late thirties. The CLOSED sign was up, so Emeka waited for the two of them outside. Their store was at the end of the block of buildings, so she led them to the store's side entrance when they arrived.

Her mother offered the woman a seat and asked about the location of the pain. The woman motioned around her stomach. "I cannot explain how sharp this pain is. How much it pains me to eat or to lie down." She sounded as if she might cry. "I don taya, Aunty. I don't know what to do."

"Here?" her mother said, pressing her fingertips against the woman's abdomen. "Is this where it is paining you? I'm feeling something, like a stone."

The woman flinched. "Yes, the thing. That's it, o."

"Am not causing you pain? You'll let me know."

"Aunty," the woman said, "did you go and learn medicine somewhere?"

"Don't ask nonsense questions," Aunty-Mrs. said from her corner. "Did I tell you I was bringing you to one doctor or did I say you were going to be healed?"

"Let her ask questions," her mother said. "No, I didn't study anything. Not like Emeka."

"Before you came to America, nko?"

"I taught primary school," her mother said. "Okay, now, you must believe with me when I pray. You understand? Where two or three are gathered in his name…"

The woman nodded. "Yes, Aunty."

"What is your name?"

"Lamibwa."

Emeka's mother lowered her voice so that neither Emeka nor Aunty-Mrs. could hear what she was saying. Lamibwa also closed her eyes and exhaled. With her hands on Lamibwa's stomach, her mother began a prayer. Two minutes later, she finished.

Aunty-Mrs. crossed her arms. "Mama Emeka, you better pray longer, o. This one is not like my own cancer. Make you no rush."

"I have prayed," her mother said. "That is what you asked."

Emeka escorted the two women back to the parking lot, and the entire time, Aunty-Mrs. repeated to Lamibwa, "You will see. Wait and see what happens to you."

It was one week later exactly that Lamibwa returned. Emeka had wrested a cart from a would-be thief and was pushing it back to the store when Lamibwa parked her minivan diagonally across two parking spots and waved to her from the driver's seat.

"It's gone," Lamibwa shouted, her eyes glinting. She hurried out of the van. "Just like your mother healed Bunmi's cancer, she's healed my stomach."

The night that she had come with Aunty-Mrs., Lamibwa had worn a long, shapeless dress and a plaid scarf around her head. Her eyes had been downcast during the prayer session. Now her eye shadow was a thin blue crescent underneath her eyebrows, and her box braids were freshly done.

Emeka's face must have conveyed her disbelief, because Lamibwa added, "I nearly did not believe it myself. Three days after your mother laid hands on me, I stopped thinking her prayers had done anything. I woke up that fourth morning without pain, and I said to myself that the pain would come. The entire day, I did not feel anything. That was many days ago."

"Are you sure?" Emeka asked, not knowing why she felt such a tension in the pit of her stomach, a desire for it to be true and a fear of what might come if it were true. One case of healing was a fluke; twice in a row would be something else.

Lamibwa laughed, as if she had known Emeka would ask. "I had stopped taking medicine long

before I went to your mother. After she prayed for me, I didn't think it worked. It was when the pain left me that I went back to the doctor. Nothing, Emeka. Nothing on their scans. They said they could not understand what had happened to the stone. Please, take me to your mother."

The next week, Aunty-Mrs. returned with her neighbor's daughter who had injured her arm, and days after, it was Lamibwa bringing a coworker who had been diagnosed with arrhythmia. The following Tuesday, Aunty-Mrs. brought Uncle Gbenga. He had suffered from tinnitus since his automobile accident in January. Three days after Emeka's mother prayed for him, Uncle Gbenga was proclaiming that he was healed. Since he was a deacon at the African Interdenominational Church of Christ, he gave a special announcement to say that on Tuesday night, Mrs. Susan Okeke, wife of John Okeke and mother of Emeka, owner of Variety African Market, had prayed for his ear, and he had been healed completely. "Hallelujah!" Uncle Gbenga shouted at the podium.

The following Tuesday, after the store closed, others arrived asking to see Emeka's mother— one woman who suffered from kidney failure, and a young man with a dislocated shoulder, another with glaucoma, a fourth afflicted with epilepsy. Emeka could not believe that these people were coming to see her mother. She had no healing oil, no candles, no prayer beads, and no holy water. Nothing like the men on television, dressed in double-breasted suits, women and men collapsing at their feet or falling backward into outstretched hands. No, it was just her mother, wearing an ordinary blouse and wrapper, plain as can be, her relaxed hair copper-streaked and thinning, held together with a rubber band that Emeka swore she had snagged from a loaf of sugar bread.

"Ma, how is all this healing happening?" Emeka asked one afternoon when the two of them were in the back room, filling small, clear bags of raw shea butter for the beauty section.

"Emeka," her mother said, "I don't even know if this is truly happening. Those four people that came, have they returned to say that they have been made well?"

"But people are saying that it's true—"

"People will say anything, bah?" Her mother drove the knife into the butter, dislodged a jagged rock of it. "They are wanting so much to be well that even this small thing of having me pray with them is making them to think it's me healing."

"How did you not know that you could heal?" Emeka said. She thought about the asthma she had suffered as a child, the wheezing and insistent tightness, like a rubber band constricting her small chest, the misery she could have avoided if they had known that her mother possessed such power. "How did we not know when I was sick?"

"You're asking me all these questions. Don't you think I'm wondering too?" Her mother looked unsure and tired. She gripped a lump of the hardened butter in her hands, and crumbs broke off between her fingers. "I don't know, Emeka. I might have just received the gift now. You recall how Aunty Bunmi said I should use my hand on her leg? I had never tried that before. All this time, I would be feeling myself wanting to pray for people's illnesses, but I didn't know that it was me needing to stretch my hands over them."

Emeka saw her mother's discomfort. "Ma, if this is true—"

"Abeg, Emeka," her mother said, tying a knot in the last bag. "Leave me."

The healing evenings continued like this for a couple of weeks, people coming on Tuesdays after the store had closed. Emeka's father said they should charge people for her mother's prayers, because he was not going to be the one paying for the extra electricity they used after closing time. Her mother refused. She was not going to charge anybody for healing.

It was mainly people in the African community in Urbana that came. People were telling Emeka's mother stories about how they did not have money for hospitals or insurance. How they did not understand all of the new insurance changes the president had made. What about their family members who did not have legal documents? If they went and signed up for this national insurance, would this jeopardize them? The people, their pain, their questions affected Emeka's mother. After each session, her shoulders were hunched and her eyes were half-open like a sleepwalker's.

"Should you be doing this?" Emeka's father said to her mother. "You're not functioning as you were before. See how all of this is taking your energy."

by
AFABWAJE
KURIAN

"If it's working for people," her mother said, "how can I stop?"

Then one exceptionally hot Tuesday evening, days before the Fourth of July, Emeka's mother healed a Ghanaian woman in a wheelchair. Emeka and her father were in the back room when her mother lifted the woman's hands and slowly pushed the wheelchair away from her legs. The woman took one tentative step, like a newly walking infant, then another step, and when her mother released the woman's hands and moved backward, the woman continued walking on her own. The five or six people witnessing the miracle erupted in shouts. The following week, Emeka opened the side door. Instead of the usual five or six visitors, a line of about twenty people, including some faces she did not recognize, curved around the building. As Emeka led each person into the back room, they said that so-and-so had told them that it was here they should come for healing. This was how the Summer of Healing—as Emeka came to call it—began.

Her summer took on a routine. She stocked, shelved, mopped, unloaded, and handled the register in the mornings. And every Tuesday evening after the store closed, she patrolled the foot traffic for the healing nights, asking visitors to maintain their place in line, noting first-timers, second-timers, and caregivers. Emeka's father had come around once he realized that they could charge people for drinks and snacks, as steeply priced as in American movie theaters. On healing night, Emeka went from person to person, dragging a large red cooler stocked with cold bottles of Malta India, Fanta, Sprite, and carrying a box of biscuits, peanuts, banana chips, chin chins, and wafers. People fanned themselves and reclined in folding chairs. Returnees explained to the newcomers about the healing energy, warm and sweet, that traveled through their bodies when Emeka's mother prayed. "Like someone is playing a flute inside of your pain," one man explained. And inside, Emeka's mother waited in the back room, saying, "Bring the next person," as if she had been doing this all her life.

Summer had always been the worst time to work in the store. Toots had remarked that

in temperatures above eighty, the store reeked of dawadawa, the musky smell of fermented locust beans. *Hot* dawadawa, Toots had said, in case she was not clear enough. The store was muggier and filthier in the summer, the ceiling fan more quickly caked with dirt, children were more likely to drop their candies and stick their gum under the shelves. Customers were more irritable, less tolerant of mistakes.

But this summer, these things paled in comparison with the excitement that surrounded the healing nights. Slowly, Emeka and her parents converted the back room into their vision of a healing room. Emeka's father salvaged a dull mauve chaise from a dumpster blocks away, and he and Robby dragged the chaise into the back room. Emeka was the one who had to spray it and wipe it clean. Emeka borrowed a room divider from Toots to separate the healing space from the desk, chairs, and the locked files of invoices and shipping orders. They wallpapered the room with Bible verses and a poster that said: DON'T BELIEVE EVERYTHING YOU THINK. Emeka bought artificial flowers, purple and white morning glories, and a carafe, which she filled with water and set on a small table with a number of candles. More than once, people seeking healing had come into the back room, taken one look at Emeka's mother, and left because she was not what they had thought she would be. So Emeka drove to the Hair Emporium one afternoon and found on sale a voluminous curly lace-front wig, one that would give her mother that larger-than-life presence that a TV personality possessed. Her mother refused to wear it. She was not healing for show. She was just there to heal, in Jesus's name.

Her father said he had once heard on NPR that a scientist had cured a mouse of breast cancer through hands-on healing. Emeka should find the article and post it in the back room.

Emeka sighed. "Mice?"

"Find it," her father had said. "Do your online. How else can we reach more people? More will come if they see this kind proof."

So those articles, too, were tacked to the wall.

Toots finally got around to coming to see what all the commotion was about, because a girl that she worked with at Gordmans in Champaign had blabbered on about healing night. She brought Emeka pictures from her recent sizing session. They sat outside the store in Toots's car,

and "Eminado" played low in the background. The car smelled faintly of butterscotch and cigarette ash. Two months ago, Toots had dated a mechanic who carried butterscotch candies in his pockets, sometimes unwrapped, smacking his lips so loudly when he popped the disks into his mouth that Emeka had nearly wished him to choke. A few of his leftover candies were still stuck in the corners of Toots's console.

"Which ones should I get?" Toots asked, handing the photos over.

Outside, another couple joined the healing line.

"I've got to go sell these snacks," Emeka said.

"It'll be quick." Toots pulled out a piece of gum. "Just take a look."

"This one." Emeka pointed to a photo of Toots in a black lace bra. "They look more natural."

Toots squinted at the picture. "If I wanted them to look natural, I wouldn't be doing this." She shuffled the photos. "What about these?"

"Are you kidding?" Emeka said.

Headlights outside illuminated the interior of Toots's car. Another patient for healing night. Toots whistled, eyeing the crowd. "Your parents could make a killing. Charge ten dollars a head. How'd you manage to find every African in this state? I didn't know there were this many of us."

"They've just been coming from church, from the store, their friends. I don't know."

"Is your mother for real?"

"Really, Toots?"

Toots smacked on her gum and said, "I mean, are people faking it?"

"I can't believe you're even asking me," Emeka said. It was no longer just a delusional Aunty-Mrs. or Lamibwa. Emeka had seen pain disappear for many others.

Toots shrugged. "Look at that Pastor Kanyari and the pomegranate powder on his fingers."

"I don't think it was pomegranate," Emeka said. It was potassium permanganate that Pastor Kanyari used to convince his worshippers that his fingers could leach blood from their sick bodies. She did not say this, because Toots would have accused her of showing off her two years at Parkland College.

"Whatever it was," Toots said, "it wasn't real."

"This is real, Toots—we have hospital scans and reports. I'll show you."

"You better insure your mother's hands, then," Toots said. "Like all these celebrities insuring their asses and legs. Two million dollars for one dinky leg."

Emeka laughed and reached for the door handle.

"I should open my own healing center," Toots said. "Take your mother's business."

"Who'd come to you, Toots? When you don't have the gift?"

"Du jour, du jour," Toots said, tucking her photos away.

Members of the African Interdenominational Church of Christ recognized Pastor Francis when he came to healing night. Emeka was leaning on the side door to the back room, taking a short break and stuffing dollar bills from the snack sales into her fanny pack. Those who knew Pastor Francis nodded approvingly, as if his presence somehow validated her mother's healing. He did not join the line, as Emeka had expected. He shook the people's hands, as he did at the end of every church service, and he walked as if he were a person of importance, so that people who might ordinarily have shouted about cutting the line bridled their tongues.

Pastor Francis's warm pink shirt softened his bespectacled face. He bore a paternal pouch, which Emeka had always thought humanized him, made him seem accessible. "Emeka," he said, placing his hand on her shoulder, "I'm here to speak to your mother."

Emeka waited for a patient to emerge from the healing room before leading Pastor Francis inside, where both her parents welcomed him. Her father offered him the chaise and beckoned to Emeka to bring water and a plate of fresh sliced mangoes, which was one of their new offerings. Pastor Francis did not sit immediately; he walked around the room, studying the scans, the copies of doctors' reports, and the pages of patient testimonies taped to the wall.

"Sister Susan," Pastor Francis said, turning from the list of testimonies, "it appears that you have been blessed with a gift. Our church members have been speaking of nothing else."

Emeka's mother sat in the straight-backed chair. "Yes, Pastor Francis," she said.

"Myself and the elders are worried about you—"

"Why do they need to worry? There's nothing wrong with me."

by
AFABWAJE
KURIAN

Pastor Francis smiled. "You've been given power, but that power must come under authority. This is why they are concerned for you. You are here doing this without guidance."

"Authority, Pastor Francis? What are you saying?"

"Whose authority are you under, Sister Susan?"

"God's," her mother said.

"Mama Emeka, yes, you are under the authority of the living God, but he has charged us leaders in the church with the responsibility of overseeing our members."

Emeka spoke up then. "Pastor Francis, are you saying my mother needs your permission to heal people?" How was it that he'd been here for just a few minutes and he was already telling them what to do?

"Emeka, quiet—" her father said.

"No," Emeka said, her frustration rising. The fanny pack seemed to tighten around her waist. "We have to know why."

"What your mother has been given is not intended for her alone," Pastor Francis said. "If she is under our authority, then this kind of thing can help our church. Do you see?"

"Am I not already attending church?" her mother said. "So whether these people go to the church or come to our store or enter my house, what is the difference?"

"Sister Susan, do not allow obstinacy to blind you—"

"You want to profit from this?" her mother said. "That's what I'm hearing."

Her mother sounded like a different woman. Many weeks ago, Emeka would never have imagined her mother speaking to the pastor like this. Pastor Francis appeared surprised too. Emeka could see the changes in his posture, the crossed arms, the subtle shift in his shoulders.

"I fear that you've not heard me correctly, then, if this is what you believe. How long have I known your family? Since Emeka was how old? You should understand why I am here. It's for your protection, not for the church's benefit."

"What am doing," her mother said, "am not doing for myself but for the people who come."

Pastor Francis said, "The elders and I have spoken—"

"Show me where it says that what I'm doing is wrong."

"—and we believe that it is in your best interest to come under our authority or cease altogether what you've been doing."

"Stop altogether?" her father said.

"Why," Emeka said, "do we have to stop?"

A heavy silence followed. No one spoke for several seconds. As Pastor Francis was standing to leave, cries and shouts suddenly came from outside. The four of them hurried out to find that a woman had collapsed near the side door.

"She just fell over," someone said. "We don't know what happened."

Her mother knelt next to the woman, cradled her head in her lap. "Bring water."

"Heal her, Prophet Susan!" a woman shouted.

Her mother said, "Call the ambulance."

"Don't call ambulance," one man said. "We don't need ambulance. Pray and heal her."

Someone yelled, "Bring her back to life!"

"Call the ambulance," her mother said. "Emeka, go and call."

Emeka called 911, and as she explained the situation and gave the store's address, she heard the whispers: "Why would she have us calling an ambulance? Is she not supposed to be healing? Why did I come when I can just go and carry myself to the hospital? Has she been deceiving people?"

Her father was shouting that the crowd needed to disperse. Everyone was to go home. What would it look like if the ambulance were to come and see all of these people here?

In the midst of the chaos, Pastor Francis stood off to the side, as if he had single-handedly orchestrated the turn of events, and then washed his hands of the entire affair.

The woman lived. She had fainted from heat exhaustion and dehydration. Nevertheless, Emeka's mother was troubled and canceled the next healing night. Emeka and her parents did not attend the African Interdenominational Church of Christ on the Sunday after Pastor Francis came. They did not talk about the strangeness of the two events happening on the same night, Pastor Francis's visit and the woman fainting; to speak of it would have meant acknowledging that failure to heed his words presaged misfortune over their healing nights.

On her regular pounded-yam Tuesday, Aunty-Mrs. scolded Emeka's mother for not praying over the woman and insisted that she not cancel any more healing nights.

"What were people expecting me to do?" Emeka's mother said.

"To heal her," Aunty-Mrs. said. "They wanted to see a miracle."

Emeka's mother said, "I don't tell these people to stop taking their medicines or seeing a doctor. Why would I not have called an ambulance for the woman?"

Emeka and her parents also did not talk about the minor decline in the number of people who attended the next healing night. Emeka mentioned it to Toots one Friday night while they shared a plate of kuku curry before Souks closed its kitchen.

"Don't worry," Toots said, drenching her rice with the cumin-flavored sauce. "They'll be back."

"You think?" Emeka said.

"People are desperate when they're sick."

They smelled Grandfather's Aramis cologne before they saw him. He was dapper-looking in the taupe suit that Emeka did not find as unflattering as Toots did. They noticed a slight limp in his walk.

"What happened?" Toots asked when Grandfather sat down.

"My ladies," Grandfather said, twisting his shirt cuff, "I nearly collided with a bicyclist a week ago, and I suffered a fall. I'm not as I was when I was young. I can't recover as quickly as the pair of you."

"You should go and see Emeka's mother," Toots said.

"Why? Which kind doctor is she?"

"She's not a doctor," Emeka said as she halved a piece of chicken with her fork. The fainting incident had shaken her, and she was reluctant to offer any promises.

"Emeka, you're doing poor advertising," Toots said. "We don't know what the man means when he says 'doctor.' She heals people, does she not? Isn't that what a doctor does?"

"What kind business is she doing?" Grandfather said.

"She heals," Emeka said.

Grandfather rose, adjusting his shades. "You ladies are pulling my leg."

Toots was a little drunk, so she rattled off the illnesses that Emeka's mother had healed: the broken arms, arthritis, seizures, cancer, gallstones, all from laying her hands.

"Really? Even cancer?" Grandfather said.

"We don't know if it's cancer in every case," Emeka said, thinking of Aunty-Mrs.

Grandfather was quiet a moment. "Where is your store? If you are not pulling my leg, I'll come. If what you say is true, you will see me there."

"It's true," Toots said.

Toots was right. People returned to healing nights. Soon, freshly printed flyers announced the new name that her father had given the store: Variety African Healing Market. He still had not changed or repainted the actual sign above the building, so it was liable to confuse people who came on account of the flyers. Their store was also the largest African grocery in Urbana, by virtue of being the only one. Her father had declared this on the orange flyers as if it were a noteworthy fact. Those coming to the night of healing started frequenting the store, and Emeka's father had to ask Goodwin to work weekday shifts with Robby. Orders increased, and Emeka had less time to rest between checkouts. More and more, the parking spaces in front of their store and those of the boarded-up ones in the strip mall filled with vehicles. This attracted the attention of Ms. Cooper, owner of Cooper's Flower Shop. Usually, she only entered their store with complaints or threats to tow a customer's vehicle, but she came in one morning to conduct reconnaissance under the pretense of bringing Emeka's mother a gift of potted orchids. It was obvious that something was happening for them.

"Emeka," Goodwin said one afternoon when he was taking his break in the storeroom, "I'm hearing that your mother is doing miracles. Where is she doing her magic?"

Emeka said, "Where'd you hear this?" She had come to find the box holding the jars of ground peanuts. She searched the shelves and pushed boxes of red millet flour aside.

"Don't you think that these customers talk and ask me questions?" Goodwin was in the same white apron that Robby wore, sitting on twenty-five-pound bags of jasmine rice, his feet rocking on the pallet. "Your mom has become TB Joshua?"

"She's not like him."

"My sister in Lagos," Goodwin continued as if Emeka had not spoken, "she used to believe all that TB Joshua was telling her, and she traveled far to that church of his on Egbe Road. Gave the

by
AFABWAJE
KURIAN

church all of her money. She went and rented a room, waiting to meet him so that he could cure her."

"Okay. So?"

"She was not healed," Goodwin said, and that look Emeka disliked returned to sour his face. How could Robby ever have suggested she invite Goodwin to Souks?

Box in her arms, Emeka prepared to leave. "I'm very sorry about your sister," she said.

"What about the boy that died? The one your mother claimed to have healed."

Her throat dried instantly. "No one died, Goodwin."

They would have known if anyone had died. She was sure of it. Goodwin was lying, saying it only to get a rise out of her, like the time he told her she had misread the price tags on the packages of fish and overcharged customers. It turned out she had done nothing of the sort, but it had sent her into a panic.

Goodwin saluted her. "Soon the three of you will be selling holy water and anointing oil."

"That's not how my mother is. She's not like the others."

"Isn't that what they all believe when they start?"

Molly was in a white tank top and distressed jeans, her arms around Robby's waist, on a drizzling August night when the two of them came for healing. Emeka was embarrassed for Robby to see her in an unflattering hooded rain jacket, ferrying the box of snacks and cooler of drinks. He stood with Molly near the now-soggy sign her father had posted on the brick wall: NO OUTSIDE FOOD OR DRINK ALLOWED. At one point, people had started bringing their own Tupperwares of fried rice and meat pies.

"I didn't know this many people showed up," Robby said, taking in the crowd.

"I told you," Emeka said.

Even with the rain, there was a lot of energy in the crowd this evening, more than usual. Any doubts about the woman's fainting had long faded. It was as if it had never happened. The people in line tonight also seemed to know one another, and their sicknesses and expectation for healing served to bring them together as they waited, chatting and laughing.

"It's so hot," Molly said, sheltered under their shared umbrella. Two bracelets adorned her wrist, ribbons with wooden beads of mismatched colors and shapes, like they had been her kids' craft project.

Emeka shoved up the sleeves on her rain jacket and flung open the cooler to offer Robby and Molly bottles of malt for two dollars each.

"No way. You marked it up," Robby said, amused. "Should be fifty cents a bottle."

Emeka said, "Just take one. No charge."

Robby used the hem of his shirt to twist off the cap and gave it to his wife. Molly sipped the malt, made a face, and handed it back.

"Do people really pay this much?" Robby asked.

"It gets hot and the wait is long."

"This is crazy, Robby," Molly said, digging her hands into her back pockets. "It's not like she's anyone famous, you know— Sorry, Emeka. I just don't know if I buy this stuff, famous or not."

"There's mice that got healed from this," Emeka said.

"By your mom?" Molly said.

"No, some scientist."

"How come I never heard of it?" Robby asked.

"Conspiracy," Emeka said, and Robby laughed. Emeka turned to Molly. "Why'd you come, then, if you don't believe it works?" She tried to guess what diseases Molly might have.

"It's not for me," Molly said.

"It's my back," Robby said. "It's been giving me problems for months."

"I didn't know," Emeka said, and if she had been as daring as Toots, she would have looked up at him and said, *Show me where.* But she was not so audacious, so she hugged the case of malt and said, "I can't believe you lifted that chaise with my dad."

Molly touched his back. "You should see a chiropractor, hon."

"We'll take care of him," Emeka said. "Don't worry. It works."

"Every time?" Molly said.

Emeka thought about the woman who had fainted and the boy Goodwin claimed had died. But she didn't like Molly's skepticism. "Yeah," she said. "Every time."

"What if it doesn't?" Robby pitched the empty bottle into the trash can. "Then what?"

"I'll owe you one," Emeka said. "A drink or something."

Robby, who had given her no signs all summer and was married to Molly, smiled. "All right, Emeka," he said. "I'll hold you to it."

Emeka moved down the line, dragging the cooler behind her and carrying the box of snacks, struggling to protect them from the rain. Was it possible that she could counteract her mother's prayers with her own? Could she pray that the healing for Robby would not work? She could see the two of them driving to Souks after work so that she could buy him the drink she'd owe him, or to wherever it was Robby liked to go when he went out, if he went out. She walked down the line, and as usual, some of the people she sold snacks to disclosed intimate details about their ailments. It did not take much for them to give you a list of their symptoms, the genesis of their disease, to tell you how many medications they swallowed a day and what surgeries or procedures they required. Once, Emeka had listened to an old woman tell about the time her big toe had gotten infected. She told Emeka about the blackness and the yellow pus, and how the surgeon had amputated it.

"If I ever get like that, shoot me," Toots had said last week when Emeka went to visit her. It had been a couple of days after her augmentation, and Toots's bandaged breasts were swollen. Both breasts looked to be the size of Toots's head, and the sight of them had made Emeka feel suddenly dissatisfied with her own. "Do they go down in size?" Emeka had asked. "I hope not," Toots had said, peering down at the set.

Emeka reached the end of the healing line and found Grandfather waiting. He was dressed in a white shirt tucked into crushed khaki shorts. He winked at her.

"You came" was all she could manage.

"Yes," Grandfather said.

She was unaccustomed to seeing him outside of Souks. She felt as if she were seeing him nude, without his crisply ironed suit and shades. His legs were exposed and marked with tiny curls of hair. He smiled at Emeka, a rueful smile, as if apologizing for his appearance. When Grandfather finally walked through the side door for his healing, her father gently guided Grandfather's arms and shifted his legs, because Grandfather did not seem to have the energy to recline on the chaise by himself. His thin, wrinkled shorts gaped around his legs in such a vulnerable and

intimate way that Emeka headed outside so she would not have to watch his session.

"That man," Emeka's mother said, folding the divider after the doors were closed and the people gone. "Do you know him, Emeka?"

"Which one, Ma? There were so many."

"The old one that just left. It's not a bicycle accident. I don't believe him."

"So," she said, trying to sound disinterested, "what's wrong with him?"

Emeka's mother looked at her sharply. "Do you know him?"

"I swear I've never seen him before," Emeka said, glancing away. "Anyway, Ma, where would I even know him from?"

"It's not his hip," Emeka's mother said, sitting on the chaise. "When I asked him again, he said that I should pray for his hip, that this was why he came." She sighed. "There are things that people don't want to know about themselves. I don't know what he has, but there's something else."

Emeka swallowed and said, "You prayed for the other thing too."

"Yes, of course."

"Then your prayers will work," she said.

Two weeks later, Grandfather returned to the store to declare that he had been cured. He cut the line and walked into the healing room, hefting two cases of pop for Emeka's mother. Her mother said nothing about his poor choice of a gift. Didn't they have stacks of Sprite at their disposal in their storeroom? Instead, she thanked him. Her mother was now used to such expressions of gratitude from the patients. So often they returned, eyes brimming with relief after being cured from an illness they thought they would have to suffer for the rest of their lives. The Americans came with carnations and boxes of chocolate (which her father repriced and sold). Their African customers brought puff puff or jollof rice in CorningWare, wrappers, or dried stockfish from a recent trip back home. Some patients offered drawings from their healed children. One girl had drawn Emeka's mother as a towering stick figure with yellow lightning shooting from her fingers and squiggles for hair. The girl had drawn herself next to Emeka's mother. A distorted smile stretched beyond the perimeter of the smaller figure's head. This drawing, of course, was taped to a wall of the healing room.

Grandfather clasped her mother's hands. "See how God has given you this gift."

"I'm very happy for you," her mother said. "That you are well—"

"Never before have I felt as I do now," Grandfather said, grinning.

As he passed Emeka at the door, Grandfather tipped up his retro glasses. "You were right, my lady. Your mother—the woman can heal."

by
AFABWAJE
KURIAN

The night that the Variety African Healing Market ended up on the eleven o'clock news began as any ordinary night of healing did. It was humid and the air conditioning in the back room was still unfixed, so heat overwhelmed Emeka, following her as she hurried back and forth. A teenager in line played music from his phone, something bland and instrumental that nobody could object to. As usual, forty to fifty people had gathered; some brought lawn chairs, and others stood waiting against the brick wall, drinking their cans of pop.

The sirens came first, shrill, but so distant that Emeka thought the police were heading to another neighborhood. Then the noise amplified, and she saw the flashing blue and red lights looming. Everyone in line seemed to sense a panic rippling through as the police cars veered into the parking spaces in front of the store. Doors slammed and two police officers stepped out of their cars, hands on their holsters. Those in line immediately raised their arms above their heads. Those whose arms were the reason they had come for healing did their best to appear surrendered. The boy who had been playing music switched it off.

The first officer clicked on a flashlight, letting it wash over the faces in the crowd. "Who's in charge here?" he asked. Emeka read his badge: OFFICER JACKSON.

"Prophet Susan," someone shouted, and a wave of defiant laughter swelled through the line.

Emeka stood up from the cooler. "My parents," she said.

Before she could offer to call them, her father emerged from the room. "Officers, what is the problem? What have we done?"

"Sir, I need you to calm down," the second officer said.

"He's calm," Emeka said, frightened for her father. "He's not doing anything."

"Ma'am, there's no need to raise your voice," Officer Jackson said. "We all want the same thing here."

"But we don't know what you want," her father said.

"We've gotten reports of illegal activity," the first officer said.

"What kind of illegal activity?"

Officer Jackson asked, "Do you have a permit to hold a public gathering, sir?"

"Permit? Well—this is our store," Emeka's father stammered.

The officers warned people not to leave, telling them they needed their cooperation. The first officer entered the healing room, and Officer Jackson called for backup.

It did not take long for the news crews to arrive in their white vans, thrusting microphones in people's faces and asking about the story behind Variety African Healing Market.

How delusional they all looked, under the glare of the camera crews' nightlights. Emeka, sweating and confused, wearing the fanny pack of change around her waist. Her mother, standing by the side entrance to the back room, concealing her face with her hands. How ordinary-looking she was on the clip that aired, nothing about her to lend credibility to people's claims of healing. Her father was a stout figure behind the officers, brandishing his scientific articles that he had unfastened from the wall, his words unintelligible, beyond the scope of the reporter's microphone. The footage panned across the people who had come for healing, caught their fear and bewilderment.

The reporter shoved microphones in the faces of the newcomers and the returnees. The returnees did their best to answer the questions candidly, not knowing how foolish they sounded. Yes, they had been healed. *By whom?* That little woman standing over there. *How much did she charge?* She never charged. The snacks were pricey, though: three dollars for wafers the size of your fingers. *Was this so-called healer a practicing, board-certified physician?* No, not to their knowledge. Well, actually they weren't sure exactly, because they had never asked. *Where was the proof?* In their doctors' offices, on the scans: if you looked, you could see bones healed, ligaments repaired, tumors vanished. *So you were seeing a doctor at the same time that this woman claimed to heal you?* Yes, well, no, not exactly. *You were or*

were not seeing a doctor when this woman claimed to heal you? They could not remember the dates, but maybe, yes, there had been overlap.

The news clip aired with the caption "False claims of healing at Urbana's largest African market."

It took a toll on Emeka's mother—the news clip, the camera crew that came to the strip mall the following day to interview Ms. Cooper and Sonya. It turned out that Goodwin's story about the dead boy was true. The news channels covered this too. The woman whose son had died had driven from Rockford, Illinois, to Urbana for a healing session in early August. She said she had not wanted to make trouble for Emeka's mother, so she had said nothing about her son's death. They had seen signs of improvement after the prayer, diminished fever and increased mobility, and as suddenly as those signs had come, they disappeared. The boy's kidneys shut down, and seven days after the healing night, he was dead.

"Emeka, what did I do?" her mother said when they watched the woman's interview.

"It couldn't have worked every time," Emeka said, and even as she said these words, they felt inadequate, hollow in her throat.

Three months after the news stories aired, Variety African Healing Market officially announced it was closing its doors. Business had declined. No new customers had come, and with the bad press, the regulars had stayed away, except for a few loyal customers like Aunty-Mrs. and Uncle Gbenga. A few people visited the store seeking healing despite the news stories, but Emeka's mother sent them away. The only thing she talked about was finding the woman whose son had died. Goodwin had quit a week after the incident with the police officers. He had ceremoniously taken off his apron and handed it to Emeka's father, saying that he did not want their reputation to sully his.

During his last shift, Robby said to Emeka that they never did get that drink, because his back had healed. The two of them went to Caribbean Delights. They drank ginger brews and snacked on coco bread. Robby said he was going to work with Molly's father for a while, until something else came along. He asked Emeka about her parents. What was next for

them? Her dad had worked for a shipping company before, she said. He'd go back to it and ask around for work.

"Your mom's going to come back to it, though?" Robby asked.

"I don't know," Emeka said.

Emeka did not tell Robby that she had initially suspected Molly was the one who had called the cops, given her interrogation about the healings. Ultimately, though, she concluded that it must have been Ms. Cooper. They had not seen her for many days; she had not even come to water the outdoor begonias that she stacked like pyramids in front of her shop. Emeka said this to Robby.

"It wasn't Ms. Cooper," Robby said.

Emeka looked at him. He knew something. "Who else, Robby?"

"If I tell you, you've got to promise not to tell anyone."

"Who else?"

He sighed. "Goodwin."

"I don't believe you," Emeka said. But she did, even as she said it; she believed him completely.

"He was upset about his sister in Lagos. Didn't he tell you? Fraudsters, shams—that's what he said about that Joshua guy."

"Because his sister wasn't healed?"

"Because she died."

Emeka closed her eyes.

"You all right?" Robby said.

"Yeah."

Outside Caribbean Delights, before they parted ways, Robby said he would come to Emeka's mother if he ever had any issues. It had been good while it lasted, he said. The store, the healing nights. Emeka agreed, though she was certain that she would not see Robby again.

Emeka and Toots went to Souks less and less often. For Emeka, Souks had lost its appeal, but with nothing for her to do during the day except search for work, it gave a bit of structure to her week. Toots's implants had healed, and the men at Souks were letting their approval be known with double takes and free mojitos. "They don't even see my face anymore," Toots complained to Emeka, but her spine was arched, and she teased the bangs of her new weave.

Grandfather had gone missing from Souks, and it was the bartender who told Toots and Emeka that Grandfather was undergoing radiation treatment for cancer.

"What kind of cancer?" Emeka asked.

"The kind wey dey disturb man," the bartender said, turning in embarrassment.

Several Fridays later, in December, Grandfather returned to Souks, scratching up the dance floor with his crocodile shoes. He was thinner, and his glasses did not fit his face as they used to. Though Emeka allowed him a dance, it was nothing like how she had danced with him before. She saw his eyes through the sunglasses, as somber and red-veined as they had been in the healing room when he'd first come to see her mother. He was not well. He was not healed. It was as if she were dancing with a delicate marionette, and when his hands moved down her waist, she pictured them skeletal, the skin sagging. As the song mixed into the next, Emeka slipped out of his reach, saying that she needed a break because her feet were hurting. Grandfather tossed his head back and laughed. "Maybe you should go and see your mother for healing." Emeka heard a sinister note in his laughter, like the reporters', like how Goodwin had laughed. With his laughter ringing in her ears, Emeka turned back toward him and began again to dance, despite her aching feet. As the music swelled in the dim room, Emeka allowed herself to feel the sweetness of it in her veins and the warmth of light on her skin, and she imagined that this was what the people must have felt as they stood in anticipation, faces searching and hopeful, waiting for her mother's touch, believing like Grandfather had believed, just as she, too, had once believed.

by
AFABWAJE
KURIAN

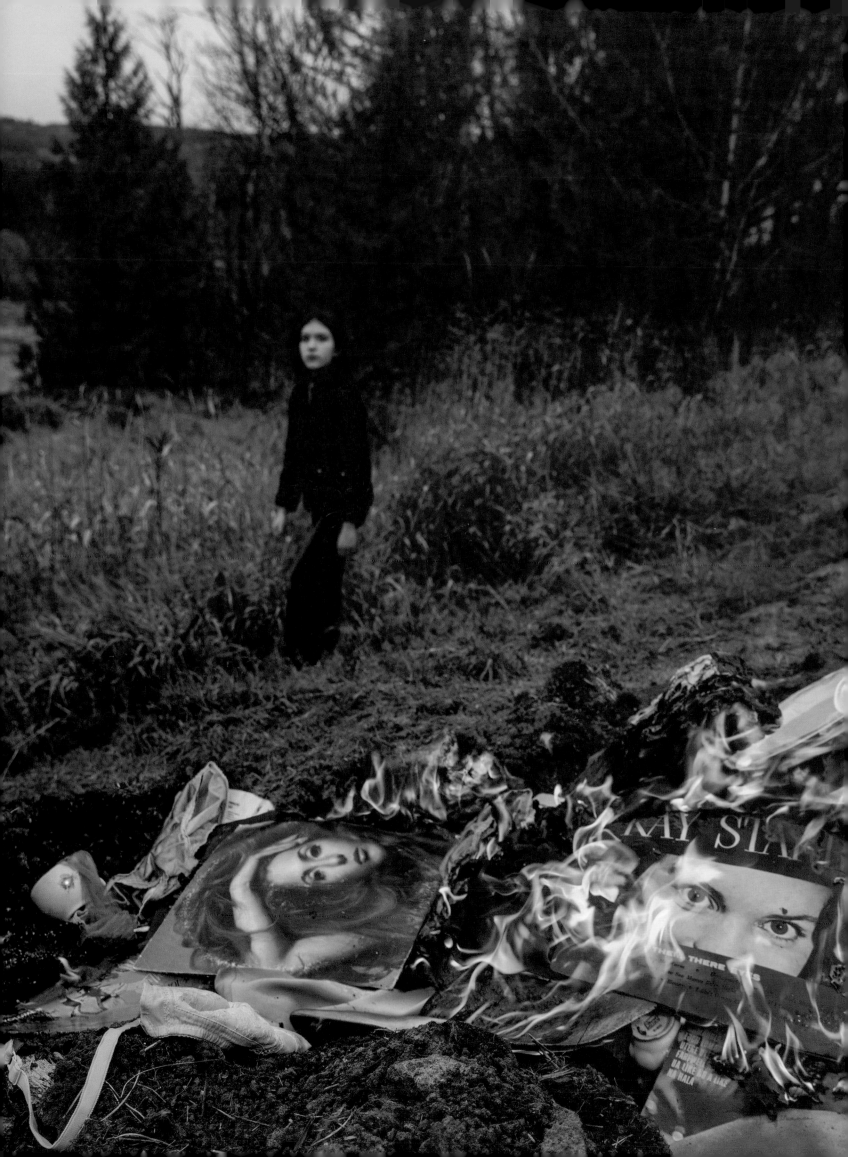

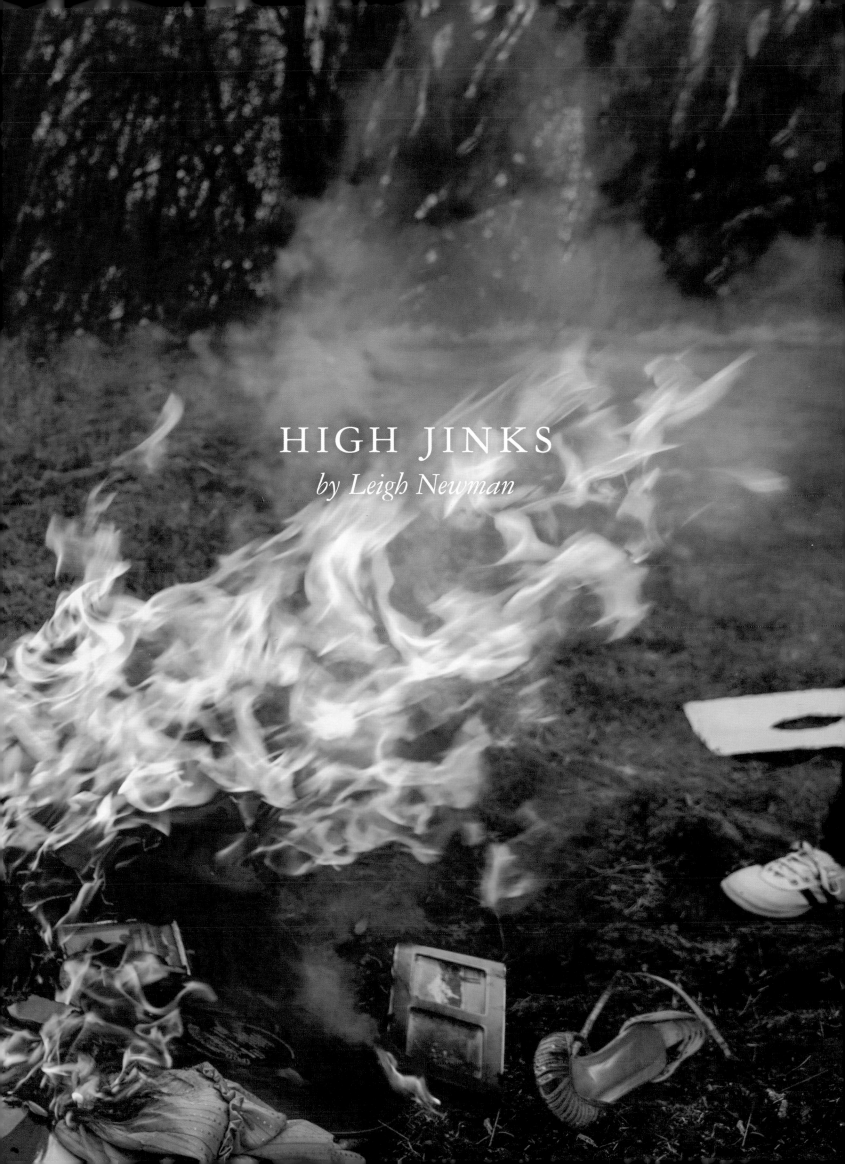

HIGH JINKS
by Leigh Newman

The morning of the father-daughter float trip, Jamie's father has the horrors and can't leave the can. Jamie's mom runs Jamie down to the dock and helps her into the cockpit, Jamie still in her nightgown but with a rain jacket over it and hip boots underneath. Two pairs of ragg wool socks dangle limply from her pocket. A jumbo box of Cheez-Its leans out of the grocery bag she has falling out of her arms.

"Junk food and dry feet!" says Katrina's dad to Jamie's mom. "What else does a girl in the wilderness need?"

Jamie's mom says, "Jamie, don't be too upset. Your dad didn't mean to get so sick."

As soon as she walks up the hill to the house, Katrina's dad says quietly, and only to Katrina, that she is going to have to share all her gear during the float trip, toothbrush included, as if she and Jamie were sisters.

Katrina would like to say that Jamie and she are already almost sisters, since her dad is always taking Jamie to Baskin-Robbins with them or to the movies with them or bossing Jamie around about honor roll and making her go to sleep during sleepovers. Even when Jamie already has a sister, as well as a three-wheeler, a fluffy white pound kitten, and a pair of diamond stud earrings. None of which Katrina has or will ever have.

Her dad, however, has mentioned more than once that he will not brook any unkindness on this trip. Jamie has to fend for herself in a house full of grown-ups that act like children. Jamie needs understanding, even when she fibs and doesn't share.

Which is why Jamie gets to sit up front with Jim the Pilot, while Katrina is stuck in the back of the plane with the cooler and a puke bag. Her dad settles in beside her. One extra headset dangles from the hook, and before he can hand it up to Jamie, Katrina slips it on. The world goes fuzzed and silent. Dust bits trickle through the sunlight. A smear of slapped mosquito bloodies the corner of the map by her knees.

Before Katrina's mom left for forever, she always got the front seat. Her mom was best friends with Jamie's mom. And Katrina's dad was best friends with Jamie's dad. And Katrina was best friends with Jamie, even if Jamie didn't let her touch her diamond studs. They were twin families and each other's only real family, since their other families, with grandparents, lived thousands of miles away, in the Lower 48.

Now Katrina's dad doesn't want to be best friends with anybody. Or go over to Jamie's parents' big white house, across the lake from their house. Or tell holy-shit stories while the moms all do the hustle on the deck. He wants to sit at home and tie flies. He agreed to the father-daughter float trip only because he and Jamie's dad and Jamie and Katrina have been doing the trip since Katrina was six and Jamie was seven. Each year on a different river. This time, their fourth time, they are floating the mighty Deshka.

Static crackles through Katrina's headset. Jim the Pilot talks to the tower about a southwest takeoff and another plane with priority at two o'clock. The back seat shudders under her thighs as he buzzes them over the water and up, up, up over the tree line at the end of the lake. The flats of Cook Inlet spread out below, and the last of the Anchorage houses. Then Fire Island. Which is where Jim the Pilot finally gets on the mouth mike to fill in Katrina's dad on the high jinks that came to pass last night at Danny Bob's.

Danny Bob is Jamie's dad. Katrina keeps her breathing slow and quiet so they will forget she has a headset on too. The high jinks went as follows: Jim the Pilot stole the blue bear out of Danny Bob's living room. Danny Bob had brought down the blue bear last fall but shouldn't have, since the shot belonged to Jim the Pilot. As they had both agreed on at the start of the trip.

The fact that Danny Bob had had the bear mounted and stuck it in his living room so that every blessed guest at the party could ooh and aah, congratulating Danny Bob on the kill of a lifetime, had been too much to stomach. Jim the Pilot waited until Danny Bob was lost to the sentient world, loaded the bear into the bow of his canoe, and headed home. Which was, in retrospect, an error in judgment. Somebody on the lake had to have seen him—and the bear— and that somebody was going to call Danny Bob.

"Well," says Katrina's dad, "maybe they mistook it for a dog."

"Buddy," says Jim the Pilot, "it's a blue bear."

"Jim," says her dad, "it's not a blue bear."

by
LEIGH
NEWMAN

"It sure as Sunday is a blue bear," says Jim the Pilot.

There is a long, crackled silence. Then her dad says, "It's a blue cub."

And this is the end of the talking. Katrina's dad, even Katrina knows, has broken the rules, because even though Danny Bob's blue bear *is* a cub and too little to shoot, you are supposed to call it a bear. The blue bear is actually also more of a gray-white-tan color. It didn't eat enough glacier ice or blueberries or whatever bears eat that is supposed to turn them blue.

What makes something what it actually is—or what it isn't—is something Katrina has been thinking about for some time. Jim the Pilot, for example, really is a pilot. But all the dads on Diamond Lake are pilots. It's just that none of them get called pilots except Jim, because he has his instrument rating and owns more planes than the other dads say is tasteful. This is why he offered to fly out Katrina and her dad and Jamie and Jamie's dad to the put-in site on the Deshka, as a favor among friends.

But now he is so mad, he doesn't even offer to help unload. He stays in the cockpit, slapping at horseflies and picking at a hole in his chest waders. Katrina and her dad have to slosh through the thigh-high water with the raft and coolers and tent and duffels and rods, while Jamie sits on the float of the plane, bouncing her long curly brown hair over her shoulders as if to catch the sunlight in each strand.

Katrina's dad says, "Let's crack open those Cheez-Its."

Jamie holds out the box to him. "Take a few," she says in a drippy, stewardess voice. "You need your strength."

When Katrina wades over, Jamie shakes her head. "Cheez-Its go straight to your hips."

"Suck my dick," says Katrina.

"Lesbo," says Jamie.

"Dildo-dingleberry-asswipe."

"You don't even know what that means." Jamie pops a single Cheez-It into her mouth—and sucks on it to make the flavor last, without ingesting calories. Yet another trick she learned from sixth graders.

"See you in a week," says Jim the Pilot, looking at the propeller instead of at her dad. "Noon. At the mouth."

"Seven days," says her dad. "Not five."

"I know what you mean by a week," says Jim the Pilot. "When I discuss the details of a trip, I pay attention. I don't handshake on something, then do something else."

"Seven days," says Katrina's dad. "At noon. At the mouth."

"I'll be there, buddy," says Jim the Pilot. "You've got the girls with you. And even if you didn't, I'm your friend—remember?" He reaches into his pocket and tosses Jamie something round and glinty. A coin. He tosses one to Katrina too. It is the size of a quarter but worth a dollar, with an angry old-lady face on one side. Susan B. Anthony. LIBERTY, it says, and 1981.

Katrina rubs the eagle on the backside of the coin, feeling the finely raised feathers, the talons, that make her think of the bumpy embossed fruit on the edges on her mom's china.

The china and her mom are gone for forever, but sometimes, inside her head, where nobody can see, Katrina wishes her mom would come back. Her mom didn't mind if she didn't fall asleep. Her mom even woke her up sometimes for midnight popcorn. And told her things, grown-up things. Like that women are a woman's best friend. Or that girls like Katrina often blossom in college. And that men with the horrors are worthless. Men can't handle hangovers after age thirty-five. They've never had a baby and they just aren't used to adversity.

The first two days are what Katrina's dad calls a "classic Alaska" family vacation. A steady drizzle hisses off the river; waves nibble at the sides of the raft. Save for the green of the birches and alders, everything is a thick, gloppy gray: the sky, the water, the rocks, the mud, the weeds where the mud has sloshed up and flattened them into matted lumps. Katrina's dad sits in the back seat of the raft, but the girls have to take turns up front, paddling.

Mostly, it is Katrina's turn. Her arms burn and grow leaden. Jamie sits in back, asking Katrina's dad if he's a Republican, if he thinks nuclear bombs are going to blow them all into black ash, if he wears V-neck or crewneck T-shirts, because the crewnecks are totally more classy.

Driftwood beach after driftwood beach slides by, almost no birds. They set up the tent in the rain and sleep with drops splatting onto their faces from the condensation, water seeping into

the sleeping bags from the seams where the tent sides meet the floor. They eat the bananas and hard-boiled eggs before they go bad. The yolks taste soggy, Jamie says. There is *no* way she can eat them. Katrina's dad orders her to eat them. They are not exactly swimming in food. They will catch a king tomorrow to supplement.

The sun comes out, finally, drying out their gear. The air smells of hot new car from the raft rubber. And spruce. There seem to be no fish, or they are not fishing right, despite the detailed instructions Katrina's dad gives them: more weight, less drag, switch your Pixie to a Teaspoon to a big swively Meps, let your lure bounce along the bottom but not land on the bottom and not float either. "Bump, bump, bump," he says. "Can't you feel it?"

Katrina cannot.

"I can feel it," says Jamie, without any extra breathy stress on *feel*, despite her many late-night renditions of "Do Ya Think I'm Sexy?"—a song she performs with multiple shudders and all the wrong words, moaning into her hairbrush-microphone as if it were a big, thick, bristly penis, "If you really need me, just reach out and feel me." Even though what Rod Stewart actually sings on the record is "If you really need me, just reach out and touch me." Touch!

"That's the way," says Katrina's dad. "Work the water behind that rock." Katrina studies her fishing line floating down the river, so that she will not have to listen to her dad complimenting Jamie's back cast or praising Jamie's handling of a tricky snag.

"Katrina," says her dad, "ye who catches the first fish shall be the Great and Mighty Queen of the Deshka River."

Katrina watches as her lure pops up to the surface, but she doesn't recast. The water riffles, her lure bobs along. She is thinking about how her mom and Jamie's mom used to do the hustle on Jamie's deck in the summer. They did it barefoot, their high heels kicked off. They wore flowers behind their ears, and lipstick. They got all the other moms to do it with them. But Katrina's mother was the best. She was taller and wore a shimmery peacock dress, with her hair in curling-iron curls. She knew how to wave her arms and swish her hips, on top of all the other moves you did with your feet. Her dad liked to stand there and watch her like she had skin

made of moonlight. All the other dads did too. Until one time, the V-neck of her peacock dress slid all the way off her shoulder and she just kept dancing, and Katrina's dad grabbed her by the elbow and told her it was time to go home. Now. No stops at the bathroom, Diana.

"Tater Tot?" says her dad.

Tater Tot is the nickname her mom gave her. Her dad now calls her Tater Tot all the time. He makes her mom's zucchini bread and brushes her hair 101 times a night the way her mom used to. She loves her dad, her dad would never leave her, but watching him try to be her mom is harder, somehow, than when he was burning all her mom's clothes and records in their trash cans and kicking them, still burning, off the dock at the back of their house.

"Do you want to try my fly rod?" her dad says.

"I hate fishing," she says. "I hate fish." But even she knows her dad doesn't believe her. She can tie a blood knot in the dark. She can fish like nobody's business.

They pull over at a gravel bar. It's Katrina who has to sort out the poles and hold the end of the rain fly, putting up the tent. Jamie only has to gather wood for the fire, while Katrina's dad primes the stove. They are having spaghetti, but only because they are saving the Mountain House for tomorrow. After that, they have to catch a fish.

Katrina's dad does not know that you are supposed to boil the water *before* adding the spaghetti to the pot, though, and Katrina doesn't know this either. Katrina's mom might have known this, but she is in Homer doing coke off the ass of a guy named Derek, which Katrina heard about only because her dad had shouted it to her mom on the phone last winter, saying, "I hope you're doing coke off Derek's ass!"

Jamie heard Katrina's dad say this too. She was sleeping over, on Katrina's floor in a sleeping bag. Their bedroom door was open when something jangled and crashed across the living room downstairs. Jamie did not say anything and did not say anything, until she finally came over to Katrina's bed, said, "Don't be gay. Move over." Then she slid in beside Katrina and wrote letters on her back—*S*'s, *T*'s, *X*'s, the easiest ones, ones so easy that Katrina didn't need to stop crying to guess.

This is the Jamie that Katrina tries to remember while eating the spaghetti glop and

by
LEIGH
NEWMAN

watching Jamie wriggle into Katrina's last pair of dry pants. After which she announces: "Time for the show!"

The show is a routine that Jamie performs in her room with the door closed, when Katrina is allowed to sleep over. Either she does the hairbrush number to Rod Stewart or a dance routine during which she humps the carpet and leaps around doing full splits. The last few times, it has included a part for Katrina where she is the lady at the party and Jamie is the stud and they go on a date to a waterbed and kiss with tongues until Katrina finally sits up and says she has to pee or that she feels like playing Atari.

Out here on the river, the show is different. Jamie sits on a rock with a sad, romantic look on her face and sings, "Sunshine on my shoulders makes me happy. Sunshine in my eyes can make me cry." She has a voice that makes little sparks float up Katrina's spine and all over her skin. Katrina's dad looks at her like she belongs in one of the scrapbooks that he pulled out from a trash can fire at the last minute. All the rubber cement melted, leaving the pictures of her and her mom and him smiling on a mountaintop or by the old VW camper bus covered in a honey-colored ooze.

"Katrina," he says, "why don't you sing us something?"

Her favorite song goes: "You gotta know when to hold 'em, know when to fold 'em." It's from *The Gambler*, her favorite record. But nothing about Kenny Rogers is romantic. She tries to think of another song, one that makes shivers float up your spine, one that makes everybody cry and think of their old dead dogs.

"Don't worry," her dad says. "I never had much of a singing voice, either."

On the third day, two successive emergencies arise. Katrina gets her boot stuck in quickmud, which is like quicksand, and pulls out her foot, leaving the boot and sock still stuck inside it. Her dad has to dive around in the frigid, murky shallows trying to find it, which he finally does—just as Jamie announces she needs a new ponytail holder; her hair is naturally thick and will get knots requiring a mayonnaise treatment if she does not pull it back off her face. Katrina's dad is still in his wet clothes. Mud leaks down his

face. A whitefly bites him on the shoulder. He shouts that Jamie can pull her hair back with a goddamn twig.

Katrina smiles inside, where no one can see. But for the rest of the day, Jamie sticks by Katrina in the raft, whispering with her like they are best friends again, even if Katrina is only in fourth grade and embarrassing around her fifth-grade friends. They give Katrina's dad the evil-dictator eyes. They call him Sir. Then Admiral Bossy.

He almost notices, but not really. He is fishing all the time. He is a master fisherman. Everybody says so. He is famous back in Anchorage, especially at the fly-tying store.

All there is for lunch is granola bars and the rest of the Cheez-Its.

"What we really need is a king," says Katrina's dad. But he would take a dog salmon at this point, any kind of salmon. Danny Bob was supposed to have brought half the supplies. All they have is enough food for two people—which back in the plane he'd thought would be fine. In his mind, two girls made one person and he was the other. When did girls start eating so much?

"We're animals," says Katrina. "Me eat meat. Me no want stinking granola bar."

"I don't mind granola bars," says Jamie. "They're really quite delicious."

"Thank you, Jamie," says her dad. "That's very gracious of you."

Katrina sits in the bow of the boat, pretending to nap, listening to Jamie ask question after question about the lame, boring fishing knots, while the sun gives her sunburn all over her nose. That night, she is surprised when Jamie asks to sleep next to her and whispers, "I wish we really were sisters, don't you? Don't you wish this float could go on for forever with just me and you and your dad?"

Katrina doesn't know what to say. Most of the time, it is her wishing that she could live with Jamie at her house with Jamie's dad and Jamie's mom and Jamie's sister, where everything is still like it was before. Jamie's mom lets Jamie and her sister stay home from school for "snuggle days" and lets them stay up late on party nights, even if they steal people's olives and orange slices and scoop hot tub bubbles into grown-ups' drinks.

Jamie's face looks sad and alone, even if Katrina is right there. She tries to comb Jamie's

hair with her fingers. "Is your mom on coke too?" she says.

"My mom just sleeps," Jamie says. "And my dad is never there unless people are over."

Katrina is confused. She loves Danny Bob. Danny Bob hugs her. Danny Bob calls her a pistol and says she looks just like her mom, even in front of her dad. Nobody is allowed to talk about her mom. It's not a rule. Except it is.

"Forget it," says Jamie. "Your dad, like, worships you and tucks you in."

The morning of the third day, a plane buzzes by overhead. It's a Super Cub—white with red stripes down the sides. It swoops over them, around and around in circles. Jamie is the first to wave. "It's Dad!" she says. "Hey, Dad!" She starts jumping up and down.

"We're on a river," says Katrina's dad. "He can't land on a river."

"He'll land," she says. "He can't bear to be without me."

And just at that moment, the plane banks and starts to lower in the sky, not headed for their gravel bar, but for somewhere behind them, deep in the alders. "There's not enough clearance—" says Katrina's dad. But there is a bump, skid, the sound of branches crashing, the whine and roar of a propeller. Then nothing.

"For the love of Christ," he says, and hands Katrina the rifle, safety on. "The chest," he says, pointing to his chest. "Not the head. And don't shoot at a goddamn bear until you see it—really see it—and only if charges. Understand? There's no shame in letting it trash the camp and wander off with everybody alive."

Katrina nods.

He pulls out a hatchet, sprays himself with bug dope, checks the pistol in his chest holster. Off he goes. For a while, Katrina sits with the gun by the cooler. But nothing comes out of the bushes. She puts the rifle down.

Jamie starts prancing around in her hip boots doing the sizzle, sizzle, burn dance. Then she wades out a little and casts. Katrina throws a rock at her but misses. Just then, Jamie's rod bends. A tail slaps the surface. She has a fish. A big one.

"It's a king!" she yells. "It's a king!"

"Don't let go down by the ripples," says Katrina. "Pump and reel."

"I know what I'm doing," says Jamie.

Jamie does know what she's doing. She works the fish down the bar, letting it out and reeling it in, keeping her tip up. Then she backs up, slowly dragging it onto the beach. It is more than big; it's huge: thirty pounds or even forty—and the first and only fish of the trip. Katrina tries to remember where the bonker is. The bottom of the tackle box. But Jamie just grabs a rock and bashes it on the head, the fish shuddering and trying to bounce off the gravel until she gives it a final smash. Dead. Down to its imploded eye.

"Victory!" says Jamie. "I'm the Great and Mighty Queen of the Deshka."

Katrina goes slowly over to the fish, touches it with her boot toe. Jamie knows it all and has it all, and now she has Katrina's dad too. Some girls get married to old guys. She has seen it on 60 Minutes. Iranian girls the same age as her.

Out of the alders come their dads, crashing through the branches and tossing their hatchets onto the gravel. They pull off their clothes and jump into the water—a black cloud of mosquitos following them like smoke. "Fuck, fuck, fuck," says Danny Bob. They've been bitten on the eyeballs! They've been bitten on their balls!

Katrina's father says nothing. His face is grim, swollen, and smeared with bug guts and blood.

Jamie holds up her king by the gill cover. "Look what I got, gentlemen," she says.

Danny Bob is the first to see. He spits out a mouthful of water. "Jamie," he says, "there's no need to fib."

"I'm not fibbing."

"Katrina," says Danny Bob, "did you get that fish?"

Katrina thinks a little. Then she says slowly, in the kind, generous voice of her school librarian, "It doesn't matter who caught it. We all can share." The lie hangs there golden and perfect in the silence, and the smile that both dads give her for catching such a huge and amazing fish is like the minute before you go downstairs at Christmas, when all the presents can still be anything you've ever wanted. Even a kitten.

Jamie stomps off down the river. "I know how to fish," she yells. "Katrina's dad taught me all his secret tricks when you weren't here. Again!"

by
LEIGH
NEWMAN

"Jamie," says Danny Bob, "did I ever tell you the one about Pinocchio?" The gist of it is, when Pinocchio told a tall one, he got spanked.

That night they gut the king—a male, no eggs—and build a fire. Katrina's dad jerry-rigs a grill out of green wood and they eat the fish on paper plates. Danny Bob has a trash bag filled with Irish emergency supplies. He hands both girls two cans of Cokes from the trash bag, then takes out a bottle of whiskey that he cracks open with his mouth. He sloshes it into two cups. The dads cheer and tip it back. Then they tip back another one, which Katrina's dad never does, since his rule now that her mom is gone for forever is two half glasses of white wine, period. One before dinner. One with food.

They eat a little of the salmon, then Danny Bob says, "Well, this is one for the holy-shit story hour." He points to his head, where the holy-shit story hour is recorded for retelling later, when it's funnier and the repairs to the plane are long paid off. They drink some more whiskey and talk about what kind of idiot would try to land on a strip of sand and gravel less than 150 feet long, most of it covered in alders.

"Time for the show," says Jamie.

Danny Bob sucks off the bottle, hands it off to Katrina's dad.

"Dad!" says Jamie. "Pay attention! You have to look."

"I'm paying attention," says Katrina's dad. "Me first." His eyes are bright, his hair standing up from the muddy water that dried in it. He does the hula dance that he, Katrina, and her mom learned in Hawaii when she was six: "Along the beach at Waikiki," *hip, hip, hip,* "a handsome stranger waits for me," *hip, hip, hip.*

Danny Bob does a jig he learned growing up in shantytown Oregon. Even with his waders on, he keeps his back very straight and his feet moving. "Take that," he says, and points at Katrina. Katrina blinks, everybody looking at her, the fire smoky and hot. She doesn't know the words to "Sunshine on My Shoulders," except for the chorus. She doesn't know anything. Her mind is a big empty field with fireweed fluff blowing though it—until it comes to her.

"If you want my body, and you think I'm sexy, come on, honey, let me know." She wriggles around like Jamie does, raising her hands like the moms do when they do the hustle on the deck. Danny Bob is laughing. Jamie is clapping and—

Something hits her, hard and fast. She falls back a little and looks at her arm. Down on the ground is a can of Coke, a full one. Her dad's face is white and flat and he says, "I don't ever want to see you do that again."

Katrina will not cry. She will not.

"What the fuck," says Danny Bob.

"She was only dancing," says Jamie.

Something about their being there only makes it worse. Katrina sits down. She pulls her knees in front of her face.

"Will," says Danny Bob. "You're over the line. You're messed up in the head."

"I'm messed up?" says her dad. "You're too hungover to get in the goddamn plane. You threw your daughter at me like a goddamn sack of dog kibble. In her nightgown."

Danny Bob stands up, swaying a little. He grabs Katrina's dad and hugs him. Her dad tries to struggle his way out, but Danny Bob is taller, stronger; they both fall over. They roll over and over almost to the river, where Danny Bob sits on her dad and pins his arms down to the gravel. "Give in," says Danny Bob. "Give in, you sadsack fucking fuck."

Her dad turns his head so that Katrina can't see him. He is crying—big, heaving sobs unlike any Katrina has seen before. "I'm sorry," he says.

Danny Bob rolls off him. "I miss you," he says. "We all miss you."

The look on her dad's face is strange, distant. "It's not like I died."

"No," says Danny Bob. "You didn't. Let's keep it that way." He pulls out a crooked cigarette and lights it, sucks in, passes it to Katrina's dad.

"Dad," says Jamie, "you promised Mom no smoking."

"This here is a peace pipe," says Danny Bob. "A peace pipe is different. Suck on the peace pipe, Will."

"Time for bed, girls," says Katrina's dad. But he doesn't climb into the tent with Katrina and Jamie. He sits down by the fire and picks up the whiskey bottle. Danny Bob puts his arm around him.

Long after dark, Katrina hears a rustling, a thud. She feels for her dad's back. His sleeping bag is

empty. The gun is there and Danny Bob is there but he will not move, even when she shakes him again. He goes on sleeping, just like Jamie. She takes the gun and checks that it's loaded and unzips the front door very slowly, moving with the barrel pointed at the ground. The rustling out there is her dad. He is crouched by the fire, staring up at the sky. Stars glint through the cloud cover. Trash litters the sand at his feet—an oily sardine tin, an empty jar of peanut butter, a package of Nutter Butters. He has eaten almost all of the food in the dry box, even though he is always the one saying to portion out the food to last the whole trip. Something is wrong with him. Maybe he has the horrors, which Katrina has never seen before, only heard about in the morning. She is a little worried. His eyes are bloodshot.

"I love you," he says. "You know that, right?"

She picks up the paper and plastic, throws them into the fire, just in case of bears. Jamie's king is cached from bears in the locked metal cooler way, way down the beach. "Katrina?" says her dad. His face is soft, somehow pleading in a way that makes her want to not look at him. "I shouldn't have asked your mom to leave," he says. "Now she won't come back."

The last time Katrina saw her mother, Katrina was in the part of the den near the breakfast bar, where you can see inside the kitchen. Her mom was by the refrigerator. It was so far past bedtime, there was a rainbow on TV.

A milk crate with her mom's records was under her mom's arm and, in her other hand, the lamp from the living room. She wanted the china. Her dad had the china. He was sitting on the counter throwing plates to the floor, aiming for her mother's feet.

"It's mine," her mother said. "It was my mother's."

Her dad threw another one. It missed. He threw another one. It missed too. The broken pieces bounced off the linoleum, gold and winky. Her mom had to dance around to keep from getting cut on the ankle. "That's it," he said. "That's how you do it. Take this one!" Smash. "And this one!" Smash. "And this one!" A thud, him jumping off the counter. "Get the fuck out."

There was a pounding on the front door, but Katrina waited a long time before she unlocked it. The guy on the daisy mat was a grown-up, but in a leather jacket, not old like her parents.

He leaned down and ruffled her hair, but didn't go into the kitchen to help her mom. He went into the living room and took the stereo speakers, then the lamp from Seattle. There was more yelling from the kitchen, more crashes. Each time he took something out to the car, he looked at Katrina and put a finger over his mouth: *Shush*.

When her mom finally ran out of the house, Katrina thought for a minute that she would scoop her up and take her too. Katrina was small. She could fit in the car. Or her mom could leave the records and give her the back seat, in the middle.

But her mom only hugged her. "That china is yours," she said. She handed her a broken piece, as if it were something beautiful and amazing. It had oranges on the edge, and apples, and a horn of plenty. Her mother smelled of sweat and rotten pjs. There was a little crackled star in her eye where a vein had broken.

Katrina touched it. "Does it hurt?" she said.

"Autumn," her mother said. "That's the name of the pattern." The guy yanked her on the elbow and they got into the car and pulled out. A little medal on the rearview mirror swayed as they hit the bump between the driveway and the street.

The fire pops. Katrina's dad looks up at her.

"I don't want her to come back," says Katrina. She is surprised when she says this, and not sure if she even means it. But it sounds good. It sounds hard and solid, like when you pitch a too-big rock into the river and it lands with a thunk as if it had the force to break water.

The next morning Katrina's dad walks straight into the river to dunk his head. Danny Bob is whistling and firing up the propane stove for coffee. He gets the raft loaded, the tent broken down. The coffee boils over and he strains it through one of Jamie's socks, then banks the fire with sand. "Tally ho, darling!" he says to Katrina's dad. "Load up."

"What about the Cub?" says Katrina's dad. "You're not just going to leave it."

"I'll paddle down with you. Jim the Pilot can fly me back later. We'll chainsaw out the Cub, chop-chop."

Katrina's dad drops his head underwater for another dunk. "That is exactly the kind of detail you might have mentioned before we whacked around in the bush for three hours trying to free your plane by hand."

* * *

by
LEIGH
NEWMAN

Lunch on the river is salmon. And salmon fat. And salmon skin. "I had peanut butter in that trash bag," said Danny Bob. "And cookies. Before somebody got the munchies."

They still have twenty-plus pounds of salmon. They have only two days left. They will be fine. Except that the thickest parts of the king are still half-raw, the skin blistered. Every bite tastes like the bottom of the river. "I'm not hungry," says Jamie. "How far left do we have to go?"

"Eat around the edges," says Katrina's dad. "Protein is your friend."

Danny Bob sighs. There is an inch of Wild Turkey left in the bottle. He drinks it down for the vitamins.

Rivers, Katrina's dad always says, are moody. They have their up days, their down days, their sad days, their angry days. The Deshka seems to stop moving after the next bend. The current is so slow that they have to keep floating until it's dark, just to make up the lost miles.

"Jim will wait a day," says Danny Bob. "He's not the type to panic."

"If you say so," says Katrina's dad. "Our exchange was less than amicable."

"Is there anybody you won't get pissy with?"

"I told him I would be there. I don't make one deal at the beginning of a trip, then change it on a whim."

Danny Bob gives him a look. "Well," he says, "that's good to hear. I wouldn't want you to all of a sudden change your lifestyle and get judgmental about everybody else."

Katrina's dad begins to paddle. He paddles hard. He paddles without singing. He is good at the silent treatment, Katrina's mom used to say. What she used to do is go downstairs and start playing 33 rpm records on the 45 rpm speed until he had to laugh.

The rain kicks in. They eat salmon for breakfast, they eat salmon for lunch, they eat salmon for dinner, and still they float on. Both dads are paddling now. Jamie's dad keeps wondering if they missed the take-out. Maybe there was a tributary that Katrina's dad miscalculated with the map. "I doubt it," says Jamie. "Will is far too conscientious."

All three of them look at her. She makes an innocent face.

"Jeez," Danny Bob says. "What the hell happened while I was back in town?"

"Maybe they're old enough to call us by our names," says Katrina's dad.

"Not to stand on ceremony," says Danny Bob, "but I prefer Uncle Will. Or Mister Will. Or something along those lines with some authority."

"Maybe Will and I know each other better than you think," says Jamie. "Maybe we no longer need to rely on such silly, old-fashioned formalities."

Danny Bob pulls back on his paddle. The raft stops, as if shot. He looks at Katrina's dad, who shakes his head. But Danny Bob wheels the raft around and heads them toward the shore. Jamie hunches lower in the seat. "It's not like you even know my favorite color," she mumbles. "Or what my favorite lure is."

Danny Bob paddles. The raft bumps up against the gravel. "In or out," says Danny Bob.

Jamie hunches down. "You never know if I have homework," she says. "Or make me eat my yolks."

"In or out."

Danny Bob would not really leave Jamie on a gravel bar, would he? He is her dad. But his face is not kidding. And Jamie isn't even telling him to shut his ugly old piehole, the way she always does. She is looking at Katrina's dad as if he's supposed to tell Danny Bob to stop being so mean or remind him that Jamie's favorite color is orange, which is why she orders the orange sherbet at the Baskin-Robbins, even when Katrina and her dad try to make her order mint chocolate chip. Katrina looks at her dad too.

But her dad just looks away as if he were in another raft and had nothing to do with Jamie. Katrina will remember this moment forever. Always hoping, somehow, that her dad didn't mean it. And knowing that he did.

A dragonfly lands on the side of the raft and nobody whacks it off with a paddle. "In or out," says Danny Bob.

Jamie slinks down in the seat and doesn't cry and doesn't cry. And doesn't get out. "Good," says her dad. And pushes off.

Once they are a few bends down the river, Jamie says she has a chill and that "it's probably hypothermia." Katrina only watches the

dragonfly, stuck to the raft like it is glued there by the rain and wet. She still loves Danny Bob, even if she doesn't want to. How can he not know what Jamie's favorite lure is? It is a Rooster Tail, which she likes for the feathers, even if it is less than reliable at attracting the attention of the kings. That is why Jamie hardly ever catches a king. Until this trip, when she finally listened to Katrina's dad and tied on a Teaspoon.

The talk for the next two days goes: chicken fried steak, steak with french fries, fried chicken, lemonade, biscuits with sausage gravy, baked potatoes with sour cream, mashed potatoes, potatoes gratin, potato chips, onion dip, Cheetos, guacamole, ribs, enchiladas. There is no arguing, no conflict, except when Jamie declares that she will not split a chimichanga with a side of beans with Katrina, and Katrina says she's selfish and chimichangas are too big to eat by yourself. And her dad says he will hit both of them on the head with what's left of this paddle, except they are all too tired of paddling and sick of salmon and don't know what the hell they are saying.

"Seven and seven," moans Danny Bob. "On the rocks."

It is three-thirty on Friday, the day Jim the Pilot is supposed to meet them at the mouth. He may have left already. They are five hours late. And for those whole five hours, they paddled and paddled and paddled.

Jim the Pilot is sitting on the float of his 206, drinking a Dr Pepper. He lifts it up at them. *Cheers.* "Do you have food?" says Danny Bob. "Food that is not salmon?"

Jim the Pilot tosses them a bag of cashews. The cashews are sweet and salty. The most amazing cashews in the world. Katrina eats them by the handful, and so does Jamie. They eat them down to the grease on the bag. Neither of them argues about who is hogging.

It feels good to sit back in the raft. Licking slick, rich cashew fat off their fingers. The sun blazes by from behind a cloud and the world is filled with golden gnats. Jim the Pilot holds out his hand, as if Katrina were a princess he were escorting over the pesky puddle between the raft and the float of the plane. She climbs into the cockpit. Where, because she is the first in,

she gets the front seat. And not only the front seat, but the pilot's front seat. She turns around to get a puke bag from the back in case she has to throw up later.

There is a bear in the back seat staring at her. His eyes are glossy brown glass. His coat is gray, but tinged with blue in the sunlight the way her old velveteen comforter looked either yellow or gold depending on the direction of the sun through the window. Katrina pats him on the muzzle. Little tiny bumps pimple his nose, real ones, like his teeth.

"My blue bear!" says Danny Bob, knocking on the window.

Jim the Pilot looks at her dad. "The plan didn't go according to plan."

"There was no plan," says Katrina's dad. "I'm not involved."

"Well, *somebody* was at your house," says Jim the Pilot. "She had the microwave, a truck, some other stuff. I was afraid to leave my blue bear there."

Katrina sinks down in the pilot seat. The blue bear is somehow looking at her, the way stuffed animals can. She is too old for stuffed animals, but sometimes they are good when you are sad. The blue bear is like this. He is sad with her about the *somebody,* who is really just her mother, coming over when Katrina isn't even there. Maybe because her mother does not want to see Katrina. Or maybe because she just leaves and comes back whenever she feels like it.

"You didn't stop that somebody?" says Katrina's dad.

"I didn't know if I was allowed. It's not like you tell me what's going on."

"Jim," says Danny Bob, "you didn't have the shot. I did."

"It's my blue bear," said Jim the Pilot. "We handshaked on it."

"Was anybody with that *somebody?*" says Katrina's dad. "In that truck?"

Nobody is listening to him except Katrina, who is thinking what her dad has to be thinking: how her mom never liked the microwave, because it cooked your brains. And how her mom made real popcorn when she made midnight popcorn, with real butter, on the stove. Or how her mom kissed all her toes in the bathtub. And how her mom smelled like Estée Lauder in the blue bottle on the sink.

by
LEIGH
NEWMAN

One day she will be like Jamie and say nonchalantly to her dad that her mom was only pulling high jinks. *Don't be such a crybaby. Just steal the microwave back. Or go over to wherever she lives and fill it with marshmallows and Wild Turkey and turn it on high for twenty minutes.*

But right now she only leans back and gives the blue bear a scratch. The fur behind his ears is rough and smells like skin. She can't see her face but it must look like her dad's face, soft and weepy. She will never look any different, not when she is always around him and always remembering everything that is gone now for forever.

Outside, Jim the Pilot is still arguing with Danny Bob. Three men, two girls, a bear, and all their gear will be too heavy for one trip. They will have to make two trips. Danny Bob will not let Jim the Pilot take off with his blue bear. Jim the Pilot will not let Danny Bob stay at the mouth of the river with it.

It is Katrina's dad, they both decide, who will stay with the bear. He is the only neutral party and gets off on being responsible. Jim the Pilot and Danny Bob will drop the girls off in town, together, and fly back faster than you can spit, together, at which point they can all sort this out as friends.

"Katrina," says her dad, motioning to her to hop down, while Jim the Pilot and Danny Bob unload the bear onto the beach, "let's get that raft deflated."

Before she can get out of the cockpit and not get in trouble for dawdling, the door thunks open. It's Jim the Pilot. "Scoot over," he says to Katrina.

Katrina scoots. She still has a front seat, just the passenger one. And when Danny Bob and Jamie climb in, Jim the Pilot flips Jamie into the back, before she can even try to complain. He hits the ignition and says to Katrina, "Your dad wants you to stay and help with the raft."

Katrina thinks for a minute. Then she yells over the propeller, "Screw that. Let's go back to Danny Bob's and disco."

Jim the Pilot laughs. And Danny Bob laughs, too, as he climbs into the back next to Jamie. Katrina is a pistol, he says. Katrina has a sense of humor. He doesn't say that her mom had a sense of humor, too, but only because the side window is open and Katrina's dad can still hear.

Jim the Pilot yells through the window, "We're stealing your daughter, Will! Keep the blue bear! Even trade!" He hits the throttle and takes them onto the step.

Everything, for once, is finally perfect. Katrina has the front seat. And Jamie has the back. Katrina's dad is shouting over the engine noise, waving from the bank. She looks at him, but he is looking at her like: *You better hop out right now, young lady.* She hunches down. She slips her headset on. The rubber foam sucks over her ears and she can't hear him. In the wilderness, there is no tower that you have to ask for permission. You can just take off, anytime you want.

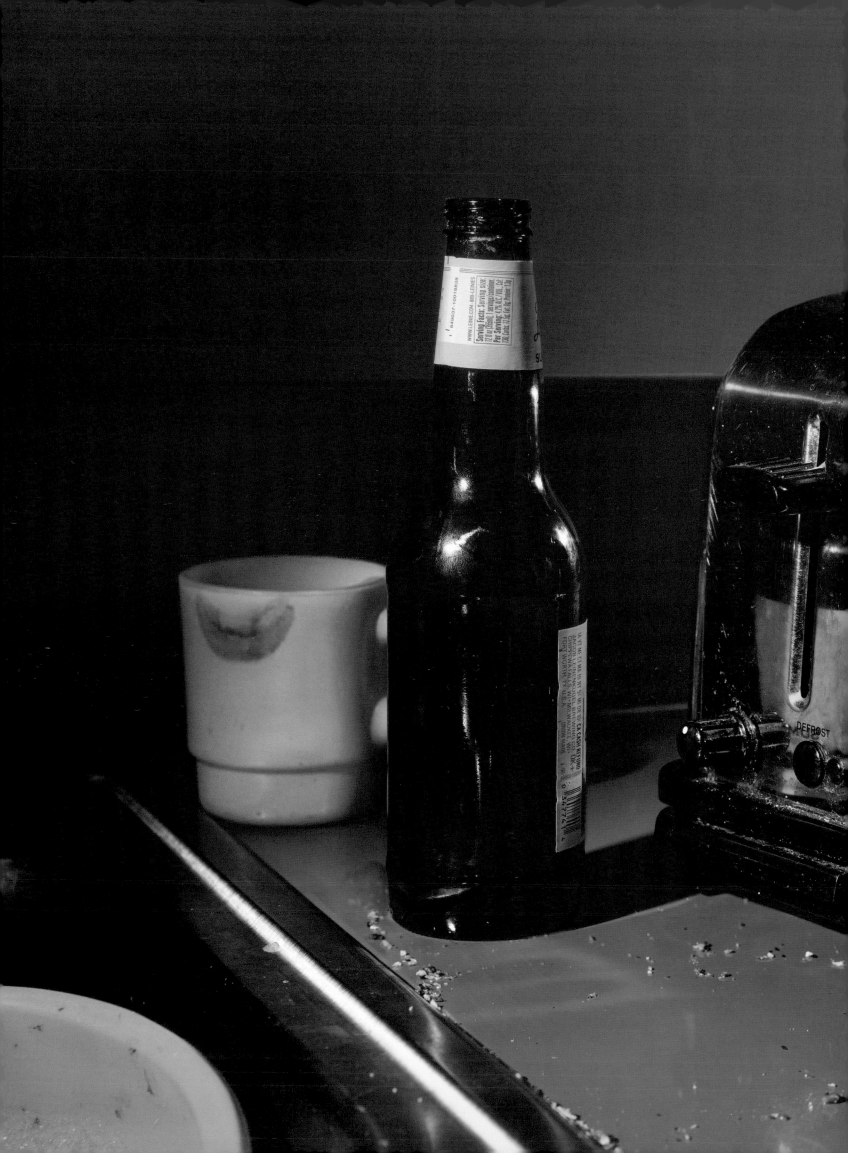

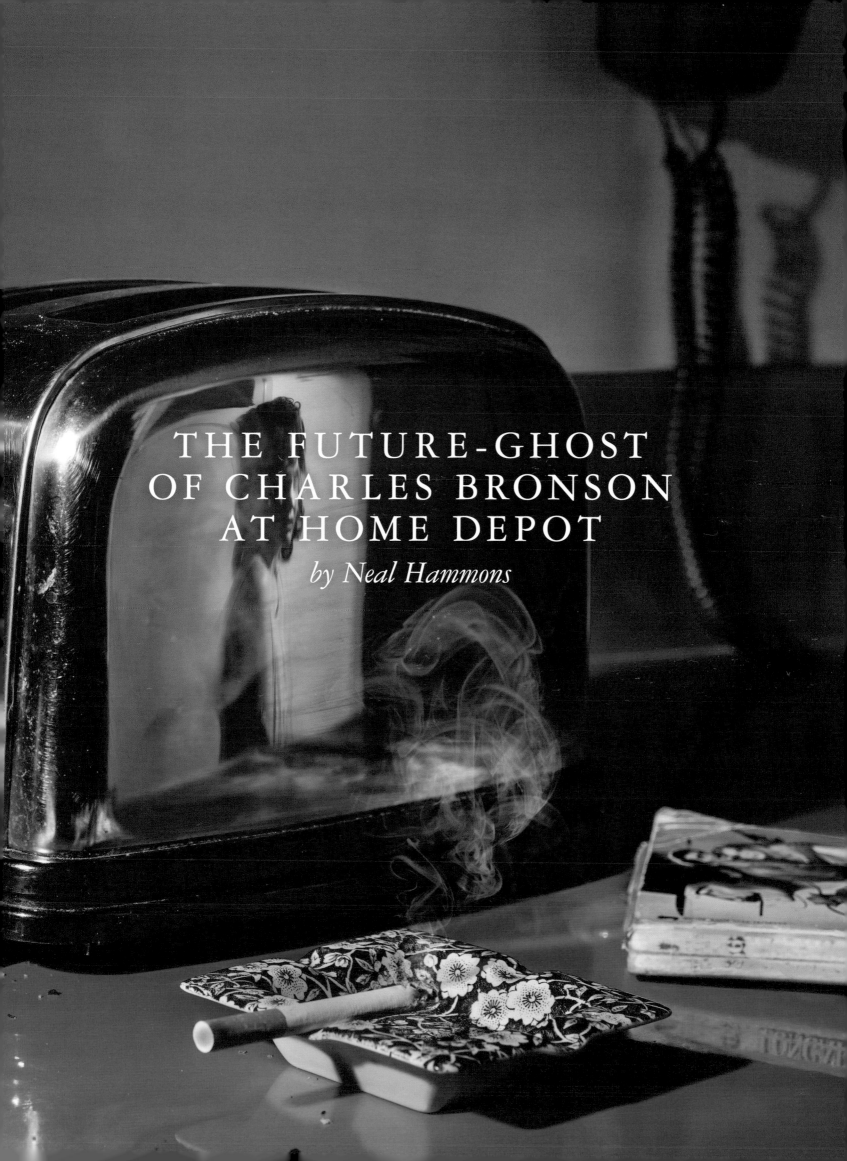

THE FUTURE-GHOST
OF CHARLES BRONSON
AT HOME DEPOT

by Neal Hammons

It is 1995. Your mother is standing in the ceiling fan aisle at Home Depot, where she works in order to supplement the disability checks she receives because of her emphysema. If she stands for more than ninety minutes at a time, she gets out of breath. She is fifty-two years old. Her hair, formerly a tight perm, is now a drape of gray loops. She likes that her orange Home Depot apron covers up the zone where her protruding stomach catches her falling breasts. The apron makes her feel more relaxed.

After she helps a young couple, both of them in their early thirties (about your age), decide on an indoor/outdoor fan for their screened-in porch, the ghost of Charles Bronson walks down the aisle and stops in front of your mother. His hair is dark, his face tan and creased, his mustache combed and trimmed, his ethnicity ungraspable. He wears a leather jacket with a wide fur collar and jeans that flare and cover his shoelaces. The entire outfit looks like it's from the wardrobe of a 1970s movie, but he owns the look.

The ghost of Charles Bronson smiles at your mother.

"Hello," the ghost of Charles Bronson says. "I'm the ghost of Charles Bronson."

Your mother is intrigued, of course, lifted out of her hardware store haze. And yet your mother is no fool.

"You're not the ghost of Charles Bronson," she says. "Charles Bronson is still alive."

He smiles, intensely grateful for her directness.

"Well, then," he says. "Looks like I'm early."

He's right. He is eight years early. Charles Bronson will die in 2003. The present-day Charles Bronson has grayer hair, a weaker voice, more kindness in his face than volatility. Your mother decides this must be the future-ghost of Charles Bronson—this isn't a past-ghost (your mother has seen *A Christmas Carol*, and this ghost seems too comfortable in a hardware supercenter), there shouldn't be a present-ghost (right? because Charles Bronson is still alive in 1995), so that leaves the future-ghost. And this Charles Bronson, this future-ghost, still has the physicality, the physique, of a man whose shoulders and chest appear sculpted beneath his collared shirt and sweater, a man who isn't past the age of using his body to get what he wants.

Because your mother gets off work early that afternoon, the future-ghost of Charles Bronson offers to take her to dinner at a nearby steakhouse buffet and, maybe afterward, stop by a local country music show she likes—at least, she liked it the last time she went out, which was months ago, when her sister (your aunt) came to visit.

Later that afternoon, your mother thinks about calling it off. She remembers the previous husbands—your father, mainly, but also your temporary stepfather and the few others who never reached stepfatherhood. Granted, there are no young children now. You, your sister, and your brother are all grown up, with children of your own. But she doesn't want to worry again, doesn't want you to have to worry again, wishes you'd never had to worry when you were younger. Still, there must be something important that brought the ghost of Charles Bronson to her this early, something that conjured him before the traditional moment when a ghost shows up in a hardware store to ask a woman to dinner.

So she goes with him to the steakhouse that night and then to the show, where they sit at a long picnic table and listen to a country music cover band play songs that she heard on repeat in the early '90s, old enough now to be classics. The picnic tables aren't crowded, because most people are in front of the stage, line dancing in unison in a way that suggests years of coming to this exact place and dancing this exact dance. Later, after two light beers, your mother convinces the future-ghost of Charles Bronson to get out there with her for a song. They stand near the edge of the line-dancing crowd and your mother demonstrates for him the basic steps. At the beginning of the first chorus, he collides with a rotund man with a stringy gray beard. The man gestures unkindly at the future-ghost of Charles Bronson, insisting that any beginners should leave the dance floor. But your mother knows this man—most people in town know this man—and she yells at him in the same voice she used to yell at your dachshund, Oscar, whenever he would try to knock over the kitchen trash can, a voice that can be heard over the music and that sends the man stumbling backward into a few other dancers. By the end of the song, the future-ghost of Charles Bronson seems to have improved his line dancing some, at least his pivot turns.

"I've never had a bodyguard before," the future-ghost says. "Can't say that I mind it."

THE
FUTURE-
GHOST OF
CHARLES
BRONSON
AT HOME
DEPOT

After your mother gets home, she watches the *Oprah* and *Ricki Lake* episodes that she set the VCR to record earlier in the day, fills her lungs with her Advair inhaler, and goes to bed. During the night she dreams of you and your children. Except you aren't your current age, you're a child again, the same age as your children, and you're all in a car with your father, and your father drives all of you into a river and the car vanishes and the bubbles are swept away with the current.

You remember the first time you met your father. It was during a visitors' weekend at a prison. You knew, of course, that this wasn't really the first time you'd met him.

"Don't you remember me?" he asks. "I know you remember your daddy."

As a present, he gives you a plastic dinosaur that you saw your mother put in her purse before you left the house. Now you walk the dinosaur across the table and roar as your father and your mother smoke and talk in low voices. A few minutes later, your father smacks the table and the dinosaur falls sideways onto your mother's lap. A pair of guards drag your father from the room.

During the whole scene—the chair overturning, your father hissing a threat to your mother about some guy named Gus, your father's shoes leaving black marks on the tile as he's pulled away by the guards—your mother doesn't flinch. She hands the dinosaur back to you, finishes her cigarette, stands up, and then you both walk back to the car.

For her second date with the future-ghost of Charles Bronson, your mother arrives early at the Italian restaurant, which is a nicer place than she's accustomed to. The host asks your mother, rather abruptly, where the rest of her party is. Your mother is only fifteen minutes early, but the restaurant is busy and the host resents that he has to explain to your mother that a party cannot be seated on a Friday evening until every member is present.

"We make that clear to everyone," the host says.

She tries to explain that this is her first time here and she wasn't the one who made the reservation, but the host turns away. Your mother

by
NEAL
HAMMONS

hates places like this. If this were the Pizza Hut near her apartment, where she is on a first-name basis with all of the hosts and a few of the managers, no one would be speaking to her like this. Here, she sits and waits another ten minutes before the future-ghost of Charles Bronson arrives. Immediately your mother tells him she wants to go somewhere else. The host has made her feel small and unimportant. Can they go to Pizza Hut instead?

Tonight, the future-ghost of Charles Bronson is wearing jeans, a wide-collared white shirt, a silver chain with a dream catcher medallion, and a denim jacket. His hair falls over his ears. When your mother tells him what happened, his eyebrows rise and he does not smile. For a moment he looks away, toward a spot that isn't inside the restaurant, and then he pats your mother on the hand.

"Wait right here," he says, and goes to speak to the host.

Minutes later, while they are being seated, the host won't look them in the eyes. He seems to be stifling a sob when he calls your mother "ma'am" and asks that they let him know if there's anything he can do for them.

Your mother and the future-ghost of Charles Bronson both order the chicken parmesan. They share a bottle of merlot. Your mother talks about her work at Home Depot, her income-restricted apartment complex, the upstairs neighbors who always complain about her television volume and her wind chimes. She talks about her worry over whether she'll be able to get by on social security and disability when she turns sixty-two, her hope that she can stay on the Advair inhaler and avoid going on oxygen for as long as possible. The future-ghost of Charles Bronson listens intently. He asks follow-up questions. He assures her that everything will be fine. He has a much lighter disposition throughout dinner, as if a potential tragedy has been avoided. As they leave the restaurant, the host waves at them but does not meet their eyes.

The prison visit is your first real memory of your father, but your second memory is the one you relate more than any other.

It happened when you were seven, soon after first grade ended and summer vacation began. You were on a coach-pitch baseball team for the

first time that summer, and you were excited about using aluminum bats. Your father was out of prison, but you hadn't seen him, and your mother never gave a solid answer whenever you asked when he was coming over. You remembered the prison visit and the dinosaur (which you lost soon afterward), but your hopes about your father were separate from what happened during that visit, separate from the things you'd heard about him from your grandfather and your aunt.

It happened late at night, waking you from sleep. You closed the bedroom door behind you so as not to wake your younger brother, with whom you shared a bed. You walked down the hallway and squinted to adjust to the fluorescent lights in the kitchen. Your father held your mother's hair wrapped around his fist and was throwing her face into the silverware drawer, until the force broke the drawer and the silverware clattered onto the floor. Your mother's face was bloody. A fork had gotten stuck in her hair and she swatted it away. She kicked at your father from the floor and they were both yelling, her yell high-pitched and his slurred. You got your twenty-five-inch aluminum bat from the hallway closet and hit your father in the knee hard enough to send him into genuflection. He didn't seem hurt and you swung again but he caught your swing in midair. He yanked the bat out of your hands and it rolled under the kitchen table, where the dog, Oscar, was hiding. Your father moved to stand up, but your mother smashed the toaster against the side of his face and kept smashing until he went quiet. You thought he was dead. She picked up the phone with shaky hands and asked you to bring her the cigarettes from her purse.

Your father went back to prison for a while. You didn't see him again. But even now, you know where he is. You're the kind of person who keeps track.

Your mother opens her apartment door on her way to work and sees her wind chimes lying on the porch. The strings that hold the aluminum chimes have been cut, the wooden top-piece smashed into shards. It must have been the upstairs neighbors—the kids are always running around and making noise, and yet the father stomps on the floor whenever he hears your mother's television. It's not a huge deal. Those wind chimes were old, anyway, from before you were born.

Over the phone, your mother tells all of this to the future-ghost of Charles Bronson. Unfortunately, the future-ghost of Charles Bronson has to go away for a week to deal with some future-ghost business.

"I need to take care of something," he says. "Don't you worry."

The night before he leaves, he takes her to a Mexican restaurant in a strip mall and impresses even the waiters with his command of Spanish. The all-you-can-eat tostada chips are a meal in themselves, and the enchiladas and Mexican rice are so good that your mother is tempted to come back the next day. The future-ghost of Charles Bronson talks about his time in the military and about his early career. Your mother tells him about how well you and your siblings turned out and repeats that her wind chimes were old and needed to be replaced anyway.

"Maybe we can find some new ones after I get back," the future-ghost of Charles Bronson says.

For the rest of the week, your mother is busy at work because Home Depot has had a rash of drug-related firings that has left her location shorthanded on the registers. Although the register isn't your mother's favorite place in the store, at least she gets to sit down. At the end of three straight five-hour days on the registers, she gets home at eight in the evening and falls right into bed without watching her episodes of *Oprah* and *Ricki Lake*. Some noises wake her up during the night—the upstairs kids being rowdy, lots of screaming—but she quickly falls back asleep.

The next morning she finds an envelope taped to her front door. Inside there's an apology letter from the upstairs neighbor along with eight crinkled-up five-dollar bills. The handwriting is shaky but the words seem sincere. Over the phone that night, when your mother tells the future-ghost of Charles Bronson about the letter, he sounds elated.

"I'm glad for you," he says, "and I'm glad the man came to his senses."

The next time your mother and the future-ghost of Charles Bronson see the upstairs neighbor in the parking lot, the neighbor drops his groceries and runs up the stairs two at a time.

*　　*　　*

THE
FUTURE-
GHOST OF
CHARLES
BRONSON
AT HOME
DEPOT

by
NEAL
HAMMONS

When your mother tells you she has a new boy-friend, you're worried. Your mother's choice of men has not, to say the least, been good. Your father; your stepfather, Gus, who once disappeared for days and, when he returned, tore the hallway light out of the ceiling to search for an FBI listening device; the boyfriends, the best of whom, Lance, was unemployed and stayed home and played video games with you for most of your ninth-grade summer vacation.

When you meet the future-ghost of Charles Bronson at the Mexican restaurant at the strip mall—"Kind of our place," your mother says—you are relieved and dismayed. The man is wearing kind clothes, but his body is a rock. You would be helpless against him. You could never break the future-ghost of Charles Bronson.

"I appreciate everything you've done," he says to you when your mother steps away from the table.

Although you're pretty sure your mother must have told him about the incident with your father, that's not, you think, what the future-ghost of Charles Bronson is referring to. He is referring to the things your mother never knew about. The gun you kept under your bed as a teenager. Your visit to your ex-stepfather, Gus's, apartment after he started calling your mother and demanding that she let him use her van, even though she'd never owned a van. Your meeting with the hiring manager at Home Depot after your mother was initially turned down for the part-time sales job. Your yearly emails to your father to explain what would happen to him if he were to return.

The words aren't complicated—"I appreciate everything you've done"—but you're afraid you'll cry and that your mother might notice your reddened, post-crying eyes when she returns to the table. The future-ghost of Charles Bronson puts a hand on your shoulder and nods to you.

You're so relieved that it's over.

Your mother is fine.

*　　*　　*

The future-ghost of Charles Bronson cannot do everything. He cannot forget the cost of protecting the people he loves. He cannot make your mother forget what has already happened—the death of your grandfather, the sight of you needing to hit your father, the guilt that has seized her nearly every day since your childhood. The future-ghost of Charles Bronson cannot redress the wrongs imposed by Gus's contractor friend, who took your mother's money and then overdosed before he finished remodeling her bathroom, leaving the family without a bathtub for three months, forcing you to bathe at the kitchen sink. The future-ghost of Charles Bronson cannot bring back the hope that once filled your mother's belly-less body and made her feel like a coiled spring that was ready to pounce on the day. He cannot give her a photo album full of trips to Branson and family reunions and church picnics that never happened.

He cannot open fire on emphysema. He cannot threaten to castrate your mother's eventual need to be on oxygen. He cannot dismember the bodies of intrusive thoughts.

For that, she has to wait for the actual-ghost of Charles Bronson, and so do you. For you know that someday soon, the actual-ghost of Charles Bronson will be here, and the sky will turn gray and the wind will cease, and the real bloodbath will begin. In the meantime, watch your mother smile as she puts on her coat before she leaves for another date. Watch your own children hop in place before they drop their toys and run to hug Grandma. Watch the future-ghost of Charles Bronson as he meets the eyes of someone who has hurt her—a dishonest mechanic, an irate customer, a spiteful coworker. Watch the future-ghost of Charles Bronson smile, barely but defiantly, before he starts his work.

THE TUM-BOON BRIGADE

by Mai Nardone

The call comes through in a static jabber: "Two trucks. Two dead. Bang Kapi."

The other side of Bangkok; not their territory. Benz lets it go. He holds the radio up to the truck's cabin light. Music squeals as he tunes it across frequencies. He beckons the new kid.

"Bring your head over here."

Tintin, slumped in the back seat, lifts a finger in the direction of the radio. "You've got to sing with it." The big man reaches for a high C, raising his hand with the note and striking an imaginary bell when he hits it. "That's the only way to tune the red radio."

Another feed comes through, this time of a hostel blaze near Khao San, that dead end of Thai tourism. No reports of casualties yet. Backpackers from neighboring hostels have flocked to photograph the flames. A fire truck is on the street and asking for assistance in keeping the crowd back.

The kid asks, "Are we responding?"

"Let one of the other groups take that," Benz says.

Tourists are dangerous; they clog up accident scenes, get run over. They try to help. Also, Benz shies away from fires; burn victims are too delicate. A responder doesn't know where to lay his hands without a shriek, without flesh rubbing off like a ripe fruit peel.

"Benz. Cautious, Benz," Tintin teases.

Benz lets the kid fiddle with the dial. Occasionally the old box picks up a signal outside of the volunteer network, a taxi dispatcher, maybe, or a crackling luk tung song. Once they even caught a sex line. "Guess where my hand is now?" the voice invited, and Tintin shook the back seat with his *huh-huh-huh* laugh.

The kid comes across a temple broadcast and they listen to a spoon-fed monk telling the city what he knows of good, hard work. "Tum boon," the monk tells them. Do good. Earn merit. Karmic rewards carry over into rebirth. Nothing the brigade doesn't know, but Tintin sits up and reframes it for the kid anyway.

"Hear what he said? With our work? Next life, I'll be born onto a bed of pearls."

They call themselves volunteers, but it's understood among the bookkeepers on high that karmic merit is their pay. They're saving up by saving people. For the promise of a future reward, either in the afterlife or another life, the team is parked under a highway, poised around the radio, waiting on misfortune.

The voices drop out. What's left is residue, airwaves recently strummed, distant night chatter.

"How come nobody's calling in?" the kid asks.

Tintin unzips his uniform to the waist. "This isn't *Batman*, kid. Sometimes there's nobody to save." He shrugs his torso out of the yellow jumpsuit. "Heat's making me crazy. Mosquitoes in this cocoon outfit."

Another dispatch about a double motorbike collision. Two dead and one injured.

"That's us." Benz starts the pickup truck.

Tintin takes the radio and calls in the team's location. He gives the siren a good whoop even though theirs is the only car on the street.

The last man dies before the team arrives. There's not much to do but hammock the bodies in cotton and haul them out. A policeman writes the accident report. The rains come.

Benz herds a group of onlookers off the scene. He's lining up orange cones when he's presented with a baby—a pink bundle in her mother's arms—for his obligatory caress and blessing.

When he touches the girl, she takes hold of his finger, brings him down to her level. "Hello there," he says. In response she pats him between the eyes—there, there—and Benz steps backward onto the wet road, washed red and blue by siren lights, feeling like he's been cleansed. He's reminded that even his first lover, a girl country-raised, nursed on ghost lore, turned away from his touch on the nights he'd handled the dead. It didn't matter that he was doing a good thing. "It's the bad that carries through." She had gestured at his fingertips. "It comes through touch."

In the beginning, collection and cremation had been their only functions, but after watching accident victims die waiting for ambulances, the volunteers started trucking the injured to hospitals themselves. They earned a small commission and no small credibility among the families of survivors. Mothers no longer warned their children away from yellow and green uniforms. Volunteers could make a wage from the donations.

For four years, Benz has worked the circuit, stood shoulder to shoulder with the bereaved,

by
MAI
NARDONE

identifying. "Did he have these chest tattoos?" or "Do you recognize this ring?" After four years, Benz has stopped revisiting the wrecks in his sleep. He has stopped counting the unclaimed (slum orphans, migrant laborers, gutter drunks). But still he recalls his first night as a volunteer, how a street boy had watched him load a gunshot victim into the pickup. The boy raised his finger like a pistol trained on Benz. "You'll put some-one's eye out with that," Benz joked. The boy leaned his head to sight along his arm: "Bang."

Benz opens the back of the pickup. The truck has an enclosed bed, like a hearse, windows splotchy where the film has peeled.

"Kid, help Tintin out." Benz gestures at a corpse.

The kid takes the foot end.

Benz finds the man who called in the crash, a motorbike-taxi driver in an orange vest. The volunteers rely on the public to call in accidents over the red radio network.

The man's eyes are unresponsive. He pulls a radio from his vest pocket, presses and releases the call button. "That's the third I've seen in a month. Does that mean I'm unlucky, or lucky it's not me?"

"Next time you call me directly." Benz holds out a phone number and some money, but the man's gaze drags back up the road to where other taxi drivers are taking charge. They reroute traffic, heap motorcycle debris, and sluice soapy water over the road. Benz walks through the suds to his truck. It's riding low. He tests the tire pressure with his boot. Tintin's sitting on the supplies cooler, explaining to the kid, "We all have things that sustain us." The boy stares as Tintin crumbles a morphine pill over sweet green custard spooned from a tub. Tintin stands to put the tub back in the cooler behind the rubbing alcohol.

Tintin licks the spoon clean. "The thing you'll find, a few months, maybe a year in, is that you need to pick your addiction. You could be a karma junkie." Tintin points his spoon at a taxi driver bowing his head, collecting donations for the victims' families. The Buddha pendants clustered at the man's throat swing and clatter. "Or maybe you're like Benz here: superhero syndrome," he says. "Death addict."

"And you are...," the kid says, glancing back at the spoon.

Tintin wipes custard from the corner of his mouth. He grins. "High."

At two in the morning, the clubs spit up drunks. They take to the wet roads. The team is parked at the end of a queue of taxis. The downpour chases people under awnings, sends them home early, turns Saturday, party night, sleepy.

The taxi driver ahead of them taps his impa-tience on a brake pedal. The brake light pulses in their cabin and strikes Tintin, blinking and haggard. Five years as a volunteer have worn the big man thin. From the back seat comes the sleepy knock of the kid's head against a window. Benz is in the driver's seat looking at his phone.

"What time do we finish?" the kid asks, shift-ing in the back.

Benz looks at him in the rearview. "Right now."

"So what are we waiting for?"

The question sits between them. Tintin says, "Lara. The last rescue call. The one that only goes out to Benz."

"Who is that?"

"Someone he found playing cards," Tintin says.

Lara had been in the habit of gambling her-self in deep. Benz saved her.

"Saved me?" Lara had laughed. "Saved me for yourself."

"Your farang fling isn't calling tonight," Tintin says.

Benz checks his phone again. "We'll give it another ten."

Once a week, Lara calls Benz and asks him to find her. She's often red with alcohol, leav-ing a nightclub with a man, telling him, "Your apartment can come afterward. Dancing makes me hungry." She sits him down at a noodle stall. She's a sloppy eater, which looks to some men like the promise of easy sex. Drugs make her teeth gnash, mill the rice noodles. She sends her location to Benz: *Find me.* He's there before the broth turns cold, taking her away in the pickup. The siren deters men from chasing her. Its bleat has the pitch of madness.

"Look at your chewed lips." Always, Benz asks her what she's been taking.

"Oh, I don't know, a little thing, a half hol-iday." She chases this with a full laugh. "Or maybe it was more."

"Answer me properly." But when Benz gets angry, Lara climbs into the back, takes turns at the spoon and custard with Tintin. On those nights, she's blue by the time they're back in his apartment. But what can he do, draw out the poison with his lips? He puts her to bed, hates the smell of alcohol, sleeps on the floor.

"Home time," Tintin says, squeezing Benz's shoulder. "Give it up."

Benz drives the crew to their apartments and then parks at his place. He brings a can of cold coffee into the shower and takes the bristle brush to his fingernails, a habit from the old days.

On the toilet tank the red radio is giving out a low drone, the expectant humming of Bangkok at night. He opens the shower window. He doesn't understand where it comes from, the city's gray music. He once thought it was the echoes of thrumming air conditioners or truck thunder from the highways, only it seems now to come from the emptiness itself.

Most of the volunteers have day jobs. For years Benz cut hair, easy work that he floated in and out of, until Tintin lured him into the brigade. They had been boys together, running small crimes to pay off the orphanage that raised them and the corrupt police from a local outfit. And while they'd been released from those debts, Benz still felt an obligation to keep an eye on Tintin. He knew the man wasn't in it for the distant karmic payout. Tintin wanted the hit now.

It's late afternoon when Benz arrives at the Filipino church listed in the funeral announcement. He hears the requiem and is drawn to the open doors, where a Filipino man says something in English. When Benz doesn't respond, the man tries again in Thai.

"Were you a friend?"

No, but Benz had carried the body from a wreck.

The casket is closed. As he enters, the music changes and the mourners start to sing. It must be a Christian song, nothing Benz has heard in Chinese temples, those dark, crowded, low places where the air is choked with incense. Here the eaves catch the music, not a lament so much as a marching tune, as if to establish a pace for life after death. But grief undresses the faces around him. He tries to feel the loss of the man in the box. The song rises and swallows the sobbing that has burst from a woman in the front pew.

As he leaves the church, the brigade's mantra comes to him. *You can't save them all.* But Benz believes in sheer willpower, and that's how he's keeping Lara close. He staves off the fear that she'll leave him. That she'll be taken from him. He can't sleep. He's taken to keeping the red radio clipped onto his belt, and if a week goes by when he doesn't hear from her, he'll spend the morning trolling frequencies, wondering if the next body dredged up will be hers.

Rama IV Road. One woman.

But how will he lose her? He's seen all the ways. Motorbike and gunshot. He's seen falls and jumps. People choke; they poison themselves. He knows heart failure. He's seen bloated corpses blue with drugs. When his imagination has been stretched to its boundaries, he's drawn across town to a familiar metal door painted sea green.

Palm on the door, Benz checks his watch. Hours until the brigade's starting time. The door opens to a tin can elevator. Inside, a fan sputters in the ceiling, and through the walls Benz can hear the big band tuning up. The elevator door slides open again, and he steps into the middle of a rehearsal.

"There aren't many respectable jobs for singers in this country," Lara had told him. She was raised singing jazz standards, her father's favorites, until he left Lara and the mother for a life back in his American hometown. She started to work toward a marketing degree at a university in Bangkok, but a childhood as a songbird had spoiled her. Lara was meant to be a star. That's how she ended up in an American conservatory, where her mother sent her to be classically trained. By the time Benz met her, Lara had dropped out of that, too, and returned to Bangkok. A mezzo singing background music in hotel lobbies. The big band was her only chance to be loud.

The band practices in an abandoned office space, too small for all that brass, but they seem to have achieved a sort of harmony, the instruments Tetrised to fit the space. They have given up telling Benz that he's not welcome.

He edges around the wall to the front of the building and slides open a filmed window. Outside, on the cement ledge, Lara is studying a score.

by
MAI
NARDONE

"You can't be here," Lara says without looking up. "I told you to stop coming here."

"I wanted to make sure you're all right."

"Why wouldn't I be? I'm fine."

She has to climb past him to get back inside. Her dress crawls up her leg.

"I used to see you more." He squats beside her stool and lays his hand on her knee. She tenses. He takes the hand back.

"What are you playing today?" He reads the title. "I don't know it."

"Of course not."

The warm-up begins with the solemn trombones, which are joined by the showier trumpets and saxophones. By the time the two clarinetists start up, Benz can hardly hear Lara. She has to repeat herself.

"I need you to leave before my part." She looks at him. "Please."

He has heard her sing only once, that first time he brought her to his apartment, her eyes washed out from moonshine. She'd slid off her clothes while watching him, amused, and he'd felt undressed. Her voice had to be coaxed out. She gave him a demonstration, feet together, hands together, standing at the foot of his mattress, which might have been a concert hall for the way she sang before it.

She saw his surprise, climbed back into bed. "This," she said, patting her voice box. "Nobody expects this. I keep it to myself."

He had touched her throat, imagined a warm engine winding down.

"You're not like the boys I've known," she said.

"No."

"It wasn't a question."

"We used to be ashamed of wearing the yellow." Tintin leans on the locker room door as he talks to the kid. "To most people, we were worse than corpses. We were cursed. But when we started carrying survivors instead, the stories became about the living. Now look at us."

The kid stands before a mirror, straightening the collar on his new uniform. Beside him, Tintin spritzes on cologne.

"Here." Tintin hands the kid the cologne and taps two fingers behind his uniform collar. "Spray there."

They leave the changing rooms by the entrance to the volunteer headquarters, passing the shrine where laypeople come to take their share of the karmic merit.

"Good work and bad work, boon and gam," Benz says as they pass the people waiting to donate money for coffins for the unclaimed. "That's all you take with you when you die. You better hope the boon measures up."

Tintin pats the truck's rickety hood for luck. He sighs.

They once had American-fire-truck dreams. An engine red and roaring. Not the trundle of their own wagon, a beat-up Toyota passed on to them by a grateful family. It used to be that the team set aside some of their donation money, put it back into the pickup. They'd bought stretchers and neck braces, fitted two side benches into the enclosed bed, and mounted a siren and lights on the roof. But that team had been younger. Of their original troupe, only Benz and Tintin remain, and they both feel they've given too much to this work. The truck's a long haul from healthy. They can hear that it's failing: the death rattle of fluids leaking from old drum brakes, the ignition's cough.

Now, in the middle of traffic, the siren and lights wink out.

"Junk! Fucking junk!" Tintin punches the roof. "Who wired this? I did—ha! Like steering scrap metal." He switches to the horn but the cars close in on what little room they'd given the emergency vehicle.

By the time they arrive at the accident, the dispatchers have gone quiet. Around an overturned minivan is a stadium of volunteers from a rival organization. A camera's flash hits the scene, shimmers on the tongue of windshield that's being wrenched from the van's face.

Beyond is the other team's ambulance, a white machine with blue stripes across the sides.

Tintin tries to break through the crowd, but the volunteers push him away.

"Back off. This one's ours."

He bulls through on his second try. Benz has to follow. Two men with headlamps are sawing the last victim out of the driver's seat. The driver's legs are pinned under shredded metal and engine. He's unconscious. Blood like a spray of feathers covers his shirt. The volunteers hold flashlights; one is siphoning the van's gasoline.

The man with the pump looks up at Tintin—"Get out of here"—and when Tintin doesn't move, the man turns the hose and squirts

gasoline onto Tintin's shoes. The others laugh.

Tintin stares down at his feet, at the men surrounding them.

"Tintin," Benz warns.

The man with the hose stops pumping and straightens. "Do the smart thing. Get back in your spit cup over there and drive home."

Benz takes Tintin's arm, has to remind him why they're here. "The work's done."

The scream of saw against metal follows them to the pickup. Tintin kicks off his soaked shoes and stuffs his socks into them. He starts the engine but lets the truck roll past the rival team.

"Hold the wheel."

Before Benz can respond, Tintin has set fire to his shoes. Heat and the stink of gasoline flare in the cabin, and Tintin hurls the shoes toward the side of the white ambulance. The flaming bundle splatters against the van's door.

Tintin jerks the truck around the emergency cones and steers them into oncoming traffic.

"Easy!" Benz says.

"Shut up." Tintin clicks the turn signals back and forth, snaps the high beams on a jittery Volkswagen, and accelerates through a red light.

Benz looks out the back window. "Calm down. The kid's getting excited back there. They're not even chasing us. Just park somewhere."

They stop beside some food vendors, and Benz and the kid leave Tintin in the driver's seat.

"You okay?" Benz orders the kid skewers. He turns up the volume on the radio and they sit on the curb.

"See, nobody pays us to bring in bodies. But this new government insurance will pay patient bills, so hospitals will pay for patients. That's what gets Tintin fired up. It's commission. Building boon requires—"

"Building boon," Tintin says, joining them. "Woulda built a fucking castle by now but for the new kids in our territory." The big man has cushioned his mood with a fix. "Six. Six alive."

"Enough." Benz replaces the spoon in Tintin's hand with a pork skewer.

Tintin points at the kid with his skewer. "How old are you?"

"Seventeen."

"Yeah, keep eating. We could use young ones like you. How'd you end up in this?"

"My mother. I never did well around religion. When I was ten I got burned by someone carrying their incense sticks low. Stuck me in the

cheek." He turns his face to display a scatter of scars Benz had assumed was acne. "Then last year she tried monkhood on me."

"Hm." Tintin's fingers run imaginary scissors over his head.

"She wanted me to take the three months as a novice—you know, for her. So she'd be okay in heaven. But I couldn't make it work. I couldn't sit still. Missed the city. So now this."

"If I've learned anything about our job, it's that it accepts all who are willing to give themselves," Benz says.

"Even movie stars are volunteering. But murderers or motherfuckers, it really doesn't matter. All that matters is to do good work. That's where the boon comes from," Tintin says.

Tintin tosses his skewer into a drain, adjusts the badge on his uniform, and stands to pay the vendor. The vendor tells Tintin that today the food's on him. No problem.

Tintin takes another skewer from the grill. "Here, kid. Better than being a monk. Free food *and* you can touch women."

A Sunday evening. She doesn't call him. He sends her a text. *Do you want to ride with us tonight?* It's all she's asked him for these last weeks, and he's always said no, until tonight.

Immediately: *A night with a brigade?*
That's right.
Come find me.

Headlights pass the accident—another motorbike, another boy—but seem to bathe Lara, crouched in black tights beside the body.

"Put your fingers here. Behind the jaw. Feel the pulse?"

"He's dead," Lara says. When Benz confirms it, she draws back, crosses her arms, and lets Benz wrap the body.

"I've never touched a corpse before," she says.

"But you wanted to, didn't you? That child's curiosity. We pretend we don't keep it into adulthood. We all resist it."

She surprises him with a kiss that he doesn't return, the sensation of a cooling body still haunting the fingertips he used to check for a pulse.

"Disgusting." Tintin comes around the truck with the custard tub cradled in his arm. He

points the spoon at Lara, slurs, "You shouldn't be here… Isn't there a rule against this, Benz?"

"What rule?" Benz says.

"I wanted to experience it—what you do," Lara says.

Tintin's smile is sleepy but conspiratorial. "So you can go back and tell your people how fun it was? A night ride with the corpse carriers."

"What's wrong with that?"

"Chase thrills too long and you'll end up like Tintin. Thinks only about today. Doesn't see consequences." Benz pinches the end of the spoon and pulls until the big man's arm is fully stretched out. Tintin doesn't let go. "See? Look at his arm shake. And the color in his skin. You want to be like him?"

"Fuck off." Tintin lets his arm drop. "We're taking her home."

"No, you're not," she says, displaying her brash American heritage, a first world confidence passed down through her father. "I'm just getting started. I'm running with the tum-boon brigade tonight. I was promised three years of merit accumulation."

Benz tries again to take the spoon from Tintin, who contemplates his clenched fist as if it were not his own. Tintin releases his grip on the spoon. He turns to Lara and laughs. "You're right, Benz. She is like me."

by
MAI
NARDONE

A woman is hunched against a guardrail, clutching the broken post of a highway marker. The marker's reflective strip catches their headlights and she flinches.

"My husband is under the car," she tells them, gesturing at the wreck up the road. "The front car."

"Kid," Benz says, "get Tintin and the stretcher over there."

"Tintin's asleep," the kid says, and then he runs to the front car to search for the victims.

"The tire blew and he pulled over to fix it. Then the other car hit us." She puzzles over the wooden post in her hands, drops it. "The other people are alive. I checked."

When Benz asks her if she's hurt, she touches her side. Protruding is a splinter of wood painted white as bone.

"I fell onto a post."

"Oh, fuck," Lara says.

"Don't move that." Benz says.

"I'm fine." The woman rests her hand on the

splinter. "See, I'm fine. I'm going to sit in your car. Girl, help me up."

Lara and Benz help her into the back of the pickup, have her sitting on the bench with a bandage holding the wood in place before Benz tries to wake Tintin.

Benz opens the door and shakes Tintin, asleep in the back seat, by the shoulder. "Hey, we need your help with the stretcher. Tintin?"

Tintin grasps the driver's seat and hauls himself upright. "It's been a fun, fun night. Where's Lara? Is she having fun?"

"We need your help," Benz says.

"Sure. I can do that," Tintin says. He pats Benz's hand and lies back down.

Benz leaves Tintin and takes the stretcher to the wreck.

"These two are alive." The kid has dragged two men out from the crash and laid them side by side.

"What about her husband?" Benz asks. He can see the man still trapped beneath one of the cars.

"Dead."

They carry one man back, securing the stretcher to the truck bed with clips.

"You." The woman pats the man. His face is ruined, bones breaking the skin. "Hello?"

"That's not your husband," Lara tells her.

"You hear me? I told you not to drive this car into the city. We should have waited for Mogh to bring the good car home."

Lara says, louder this time, "That's not your husband."

Headlights cut through the window.

"Police?" the kid asks.

"No. Another team. There's still a man out on the road," Benz says, and immediately Tintin sits up. "Out of my way." He lumbers out of the back seat.

Benz takes the driver's seat and starts the engine. "Leave him to them. Close it up. Let's go," he shouts to Tintin.

"Mogh will be home tomorrow," the woman is saying. "Stay."

The other team pulls up alongside the accident. The kid and Lara climb into the pickup truck, but Tintin holds the passenger door wide.

"It's that same team. From the other night. Young shits."

"Let's go, Tintin. Leave it."

Tintin reaches across Benz, switches on the siren, and pumps the horn as if to frighten a

pack of strays. He crouches to feel under the passenger seat. When he straightens, he's holding a gun.

Nobody speaks.

"Benz." Tintin points down the road at the remaining injured man. "That man is ours."

Benz switches off the engine. Behind the night's gray sound he can hear the accident report: Gunshot wounds. Three volunteers shot dead.

"What will happen next time that group catches up with us?" Benz says. "You're not thinking."

"I'm protecting our territory."

"You're putting us in danger." Benz turns to look at the kid and Lara. She's got blood streaking her forearms. "They're terrified."

Tintin squints at the two in the back.

Lara nods at Tintin's hand. "That's an awfully real gun."

The cabin is black and hot. Tintin claps the weapon between his palms. "It's just to scare them off."

Benz tightens his hold on the wheel. "We're leaving."

"Without me." Tintin leaves the door wide open. He walks unsteadily along the yellow highway line back to the crash.

Lara leans forward from the back seat. "Maybe we should help him?"

Benz looks at the windshield as if at a television screen. He rolls up his window. But even through the glass, he can hear Tintin confronting the men. They have the remaining victim on a stretcher, which they set down to form a circle around Tintin.

Tintin looks back at Benz in the truck. He takes the pistol from his pocket. He levels the weapon at two of the men and gestures for them to move back to the van.

"Oh," Lara whispers.

Benz watches Tintin raise the gun and fire a shot above the men's heads, reigniting the woman's chattering.

Crack.

"You hear me?" the woman cries. Benz hears her slapping the unconscious man. *Crack.* Benz closes his eyes and imagines—*crack-crack-crack*—the smack of shredded tire rubber against the road as the husband slowed toward the shoulder. Impact. *Crack.* The blast of glass and metal as the second car struck theirs.

When Benz opens his eyes, Tintin has the gun pointed at the withdrawing red lights of the other team's van. Benz starts the engine.

"You can't just leave them out here," Lara says.

"He has to learn." Benz drives them past Tintin, who stands beside the man on the stretcher and watches them leave.

Benz turns the siren on, and in the back the woman's head snaps up.

"You!" she cries. "This is all your fault."

It's two weeks later when Benz parks across from a nightclub. Like cutting taut wire, Benz knows he released Tintin with a whip crack—the backlash went deep.

Benz didn't tell the kid what he knew during those two weeks. Not after each night's shift, as they waited in empty wards while their commission was counted out; or when they hosed down the truck bed, flushing the night's stains back onto the streets; or when the kid fumbled his last goodbye wai tonight, walking backward from the truck.

And because he knew, Benz wasn't surprised when the call came for him last night. Over the red radio: "One. One of ours."

He arrived first at the old apartment building, its lights still blown out after a power surge. He was led into a dark back room by Tintin's roommates, each bearing a flashlight. And although he knew what waited there, he stopped on the threshold, headlamp roving, eyes adjusting, because he wanted to believe that he wouldn't find on the floor a body blue as night.

And although Benz knew as soon as he touched Tintin, he tried the stethoscope, ignoring an instinct that came from years of handling the dead (*it comes through touch*). He moved the stethoscope from wrist to chest to neck. The housemates knew what Benz would not announce. They turned off their lights, prematurely veiling the body, leaving only Benz's headlamp casting a white circle on Tintin's chest, the point Benz drove his hands into. He broke his friend's ribs. Then the sternum yielded to his compressions. The heart, though, did not.

What Benz knew these past two weeks he says now, alone in the truck cabin: "I let him die." An electric fan clipped to the rearview blows the chemical sweat off his skin. He has a bottle clamped between his boots. He drinks and coughs up the whiskey.

by
MAI
NARDONE

He's parked across from the club, and his impulse when Lara finally steps through the doors is to go to her. He notices the trail of cigarette smoke. She had promised to quit—the habit ages her voice.

He doesn't know why he's come. Maybe out of a need to see the wreck he's made. When he looks out again, Lara's eyes meet his. She separates from the group and crosses to him. The motorbikes on the street make way. He feels the collision of her presence before she reaches him.

She knocks on the window. He rolls it down. "I'd recognize your junker anywhere. I saw you parked outside my house on Tuesday."

He turns off the engine. "I came to find you."

"Where are your boys?"

"Gone."

She looks past him at the empty seats. "What do you want?"

He says he wants to take her home. Why is she out on a Thursday? She should be studying for the conservatory entrance exam. She promised him she would apply.

"You always know what's good for me, don't you, Mercedes-Benz?" Lara says. "Your parents had big ambitions with your nickname. But I know you. Eager to watch, slow to live. Benz. They should've gone for something like Tuk-Tuk. You could have lived that down."

"I want to take you home." He reaches for the door, but she leans her weight against it.

"No, don't get out. You stay in there."

Trapped in his deep seat, Benz feels like a child. "Stand back," he says.

"No. I didn't call you. Why are you spying on me?"

"I was driving through. I wanted to see if you needed me."

She thumps the car. "Stop it. I won't be another casualty on your roll call."

He opens the door.

She takes a step back, watches him step out, dares him to come after her.

Another step backward. She hesitates. "Are you drunk?"

"No."

"You can't even stand. What happened?"

A man comes toward them. One of her friends, Benz realizes, seeing the others watching from the sidewalk. He doesn't need to turn to the battered pickup to know that he's embarrassing her.

The man speaks to Lara. She shakes her head, and in a voice loud enough that all her friends can hear, says to Benz, "Why are you here?"

Already she's turning from him.

He picks at his badge. "You used to call me for help, remember?"

The kid doesn't answer his calls. Benz has to go alone to see his friend fired up in the crematorium.

The ceremony has nothing on a Filipino funeral, no rising voices, and it is Lara, not Tintin, that Benz thinks of as smoke funnels out through the smokestack. He leaves before the ashes come out. Doesn't want them marking his hands.

He goes to the sea green door, its elevator beyond, and stands there jamming the button, wanting to rise, even as he knows he won't find Lara above. He looks into the ceiling fan, its shape the same as the crematory exhaust, and he thinks that the only difference between Tintin and himself is now and later: everyone is on their way out.

But will every soul rise to the same place? As if responding to the question, the elevator shudders to life and the big band's music descends and envelops Benz, who, sleepless and coming down from the morphine tablet he chewed during the cremation, hears Tintin's brassy voice lifting to the call of the radio. "You've got to sing with it."

Benz takes the transceiver from his belt. He presses the call button and opens the volunteer airwaves to a eulogy worthy of Tintin: music delivered through an elevator quivering on a frayed cable, resonating in a way only an instrument on its last leg can. To this requiem, Benz pictures Tintin on the brink—black room, white powder, a flame playing along the needle.

He believes that Lara is listening, that she knows he is reaching out. He believes that volunteers across the city are tuning in. That others like him, brigadiers, first responders, are clustered around radios, under highways, on street corners, in parking lots, finally able to hear what's behind the static: a confirmation of their toil, the ovation they have been listening for. Tintin's eulogy is their rallying anthem; it calls them to work. *Tum boon*, it sings. *Do good. Save yourselves.*

IN THIS LIFE
OR ANOTHER

by Santiago José Sánchez

The boy is ready at the window when the last bell rings. He tightens the straps of his backpack and hugs his lunchbox to his chest. It's happening again. She forgot she was a mother. Either she is first in the line of cars or she's not there at all. He's worked it out to a system, these two options. Through his wet eyes, the cars at the end of the schoolyard blur into a landscape of glistening metal. He tugs the lapels of his uniform jacket around his cheeks and squeezes his eyes shut until they sting. These small pains sustain him. He's thinking hard; he has to. He has to picture her face—imagine her there, with him, and then she'll appear. He begins with her eyes and nose, which are identical to his, before he reaches a blank, unable to remember the parts of her that aren't his.

It must have been a Friday, like today, the first time she forgot she was a mother. A whole weekend passed before she remembered. They found her in the kitchen, waiting at the counter to take them to school as if nothing had happened. She wore bruises on her face like makeup, like there was another face beneath. On the way to school, the brother sat in the back seat and squeezed the boy's hand, which meant, *Don't be afraid.* She'd come back like this from the badlands, from visiting the father. It was their secret to keep. It was important that the school and the rest of the family didn't find out; the brother told him this at night, in the room they shared, beating his chest with his fists. Then, with his arms at the sides of his head, he threw punches at an invisible target. Slowly, he pivoted around their orange rug, fighting something only he could see.

One by one, his classmates—all of them boys—exit the classroom. They say, "See you next week," because they have to, because that is the rule of the classroom. He doesn't play outside anymore. He has no friends. He sits by the window, his spot, like last time. From his perch, he can concentrate on holding the world together. From his perch, he can have some privacy to do his job. Forehead pressed to the windowpane, he follows his classmates running across the courtyard, imagining himself in their limbs, in their roles—he lives between the world and his head, is what the teacher says to the mother. When the boys jump across the slabs of cement, avoiding all the red bricks, the lava, he, too, is jumping, and when someone runs up the chute of the slide, all the way to the top, the latest stunt, he, too, is triumphant. Because it's his sacrifice, keeping the world in order. But when the boys reach the fence, they don't turn around to look at him. They cross a threshold, unaware that without him, their fun would be impossible; the world would be cast into peril and chaos. His is a thankless job.

"What am I going to do with you?" asks the teacher from her desk. Her hands hold each other, a tent over a stack of papers. It's just like last time; only he and the teacher are in the classroom. The worn look on her face says, *Not again, dear god, not again,* and though these are the same words that are looping through his head, he attempts a smile, to soothe her, to convince her: *We are all right, Teacher.*

"We'll wait just a little longer," the teacher says, her voice the hollow peel of a day. Her eyes close. She reclines in her chair, waiting.

It's too much. He cannot look out the window any longer. He walks to the back of the classroom and slides into the last desk. This way, he will be a smaller problem when the teacher opens her eyes. He undoes the latches of his lunchbox and sifts through the contents. It's something to do. He's learned this from the mother. He observes her more closely than ever now, for patterns and signs, for something to predict her next disappearance. The mother is a scientist. Her method inside and outside of the lab is scientific, pure. She would be proud of him. He notes how in preparation for the father's return from the badlands, the mother begins in the kitchen, putting away every dish, polishing every fork. In the bathroom, she stores all the creams and toothbrushes in the cabinet, and turns the candles on the toilets so the labels, with the snow-frosted pine trees, face outward. For hours she does this, going from room to room, until every sign of life has disappeared. He sits on the chair opposite her when she's done, afraid to touch anything. On the couch, with her fingers tied across her chest, she lies with her eyes open. "It's something to do," she says, when he asks why. The plastic casing on the sofa crinkles beneath her small shifts. This is something to do, he tells himself now, becoming a smaller problem.

Inside of his lunchbox, he finds a banana peel, the plastic wrapper of a straw, the gooey ball of

by
SANTIAGO JOSÉ
SÁNCHEZ

a used napkin. There isn't a hint of yellow left in the peel; it's turned completely black. He folds it in half, and in half, and in half, trying to make it disappear. When it's a cube, he stops, sets it down. He isn't seriously hungry, not yet, but he can't help but wonder what would be worse: to die of hunger in this classroom or to go home with the teacher. If he went home with her, what would happen? How would the laws work? Who would tell the father? Would he become the teacher's new son? And what about the brother, already fifteen? The boy throws these questions around in his mind like a pair of dice, aware that he's only playing a game— that this is only, for now, a game.

Each time he dares himself to look out the window, the sun has stumbled farther down the street. No more boys. No more mothers. The melting cobblestones mean rain. The wind corrals the leaves into a corner of the courtyard and then, changing its mind, lifts them back across the playground in swirls, toward the gate and street. In silver lines, the rain slants down like the static across the mother's bedroom television. On the nights he joins her, the father's side of the bed is always untouched, the sheets neatly folded in an envelope and the cushions stacked in a pyramid. The boy squeezes in with the mother on her half of the bed. They don't stretch out and claim the mattress. They keep to her side as if at any moment the father will barge in through the door. The boy asks her, from time to time, why the father keeps leaving. He's a civil engineer, the mother says, the real deal, out there in the badlands, where roads and bridges are most needed. He'll be back, she says, the following weekend, or the next, or the next.

It's the first crack of thunder, somewhere in the distance, that wakes the teacher. She lurches forward in her chair, gasping for air. Her eyes survey the room, narrowing as she realizes she's still at school. She frowns; it's clear to him—he recognizes that particular look, the disappointment. He follows her eyes above the chalkboard to the clock, a full moon hovering over colorful paper worms bent into the shapes of the alphabet. She hits the light switch by the door—the brilliant shock, he'd been sitting in the dark. He closes his lunchbox, embarrassed, his fingers sticky with pulp. She takes the phone off the wall. The dial tone crosses the room and circles his ears like a mosquito. He can't swat it away,

try as he might. The teacher waits with an arm barred across her chest to let him know he's in trouble. Her fingers massage her temples, then the sides of her jaw. He has become a problem she cannot solve. He can tell as much. He walks to the front of the classroom, sitting down at his own desk, feeling like a little demon with red wings and talons, disguised as a boy. He opens his notebook to the lesson of the day, and, across the page, the cursive letters resemble zoo animals waiting patiently in their cages; thinking this makes his hands tense. This is the truth: he's at the world's mercy.

Someone finally answers. The teacher explains the situation.

"I don't care if you're swimming," she says. "Someone has to pick him up."

Her eyes are on the boy, making a bridge for the words on the other end of the phone to cross from her head to his. The boy can see the brother. He can see his body darting through the water with the unrest of an arrow. He's been swimming for as long as the mother has been disappearing, or so the boy thinks. His mind is a scattered calendar, all the months thrown into a box, then shaken.

"Do you know where she is?" The teacher turns to face the chalkboard. He's not supposed to hear this part. He clenches his stomach until he can fit his fingers underneath his ribs. He's holding himself in place from the inside. When her head snaps back toward him, he looks away, as if he's not straining to listen, as if he's oblivious. He knows his stare makes her feel strange. It's one of the brother's favorite stories, how they thought he was troubled when he was little. He didn't speak, didn't cry, didn't eat. He sat in his high chair, staring across the room into everyone's eyes. If they were lucky, he would believe their hands were planes and accept their cargo into his mouth. On the worst days, they had to take him to the zoo. There, the boy mimicked the animals, stretching his mouth silently around the sounds the lions and monkeys and elephants made, as if uttering their cries from his own throat. It was then, at the zoo, that they were able to feed him. He doesn't recall any of this, but he's sorry, sorry he was ever difficult.

"Unbelievable," says the teacher, touching her hand to her forehead, covering her eyes, as if that's all it took to disappear. After a moment, she adds, "What's wrong with her?"

He had hoped that it was only in his head. But here they are, the words he's been keeping himself from thinking: something is wrong with the mother.

"I know, I know." In his periphery, the teacher paces the length of the chalkboard, the phone pressed between her shoulder and ear, the coiled cord joining her to the wall—she's looking straight at him. What does she see? What kind of animal?

"It's not your fault."

She hangs up, falls into her chair. The springs groan under her weight.

In his notebook, the boy begins again, because he must, because it's something to do. He draws an oval. He will attempt to summon the mother again. He scratches two dashes for her eyes and coils a meticulous crown of graphite curls for her hair.

"Your brother is coming," the teacher says to the ceiling.

Honks erupt from the street. He doesn't know how much time has passed. He shoves his desk away, runs to the window, like he does when the father returns from the badlands, beating his horn like this, marshal of his own parade. The frantic rain makes it difficult to see the end of the courtyard. A figure, silhouetted by the lamppost, exits the taxi. In a white button-up and khaki trousers, the brother emerges, running through the courtyard with purpose, with his coat—too light for this weather—spread like giant bat wings set in silver. The brother knocks on the window and flicks his head heavenward. This means, *What's up*, in the secret language they share, that only the two of them speak. He flashes the boy a thumbs-up, which means, *There's no time to waste*, and the boy gathers his backpack, his lunchbox. He crams the drawing of the mother into his pocket—he pauses only to return the gesture across the window, raising his own thumb slowly at an odd angle.

In all his size, the brother leans against the railing outside. His jacket flaps in the violent wind. Strings of rain burst on his shoulders in bright, electric snarls. The cuffs of his shirt are soaked, translucent. He lets the brother pat his cheek. The lingering smell of chlorine on his wrists, the pungent odor of his swimming lessons, fills the boy. He feels his face do a thing, a glitch or flicker.

"What's the matter, boy?" the brother asks.
"Nothing."

His face sometimes speaks without him. He has to do something about it. Act funny. Be playful. He punches the air in front of him and ducks an invisible punch, shorthand for, *Is she okay?*

"That's right," the brother says, his laughter like a motor, a rumbling. "She's just kicking ass somewhere. Everything is fine, boy."

Like it's an order, the boy straightens his arms at his sides and nods once. He doesn't look into the brother's eyes but somewhere between his eyebrows, the way the soldiers and generals do on the evening news. They stand like this, like statues, inches apart. If he were going to ask any questions—like, *What is wrong with her these days?* and *Are we doomed?*—the time would be now. But even as these questions form in his head, he can anticipate every answer branching into further and further possibilities, like the hot white lightning now cracking across the sky.

The brother extends a hand. Rivers of rain spread around the boulders of his knuckles.

"How about this?" he says. "Let's not go home. Let's go into the city."

The boy feels something light up inside of him. Every other time she forgot she was a mother, they had simply gone home, ham and cheese sandwiches for every meal, pretending each time they sat in front of their plates that it was the first time. That it was a treat to be alone, without parents. He shakes the brother's hand, like a truce, like a choice. He decides to be young, ecstatic—to pretend that the mother is truly gone this time. Without her, he can be anyone.

The rain needles the top of his head. He trains his eyes on the ground, stepping only on his shadow, which is easy, with the way the headlights stretch and multiply his outline. He prefers walking with the brother over the father or the mother. The father, when he's home, makes him walk in front, meaning that every few minutes the boy must turn around and make sure the father is still there. The mother keeps him at her side, never letting go of his hand or neck; walking, they're a single clumsy creature. The brother sets his own pace, faster than the boy's. He's always ahead, in sight, and holds the boy's hand

by
SANTIAGO JOSÉ
SÁNCHEZ

only when they are street-crossing, freeing him as soon as they reach the curb on the other side. The brother faces the strangers, so that the boy doesn't have to, so that as the rain lessens, becoming a misty shower, he can look at the shirtless men honking at their girlfriends' windows, stare into the video bars where domino chips click on plastic tables and where men arm-wrestle over beers. He can look into the shops, the metal shutters pulled halfway down their fronts, where inside the owners count their coins in the honeyed light. He's free to stare at what he wants, without shame, without consequence. He looks everywhere, even at the soldiers standing at the intersections, one on each corner. He hasn't seen them in person before, only on the news. He isn't prepared for how large the guns across their chests are—much larger than on television—or for the pain that lodges in his throat as he passes the shiny gun barrels trained steadily on the ground. To draw less attention to himself, he matches his footsteps to the brother's with the logic of a shadow. Fears are smaller with the brother. Reassured, he studies the soldiers and, underneath their rain-studded helmets, he finds faces like the brother's. Unibrows, downy mustaches, pimples, and large pores. It's as if they don't see him, but he sees them, he sees them for what they are: boys in uniforms. He won't ask the brother where they'll hide when the curfew comes, or if it's true what people say happens to the boys who are caught by the soldiers. There's another hour, maybe two, before they have to think about that. For now, he returns his eyes to the ground, to his feet, pretending he hasn't seen what he has. Fleets of mice disappear in and out of the napkins stained by red lips, the telephone bills, the lost love letters strewn across the pavement, stirring, murmuring, crossing between his and the brother's feet along an invisible thread. They reach larger streets, with more people, where it's possible to forget the soldiers under the neon signs blinking VENTA VENTA VENTA. Potholes filled with the stardust of ground-up glass bottles catch the lights like portals into an underground world. Girls on billboards blow down kisses onto the traffic, and mournful folk songs spill out from the bars. Buses full of poor people and pickpockets, of bad thoughts and the smell of wet onions, of pregnant brown girls selling little yellow candies from large plastic bags for a penny or two, boom

down the avenue. Where has the city gone, the one he's known by day?

They reach the plaza, where they once fed the pigeons. As he skips down the steps, past the sculpture of three natives sailing a canoe, he sees posters with the faces of politicians all around them—on the walls of the bank, the courthouse, the old capitol. There're layers and layers of them. Some have peeled back to reveal another face beneath—there, an eyeball on a lip. An ear over an eye.

There's not a pigeon in sight, not a single one, until, for no reason at all, the brother screams at the top of his lungs. Then he is screaming too. They are both screaming like maniacs, like amputees, like orphans in the empty plaza. Because they want to. Because they can.

Suddenly, stirred from their hiding place, hundreds of white birds, their bodies swollen with rain, soar into the sky. As the shrieking mass circles, swirls, and swoops furiously around them like a vision, he sees it again, the day the father brought them here—the mother, the brother, and the boy—the family. It was sunny, the plaza full. Children flung corn across the square and the kernels caught the light like gold. The father filled his hand with corn. Instead of tossing his palmful, he lifted his arm into the air with that speculative look he got when he tested the mother's patience. Within seconds, it worked: a bird perched on his wrist. The mother, haunted by worry, by the world of germs and diseases only she could see, protested. She slapped the father's shoulder with her purse, calling him by his first, middle, and last name, as she would call the boys when they were in trouble. The father laughed. The boy wondered if this was strange or if this was the way things were supposed to be. He took the bag of corn from the father and did as he was told. He filled both of the father's hands until yellow mountains peaked in his palms, which he then held out at his sides, like a man bound to a cross. A fleet of pigeons flocked to him. He was majestic. The mother tried to pull the sons to her chest, but it was too late. They were filling their own hands. The pigeons zipped past their heads, wings brushing their shoulders. At first, the boy was exhilarated. The claws curled around his wrists, digging gently into his skin. Each pigeon had a heartbeat of its own and he felt each one thumping. Three, four, five, then more came. They flew

into one another in feathery collisions, which made his own heart race. Voices flared around him, dull, as if heard through a wall. The birds pecked at one another's eyes and throats because his arms were too small to hold them all. He couldn't tell them apart anymore. His skin was swelling red underneath their desperate, flapping wings. At night, the mother rubbed his arms with cooling slivers of aloe, and her face, as before, when glimpsed through all the feathers, was disappointed.

The brother jets across the street, to the recessed sidewalk below the offices of the national bank, and the boy, giving himself over to joy, follows. From under the enclosure, side by side, both fantastically grinning, they watch the bird droppings fall across the plaza in bursts of white.

At the end of the walkway, they cross the street again: another soldier, another gun. They begin the steep descent into the blue fluorescent flames of the neighborhood before them. The pavement turns to rubble. Six kids play soccer barefoot in the rain. Two cats fight for a Vienna sausage on the hood of a car. They are in a neighborhood where neither of them belongs. The bottom of a hill is a bad place to be, as is any place too brightly lit. These are things the mother says. The brother steps behind him and steers him by his shoulders. He's a shield or an offering—the boy doesn't know which. He pounds into the mist with his forehead, past the houses, past the grainy walls streaked with fingers of mud. His mind is sharp and clear. He notices every change in pressure on his shoulders, the brother's hands directing him like a marionette. The safe lights over the doorways ignite as they step under them, and like that the sidewalk becomes their stage. His shadow evaporates, and the tops of his hands, catching the lights, are blindingly white. Without the brother having to utter a word, he stops in front of a metal gate decorated with swirls and knots in the shapes of flowers. Behind the gate is a red door. It's bright as a day under the light bulb, and the brother's face is calm, even amused, looking at the metal flowers, past them, really, through the door, to a place of sunshine.

The jab between his shoulder blades means, *Knock*.

Out of habit, he knuckles the door like in the cartoons, five taps followed by two. Moths rocket past his face into the overhead light. As he waits, the words the mother brandished once during an argument return to him: "Your brother has always been hoping to fall into another family."

Footsteps sweep across the floors inside and come to a stop. Past the metal gate, the door opens to a pair of legs—thin, long, dark—darker than his and the brother's. The girl's hot-pink nails straighten her plaid school skirt over her knees and scratch the spot over her lips before resting at her waist. He looks no farther than her mouth. She's trying to sound concerned, older, like a mother, but there's an edge to her voice, something delicate and breaking. She wants to know what they're doing here.

The brother stabs the boy's back with two fingers, meaning, *Speak*, so the boy says hello to the girl's skirt. The knife at his back is unsatisfied and prods him to say more.

"Our-mother-forget-she-was-a-mother."

The words spill out of his mouth as if gushing from a wound. He wanted very much not to let this girl's face enter his head, as if seeing it were enough to confirm her as the new mother, but she bends down to his height, forcing him to look at her. Her cheeks are the wide handles of a pot. He tightens his fists into bricks at his sides with the fear that he'll hurl out of himself, suddenly and completely. "It's okay," she says, stroking the top of his head through the bars. She asks him to calm down, to repeat himself. For her, she says, and for her he pulls each word out of his mouth, slowly this time, hanging the mother word by word in the air between them. He's made himself understood, he thinks. Her lips strain into the shape of a smile and her eyes narrow as if recalling the name of an elusive fruit. "Listen here," she finally says. She needs to borrow the brother, just for a minute.

The cold metal gate bangs behind them. He watches through the bars. The girl backs away from the brother with her arms thrown across her chest in an X. Her clenched teeth are muttering—*stunt* is the only flying word the boy catches from outside. The backs of her legs come up against a blue sofa, not encased in plastic, like their own. The brother's trying to grip her by the shoulders but she keeps slipping from his hands like a bar of soap. He tries her name. He repeats it to her as if somewhere inside her is

IN THIS
LIFE OR
ANOTHER

by
SANTIAGO JOSÉ
SÁNCHEZ

another girl—the one he came here to see. This girl is a girl and not his girlfriend. This girl is hurt. This girl is hurting.

It's from the outside now that the pieces fall into place. The boy can see with perfect clarity that the brother is only looking for his own home. This adventure is not about him, the boy. It is about the brother and his own escape. But they don't belong here, neither of them do. The black jelly of fear fills the boy from the feet up. He can no longer hold his legs still. He crouches against the side of the house and holds his knees together to stop the shaking. The sounds of the brother and the girl inside go mostly through the boy, but every now and then something lands—"I thought you would be happy to see me" or "What sort of *puta* do you take me for?"—words that stick because they belong to the father and the mother. The rain has stopped. The wetness of his clothes is suddenly apparent. He's so still, the light above him extinguishes. He's dissolving.

"Fucking curfew," he hears. The boys who were playing soccer are marching down the street. All six are skinny and tan with identical rat-tail haircuts. Their white shirts hang like towels over their shoulders. The one with a piece of metal through his eyebrow is saying that it's true, the soldiers will pick any boy they find on the street and draft him. Their ball surges ahead of them, bouncing against the sides of cars, tapping the lampposts, climbing ashore on the piled bags of trash—rainwater explodes around each impact.

The boy rests his head on his knees under the lunar stillness of the night. He lets himself go back, back to being on the mother's lap, looking up at the triangle of her rigid jaw, ear pressed against her churning belly. The vague rumble of the father's voice wandering down to him from the phone. She would tell the boy about it afterward. How the guerillas, or the muchachos, as the father called them, had stolen a ton of cement overnight. How the guards he'd hired had accidentally shot a local after a night of whiskey and cumbias. How there were more delays, more months, many, many more months, before the roads were finished. After the bad news, her finger traced a spiral on his stomach as she mapped out the story of the guerillas for him again. "It began in the far reaches of this land, in the jungles and badlands," she said, making him

squirm when she poked his armpits and traced his nipples. "And then they spread to the small towns between larger cities." She drew circle within circle around his center. "And for now, the only safe place is here," she said, nearing his belly button.

The gate swings back against the side of the house. The brother is still saying "please" when he's spit out onto the sidewalk, still saying "please" to the door when it shuts. He's a pleading patch of skin under the spotlight.

"That bitch," he cries, rising. The coarse gravel crunches beneath his feet like seashells. In small backward steps, he retreats from the house, from the metal flowers vibrating over the red stillness of the door.

The boy says the word *curfew* to him, but not loud enough.

"That bitch," the brother keeps saying, looking around himself as if somewhere there were a way to escape he hadn't considered, a trapdoor, a chute, a ladder, a red button to another life. In the middle of the street, he picks a handful of stones from the ground and studies each one on his palm. He stops and drops all but one. He kisses the chosen one, the one now sailing through the air at the second-floor window, the one having the time of its life. The windowpane cracks with a thrilling icy sound.

Up the hill, the street is molten and strange, the surface of another planet. The lights flare. The boy has to pinch his thighs through the lining of his pants, remind them to keep climbing. His fingers pick apart the wet clumps at the bottom of his pocket—the pulp that was the drawing of the mother.

"That bitch," he yells at the top of his own lungs, like the brother.

The shouting, the curfew, that he didn't get a last look at the girl—it doesn't matter. What does matter is that the night smells terrific, like fried plantains, and the streetlights, they're huge enough to fill entire puddles.

The next morning, he's still running. From room to room, he unlatches all the windows, chanting, "That bitch, that bitch." In the mother's room he climbs atop the sill and with a firm grip on the frame he closes his eyes. The mountain breeze swells past him. For the first few seconds he's diving through water. A vigorous feeling grips

him when he opens his eyes and looks around the room at the effects of his mission. Innocent blue streaks of light ripple over the tendrils of the sheepskin rug. The lace curtains, the books on microbiology, and the loose records of medical exams are the floating organisms in an underwater world. He sees the room for what it is, the mother's old room, now buried beneath the sea.

His mission continues in the kitchen. He heaves his body up onto the marble counter, his shoulders arching as if clambering out of a pool. The stone is smooth and cold underfoot. He steps carefully around the plates with the hardening crusts of ham and cheese sandwiches the brother made for dinner last night and for lunch today. The wand hanging from the skylight clicks with every rotation, and as the sheet of glass rises, the wind whips in with the force of a wave. The roll of paper towels turns on its hinge, unspooling onto the ground. They haven't heard from the mother, as far as he knows. But that's not important now. The brother is apologizing. This whole day is an apology.

He returns to the brother, sprawled on the naked sofa. He feels useful and proud. The plastic cover, cast off to the side, stands like a clear boulder—this, too, his handiwork—next to the dining room chairs, where their jackets hang, drying. From the sofa, they can hear the stream rushing past in the backyard and the mountain trees wrestling shoulder to shoulder. Every now and then, a current dashes through the house, shaking the gold-tasseled curtains and rocking the glass trinkets in the vitrine. No inside, no outside. No order. He wishes it were always like this, just the two of them in the living room.

They wake the video games by blowing into their metal tracks. They plug them in and Mario and Luigi appear with their race cars on the television screen. They choose Rainbow Road, where stars shoot out of their wheels with loud, righteous sounds. When the brother wins, which is always, they celebrate. They drum their fists on their chests. They are already other boys. The boy seems to think so, laughing. Inside of the brother's red plastic lunchbox, there're several lighters, a tin jar with a crank, and a small book with sheer, crinkling pages. The plastic bag filled with the green nuggets of the stuff is already on the table. The brother rolls the cigarette right next to the wooden coasters and the picture of them in Miami Beach—the mother,

the brother, the boy—the trip they took without the father a year ago.

"You're going to breathe easy."

He enjoys it when the brother talks like this, in instructions rather than explanations. What a fate, to know what to do. He taps his foot to the beat of their victory as he watches the cigarette form, thin and even, like a pencil between the brother's fingers. When it's finished, the scruffy end catches the flame of the lighter and the brother blows on the tip until it's a slow, crackling orange.

"It's going to hurt at first, but you'll get used to it."

The boy wants to laugh at the serious face the brother makes, breathing through the cigarette. With his eyes closed and brow furrowed, he resembles the mother. When the brother opens his eyes and pulls the boy's chin toward him, the boy is caught off guard. His chest heaves, suddenly called to action. They are so close they are almost kissing. The smoke transfers between their mouths, a bridge. He's surprised by how the smoke fills him, how he can hold only so much of it in his mouth. His lungs spasm as if he's about to laugh or cry, overwhelmed by some elemental feeling.

"Hold it."

The brother stands up, grooving his hips, filled by the music of smoke. On the TV, Mario continues to jump in place, a golden trophy raised over his head. The brother adds a shimmy to Mario's victory dance, raising his arms above his head and stomping his feet as if firecrackers were going off. Watching him, before another thought can follow, the boy feels his lungs expand. He closes his eyes and finds a pink room inside of himself. He prickles with the newness of this secret room, its walls glazed and pulsing. As the vision begins to fade, he opens his eyes. He exhales. He doesn't know where he has just gone. He looks around at the strangeness of the house through the fog. A rod of light shoots through the kitchen window. The long white arms resurrect a soul from the sink, and all over the house, through the windows, long white fingers are touching things here and there. A fly on the silverware, sharp and green as an emerald. The white china haloed in orbs.

"I think I'm high," he says, but the brother laughs, tells him, "Not yet" and "Take it easy."

The brother takes another puff. He lets the

smoke slip out like dragon breath from the sides of his mouth, unspooling and rising to the beams of the ceiling, where it begins to collect into a face—the face of the mother. He should point it out to the brother now, share with him this vision, this ghost, this threat. Instead, he wills a breeze through the windows and forces the smoke apart into a vague bright blob holding the two of them, as brothers, together. Having saved them from danger, he feels he's earned more.

"One more," he says. He wants more. He wants to see the pink room again. Another rule is broken when he stands on the couch. The springs bounce under his feet. He's as tall as the brother, but when he reaches for the cigarette, the brother swipes his hand away. His cheek stings with the shape of the brother's hand. He's slapped him, just hard enough to assert himself.

"Who's a little man now?" asks the brother. His hands make a cone around his ear. "Huh? I don't hear you? I said, who's a little man!"

by
SANTIAGO JOSÉ
SÁNCHEZ

"Me," he shouts. "I'm a little man."

"That's right," says the brother. A slim flame shoots up from the lighter. The brother inhales from the cigarette again. A cow moos from a shed across the stream, across the line of trees, from the farms stretching over the mountains. And then there's music too—strange music, becoming louder and louder. He dances while the brother puffs on the cigarette, thinking of being near the brother's mouth again, of finding more, and more, and more rooms within himself. He thinks he's willed it when the front door swings open. They whip their necks toward the world outside, a sheet of white. It's impossible to see anything. He can imagine what will happen next. The guerrillas have reached them, even here in the mountains, the one place they were supposed to be safe. The guerrillas will force them out into the jungle, train them to carry guns and sleep in hammocks strung between trees. In his mind, these future days shimmer with possibility. With the guerrillas, they will rob the father of his tools, leaving the roads unfinished, and without a job, the father will have no choice but to return home. The mother will no longer need to visit him. We, the boys, will bathe in the rivers, he says to himself. We will be revolutionaries. The idea exhilarates him. He straddles the back of the sofa like a horse, his legs kicking at either side, beating the wooden mane with his fists.

And when he yells across the house, he does so as only a little man can:

"We! Are! Ready!"

Through the haze of smoke, the street resolves itself, and there in the driveway he makes out the mother's car with the windows rolled down, the radio still blasting a cumbia. The shape of the mother appears backlit in the door frame, her face dark, her body compact and neat and sharp. She takes a wide step inside, leaving the door ajar. She limps past him and his horse. In the kitchen, a finger of light touches her face, right under her eyeball. An open gash fills with gold. She stomps across the landing as if crushing a swarm of roaches beneath her heels; she shimmies out of her dress, inspects the garment under the light, fingering the hole in its side when she finds it. She splits the dress open until it's like the hide of an animal, symmetrically fileted. She drops it on the tall, skinny table, over the black-and-white communion portrait of the brother.

She snaps her head toward the front door at the sound of laughter. The band is saying their jaunty goodbyes over the car radio. She doesn't see him or the brother. They have become invisible. Her purse hangs heroically from her hand. The radio goes silent, the idling motor of the forgotten car takes over, the emptiness filled by the mechanical rumble. For a moment, recognition flickers on her face, like she's about to come to her senses—she's left the car on, these here are her sons, smoking—but instead she drops her purse onto the ground. The compacts and lipsticks and brushes erupt across the floor. The heels come off last, so brilliantly red, so alive, so much like bloody pieces freshly torn from her body that their hearts sink. There, on the landing, in her beige bra and panties, more naked than they have ever seen her, they catch a last glimpse of the mother. The boy could look at her like this forever, but she's at the mouth of the dark hallway now, disappearing.

The brother sweeps the crumbs off the table and stashes the bag of nuggets in his loafers. He points to the windows, and as quickly and quietly as the boy can, he closes them. The difference between inside and outside is clear to him again—clear and necessary. No need to talk to decide on a course of action. The brother leans up from the couch and leads the way, tiptoeing into the hallway; they are turning into

detectives. They peek their heads around the frame of her bedroom door. The lace curtains wave in and out of the open window. Sheets of paper circle anxiously in the air. Atop the night table, a mulatto cherub lies flat on her belly amid the gold circles of the mother's rings.

The mother's inside the bathroom. Her shadow moves across the open doorway like a slip of silk. She runs the bath and swings open the vanity cabinet with a loud thud. A candle is lit and her shadow now stretches across the floor to the bed, where it lies, sinister and flickering.

They look at each other, the brother's stare daring him to go first. The brother's eyes are red and his face yellow, orange, green, brown, so many colors. The boy shakes his head and wraps his arms around the waist of the brother. There's no way in hell he's going in there. He's no little man.

In the middle of the night, the boy is startled by the brother's arm reaching for him, zombielike, from the lower bunk. He hears his name hissed like a bad word. He stops breathing. He wants to be so still he disappears. Through his eyelids, he can see the orange-green lights of the neighborhood security van enter the room and disappear. A small dog howls from the yard next door. He hasn't really slept, or if he has, he's dreamed only of being on this bed, like this, still as death.

"Quit pretending," the brother says, appearing at the side of the top bunk. His voice is clear and direct, a jolt in the silence. He wants to make sure she didn't drown in the bath.

The boy's stomach turns; the ham and cheese sandwiches he had for dinner ball up in his center, hardening like cement. He throws up a little bit in his mouth and swallows it back down.

They find her sleeping in the center of the bed. The light of the late-night news sculpts her matronly body. One by one, they slip under the sheets at her sides. Her face is laid bare beneath him, the wound exposed, lumpy and alien in its blue sheen. He can look at it for only so long before he pictures the father standing inside of the fleshy pit, blurred and distant.

On the TV, a woman is saying that another town, somewhere else in their country, has been destroyed. Her image cuts to one of green-clad soldiers standing in a row by the side of a highway. They hold their arms at their waists, elegant as statues, even as behind them, in the trees, flames leap across the branches. In the next shot, the soldiers are seen from above, indistinguishable from one another, like ants swarming a clump of dirt. In the next, they're closer, and he can see their hands pulling roots out from under the trees in their attempt to scale a mountain. He imagines the soldiers sneaking out of the screen onto the bed. It doesn't take much for him to see that the geography of the mother's body is like the mountain's. A hundred green men mount her arms and legs, heading toward the slow-heaving knolls of her chest. He leans in to kiss the small bloody town of her cheek before they can reach it. He plants his lips there and scans the length of her body, pulsing with feeling. The soldiers are gone, held off by his shadow. When he moves to the side, the soldiers reappear, scrambling up her neck, up its tight cords. He thinks, and not for the first time, that he comes from her, that he is made of her. He feels an overwhelming gratitude; he doesn't know how to repay his eternal debt. He must protect her. He kisses her again, with more conviction this time, the way she kisses his cuts and bruises, as if love were something tangible, a balm for every injury. The soldiers are once more vanished.

A shudder passes through her. He pulls away and meets the brother's eyes over her body, and like always, follows his lead. They remove her hands from her armpits, extend her arms, kiss her from her shoulders to her palms. They kiss up and down the length of her arms. They're breathless, panting. He has no question about it; this is something he has done before, in this life or another. Nothing has ever felt so true, so perfect. He feels the brother settle a hand on the back of his head, to assure him he's sorry, she's sorry, everybody's sorry.

The news broadcast finishes and static slashes through the screen. Washed in the white light, they're still kissing her. He has no clue what they're doing anymore. He doesn't need to know if this is how things are supposed to be or if everything has gone terribly wrong, because this is just how things are. He knows without having to look at the brother that the kissing, the ceaseless kissing, means all is forgiven. If

IN THIS
LIFE OR
ANOTHER

she forgot she was a mother, it doesn't matter. He begins to chant over her body the one prayer she raised them on, until they are both chanting, their voices raised over her body in unison.

"We belong to each other."

"We belong to each other."

"We belong to each other."

Days later, the mother returns across the yard with an empty drawer in each hand. She joins the boy and the brother at the window. Together, as a family, they watch the contents of the father's closet floating piece by piece down the stream behind the house: red polos, followed by the khakis with the elastic waistbands and the argyle socks. There is charm in how the Hanes balloon in the water. They watch every piece of his closet disappear around the river bend, past the line of wind-shorn trees, rushing away from the mountains, downhill into the city, going to distant, faraway places, where the sun makes a hide of your skin, where you coarsen and sweat long strands of silver.

by
SANTIAGO JOSÉ
SÁNCHEZ

SANCHEZ DAY
by Mark Chiusano

Of course it was sad; of course there would be emotions; naturally it would be a big deal for other people at the ballpark, but Conner hadn't expected this. When he made the last turn before the players' entrance to Miller, he saw the crowd. Their eyes turned to him as he dipped over the speed bump, Bob from security already recognizing him from his license plate, even him, a rookie—he thrilled to that—and opening the gate. The people's eyes swept over his car and he could feel them wondering: Was it him, could this be the one, was their moment at hand? No, it was just Conner Belthaldt, a young guy with a not-great baseball name, one plus pitch and two mediocre ones, who had been called up midway through the final month to finish up a dead season. Soon they'd know his name and his car, Conner was sure.

But it was the Captain they were looking for today, the franchise player, the guy who had painted the city gold for the last fifteen years. Well, sort of gold; the Brewers hadn't sniffed at the World Series in decades, and even in their most recent Division Series appearance, the Captain had been conspicuously quiet. There had been whispers then—he wasn't up to the pressure. That was a long time ago, though, and now at the end the whispers had been painted over with nostalgia, so much so that as Conner's car inched through the players' entrance, the crowd was chanting the Captain's name: "San-chez, San-chez, San-chez, San-chez."

Santos Sanchez only ever went by his surname. You're a catcher on one team for that long and your name will be more familiar than even those of the few all-star pitchers who had cycled through Milwaukee. Forget about rookie relievers. Conner buzzed down his window and took off his sunglasses, smiled, waved to the throng, and saw all of their faces go blank at the same time. The "San-chez" chant stopped. Conner shut his window and continued into the bowels of the stadium, already in a foul mood.

It was Sanchez Day at the ballpark, all right. A testament maybe to the riches gained by staying with one team all your career, by building a loyal fan base and never being cruel to it. A reason to avoid the pleasures of free agency. Not that Conner was anywhere near that—he was hoping to grab a couple more good innings in the remainder of the season and convince the

club to let him start in the majors come spring. He knew he was at the beginning of the ramp; he just needed to prove it. And Sanchez being gone might allow the spotlight to shift.

Everyone knew the story. First player of Hispanic descent to really make a mark in Wisconsin. He had started playing the week after 9/11 and—would you believe it?—people yelled to get the Muslim off the field, even though Sanchez was only one-quarter Lebanese. Another quarter was Guatemalan, the remaining half Mexican. He didn't speak a word of Spanish. He'd grown up just outside Milwaukee, hometown kid, both his parents were born here, were professionals, and his walk-up music was "All Star" by Smash Mouth, if that fills out the picture. But this wasn't the big-city Yankees, the team that Conner had grown up idolizing, alongside his father, from the distant pastures of Suffolk County, Long Island. Sanchez brought his own city into the twenty-first century.

He was a career .290 hitter, probably the highlight of his stat line. For a couple years in the aughts he was in the top five or so in home runs, and one year he even won a home run derby, which then ruined him to a bad uppercut for the rest of that season. He was beloved for his golden arm, which for nearly two decades had kept runners close to the bag and thinking twice about stealing, with his signature move being a snap behind the runner to the first baseman, catching someone sleeping. He liked to say in interviews that it wasn't strength or muscle memory that did it, but knowing a man's mind. He was always good for a Zen line or two like that. He knew just when the runner was zoning out for half a millisecond; he could read something in the tempo of the stadium. That was what he told the interviewers. To the pitching staff, he had always been a boon for his ability to control their tempers between innings, and also for his steady demeanor and quiet sermons delivered from behind home plate.

This was what Conner had heard—hell, it was one of the reasons he'd been so keen to sign with the Brewers after the old birddog started showing up to his Shirley High School games. Baseball was a big deal in Shirley, but he felt he'd never gotten his fair due. Everyone idolized big hitters in those years, the aftereffects of the steroid era not yet having worn off. Conner's father, a puffed-up man and a two-bit local politician,

by
MARK
CHIUSANO

asked him on his irregular weekend visitations why he wouldn't rather take a cut every few innings like a real man, see what things looked like from the plate. Conner hated hitting. He liked being alone on the mound; he liked being the center of attention. Once, when he was very young, he'd considered going into theater, after his mother took him on the LIRR into New York City for a drama program called TADA! Conner had loved the stagecraft, the memorization of lines, the thrill of the small audience of mothers who clapped and looked somewhat beautiful out there in the black box theater. But after the divorce, his mother said the train tickets were too expensive, and she didn't have time to drive him in on Saturdays. So baseball, then, and he essentially taught himself the ins and outs of pitching, became familiar with the moments of boldness and apprehension, the feeling of attacking a hitter and coming out victorious when they swung and missed. Conner willed himself to success, but he always felt he had more to learn about the game's philosophy, more to be shown about strategy that wasn't being offered by his high school coach, a town council buddy of his father's, who didn't give him the time of day after the divorce (yes, it was ugly), until Conner's senior year, when he grew three inches and his fastball hit ninety-three. The birddog, in his decidedly undramatic windbreaker, in Conner's mother's suburban kitchen, promised before Conner signed that the Brewers had a secret weapon for developing young pitchers, to bring them to their fullest potential: they had Sanchez.

Conner parked his car, and as he navigated the dank stadium corridors leading to the locker room, he could hear the "San-chez" cheers reigniting far above him, and he remembered the time, three years earlier, when he'd first met the illustrious catcher.

It had been during spring training with the team down in Florida, a moment of maximum potential for Conner and all the other newbies. Sure, he knew they all felt they were something special, in particular the other seventeen- and eighteen-year-olds who had skipped college ball and its display of mediocrity. He was amped-up. He was sharing a hotel room with a guy from the DR named Dominic who seemed shy and apprehensive, so they shared a couple shots of tequila that Dominic had brought and then went straight to bed at something like 10 p.m. It didn't help, though, because Conner didn't sleep a second, and spent the whole night oscillating between arrogance and terror, feeling he didn't belong and also that he was too good for A-ball, picturing that first throw, that first step over the foul line, all the coaches watching in awe and envy.

And the next morning he knew he had made the right choice, he knew his on-ramp was just now extending, because after changing into his uniform and nervously scatting with Dominic and a couple of the other new pitchers and then running and tossing and stretching and warming up again and stretching more and sitting on the new grass waiting for something to happen while the hitters started BP, finally the pitching coach, Olafsen, came up to the group of them—Conner heard one of the veteran pitchers mutter, "Here we go"—and right next to Olafsen was the God, Sanchez, a bear of a man smiling this hundred-watt smile that seemed even more powerful than the brilliant south Florida day.

When Olafsen addressed them, every pitcher stood up, like it was the military or church.

"All right, men," he said. "Glad we're all back safe and sound for another season. We'll have a lot going on today, but I'm going to turn it over to Sanchez for a few words, mostly because his paycheck's bigger than mine, God's my witness."

Sanchez's arms, crossed in front of his chest, were the width of a bundle of bat barrels, his hands like two batting helmets. "Can we get all the rookies in a line, please?" Sanchez said, his voice like thunderous applause. "This is important."

As Conner joined Dominic and about six or seven others, it struck him how small they looked, how much like boys and teenagers—they *were* boys and teenagers—compared with the man before them. Conner tried to puff up his chest and tense his biceps. He prepared for wisdom.

"This one," said Sanchez, pointing at Conner. "The big guy. You look like you think you're something special."

The sun must have gotten hotter, because Conner felt the spotlight fall on him.

Then Sanchez turned around and whistled at a second-year pitcher, a guy whose name Conner didn't remember, because why would he? The

guy had spent the whole year in Single-A short season and Conner felt he was a cautionary tale, given his lack of speed, control, and mental fortitude. The second-year threw his hand to his cap with what seemed to be a palpable sense of relief and sprinted to the dugout, disappeared in its environs, and quickly came running back carrying the most enormous piece of luggage Conner had ever seen.

"This is your burden," said Sanchez. "This is my bag. For the rest of the time we're together this year, it's your job to carry it around with you. Return it to my hotel room at precisely nine p.m. and be ready to pick it up at five the next morning. If you're lucky enough to join us in Milwaukee, the same rules apply. Oh, and one more thing. You're not allowed to open it, not once. I mean never."

The giant walked toward the batting turtle, and the pitching coach said, "All right, let's get started. Conner, you better take that with you."

Conner felt dazed. The other pitchers abandoned him quickly, and he walked over to where the enormous duffel bag had sunk an inch or so into the new grass. He reached down to grasp it. He saw that there was only a single handle—it looked like it had been re-tailored to be even less useful—and it was difficult to fit his fingers into it. He had to bend down and pick the thing up with both hands. It was heavy, extremely heavy, and he couldn't tell what was in it other than maybe some clothes or cloth padding the edges, but certainly there was something else inside that weighed Conner down as he tried to move it.

"Rookie," shouted Sanchez from the batters' box he'd just settled into. The hitting coach paused from behind the L screen because everyone always did what Sanchez told them. Sanchez waved the bat at Conner. "Remember the rules."

Then the hitting coach tossed a pitch and Sanchez scooped it, like he was golfing, into left field for a home run.

All that week Conner found that the other rookie pitchers treated him differently, like he had a disabled-list disease or a bad baseball mentality. You don't want to be singled out in these situations unless it's because you're doing amazingly. He remembered one of the few moments when his dad had confided in him, fresh off losing a race for Brookhaven supervisor,

right after moving out of Conner's mom's house. "Nobody likes losers," his father had said. "You know them when you see them. They stink."

So to the bullpen; to the hotel; to the equipment room; to the bar at night; to the room in the early morning; then back to his own quarters for another hour of shut-eye; to the field again; to the wide-open cafeteria where they ate their meals, self-segregated by position and rank and sometimes race (besides Sanchez, who went where he wanted); to the equipment room; to the hotel; to the bar where Conner and the other younger rookies drank like high school freshmen, afraid that someone would check their fake IDs and they'd lose their shot, their only shot, right here—to it all, Conner carried the fucking black duffel bag, so heavy that he actually did some stretches in the morning before bearing his burden to make sure he didn't pull a damn muscle huffing the thing around, like he was in the goddamn army.

Enough. Conner felt agita rising within him, even three years later, as he entered the players' clubhouse and three attendants leaped up, asked what they could do for Mr. Belthaldt and if he needed help carrying his bag. Oh, this was the good ol' present. He was a good tipper. There was nothing like being in the majors after all the bullshit he'd had to deal with in the years before. He accepted a heated towel from the first attendant—a strange habit he'd gotten into during his brief foray in Triple-A—and waved off the second guy, who was reaching for his little gym bag, which had just some deodorant, a spare T-shirt, and, of course, his glove.

Yes, it felt like a long time ago that he'd been Sanchez's rookie and all that entailed. And soon Sanchez would be gone and there wouldn't be many people left in the organization who knew the stories of his old plight.

Conner sat on the stool in front of his locker, quickly changed into baseball pants and an Under Armour shirt. He liked being at the ballpark early, liked the rituals and ceremonies; maybe in a way they were something like the rituals his father used to have on election days, and especially special elections—the close morning shave, the coffee at Mimi's Diner, driving Mrs. Costanza to the polls whether she wanted to vote or not. It was good luck, his dad said. He'd always felt it was a throwback to the days when the political bosses knew every

by
MARK
CHIUSANO

corner, knew every household, could smell how the vote was turning by the way the scent of dinner was wafting or not wafting around the driveways, citizens back early from their civic duty. Conner shook his head. He took the stairs two at a time on his way to the field.

For his own pregame ritual he liked to see the field with no one on it, or as few people as possible in the successively higher levels of competition to which he had risen. He had developed the habit in travel ball as a kid, when there really was no one, and he could run laps between the outfield poles with his head turning left and then right, staring into the diamond and at the bases and his own spot, the pitcher's mound, empty in the middle. He'd envision how he would climb the mound, that small hill, how he would dominate it. He imagined that when he arrived on it, the field would still be like this, empty and serene. Meaning he would have absolutely no backup, no fielders to help him—it would be just him alone in the middle of it all, attacking the batter. A sneer would appear on his face. When you can do it alone—and he knew he could—what need had he for everyone else, of all those bouncing men behind him, stuck in their own strange tics and intricacies, grabbing their crotches and backsides, waiting for the next offering, the next pitch, his pitch? They were waiting for him.

It annoyed Conner to see that he hadn't gotten to the ballpark early enough. As he jogged down the first baseline to the outfield, he saw that there was someone already on the field, not even stretching or pulling at exercise bands or whatever the latest fad of the strength-and-training team was. No—the person was lying on the ground and he had a camera with him. It was Sanchez.

Conner considered detouring across the infield to start at the left field pole, but first of all, this was against his routine, and second of all, it would get him in heaps of trouble with the groundskeepers, not to mention the shortstop, a Japanese guy named Tony, whom Conner liked and tended to get along with, even though they had a hard time communicating. Worse, he saw that Sanchez had already pointed the camera like a gun in his direction and was snapping.

"Hey, rookie," Sanchez shouted when Conner was still near first base. Conner looked over his shoulder to see if anyone had heard, but luckily only a few security officers were near the field, and there was not even a sparse crowd in the stands.

Sanchez was lying on his stomach like a sniper, the old-school camera a toy in his huge mitts. His stomach, Conner noted, had gotten bigger over the years. It was time to retire, all right.

"Man, what a day," said Sanchez, sweeping one hand toward left field, floating gracefully to his feet. Conner wasn't sure how he'd done it. He'd heard the guy had been doing yoga and meditating even back in the '90s.

"What a good day," said Sanchez. "This is one of the good ones. I'm gonna remember this for a long time." He beamed.

"Glad you're here with us, rookie," he added. "I knew you would be."

He had ambled so close to Conner that he blotted out a little sun. Conner nodded and Sanchez slapped him on the shoulder. Conner staggered.

"That's my pitching arm," he whined. He immediately felt like a baby. But Sanchez always put him in a bad mood.

It was that fucking bag stunt. What a way to be introduced to your profession. He had been so excited to be there, so glad to have skipped college, so ready to learn from the pros—that's what the birddog had assured him, that it was a learning environment up in Milwaukee. He'd been ready to soak up everything from Sanchez and the older pitchers. But then the moment had come upon him, and the older pitchers were working on their own issues, coming off a disastrous bullpen year. And the little coaching they had offered always seemed to go to the other players. When they saw Conner and his black bag, they only smiled knowingly and said, "Be careful with that now, son."

During spring training, from time to time there would be a break in the middle of the day, and the position players would split back to the condos to horse around at the pool, while some of the more superstitious pitchers would simply go to their rooms to lie down and rest. Conner took this opportunity when he had the chance. He would lock his door and turn off all the lights, drop the bag in the middle of the floor, and, rather than relax, he would examine it warily, wondering what was in it, what

its purpose was, why he had been chosen for this bullshit task. He dropped the bag from the height of his waist, wondering if anything would break inside it. The soft material on the outside cushioned the fall and muted any sound. He crept close and put his nose next to the zipper, trying to breathe in whatever air was inside. He listened to hear if there was a timer or something electronic that might indicate if he'd opened the bag. The bag never revealed itself as anything more than a black bag. He'd try to do like the other pitchers did and close his eyes, keep out of the sun, and prepare for the next session. But the bag drew his malevolent attention. So he'd get up and turn the lights back on and page through his cell phone, considering a call to his mother, perhaps even to his father, just to gloat about how he'd made it, while his dad was back home telling stories to his Knights of Columbus buddies, all of whom now asked only about Conner, Shirley's best pitcher in at least thirty years. But, fuck him, he'd been no help. He didn't deserve the courtesy. Conner would text his mom and say, yep, he was doing great.

And then he'd carry the damn bag back to the field. He'd convinced a condo employee to help him out with a golf cart for half the walk, and then he'd ditch the cart just out of sight of the rest of his teammates and shoulder the bag as if he'd huffed the whole way. And somehow Sanchez always seemed to spot him the second he got to the dugout. Smiling that big grin.

"Thought we'd lost you, rookie," he'd shout from home plate, in a mask and pads or twiddling an enormous club. "Thought you skipped town." The other position players laughing, the pitchers averting their eyes.

There were no other players in the hotel corridor as he went to deliver the bag to Sanchez, interrupting his own nighttime routine. As he knocked on the door, he often heard voices inside, and sometimes there would be a beat or magazine reporter with Sanchez, sitting professionally at the side table while Sanchez sat on a chair—he was not that kind of creep. He'd be talking about what it was like to have a multicultural upbringing in Milwaukee, and even after years and years, the papers still ate it up. The reporter would exit and Sanchez would once again turn to Conner and smile his enormous smile that communicated what bullshit it

all was, at least that's how Conner saw it. And then Sanchez would say something like "You followed the rules today, right?" And Conner would say that he had and then Sanchez would say, "Okay, you're dismissed."

Then one day toward the end of spring training, Conner had had a terrible outing, one of his worst of all time—he'd never even considered that baseball could be like that, the way his pitches almost couldn't find the catcher's glove. (It wasn't Sanchez. This was late innings; Sanchez had long since gone to the hot tub or was taking in some afternoon community theater, which he told the beat reporters helped with his "process"—they loved that.) But Conner couldn't find the catcher's glove for location, and even when he located it, the ball never passed the plate because the hitters slammed it away. One pitch came flying back at Conner's head—right at his head—and it was only by luck that he dodged it. He'd never been out of control before. It was his mound, his world. These ants were meant to be mowed down, to get out of his story.

The pitching coach let him struggle for the rest of the inning, and he got out of it only when Tony, the shortstop, made two consecutive unbelievable plays deep in the hole toward third, stealing away solidly rapped hits. Conner went over to the position players' side of the dugout to say thanks to Tony, and for a moment Tony stared blankly at him while his interpreter whispered. Conner saw Tony's eyes wander to the black bag stashed under Conner's seat. Then Tony smiled and said carefully, "Okay, sorry. I hope you're back next year."

Conner huffed the bag back to his room. He dropped it just outside the bathroom door. He turned the shower all the way to hot and, despite having showered in the locker room just after the game, he got in and let the hot water seep in. The pain of it made him grimace. He found that he was crying. Then he was shouting, maybe voicelessly. The skin on his back was beginning to burn. In a rage, he got out of the shower, didn't turn off the water, didn't even put a towel around his body, because he knew Dominic was out, getting ready to party with the other successful players. He reached for the bag and with two hands ripped it open.

No smell emanated. There was no sound or alarm. Inside were a couple of fluffy white bath

towels. He pulled them from the bag's innards. The four packages revealed were so heavy they didn't even make it out of the bag. Without a thought of disguising his actions, he ripped one open, its cardboard and Bubble Wrap coating. The tape on it seemed ancient and yellowed. Conner's fingers hit metal.

It was a kettle iron, must have been thirty pounds. No words or markings, just black. Conner ripped open the other packages, found the same thing inside each. Then he dumped the bag upside down, and from the bottom a yoga mat flopped out. It slapped in place on the thin carpet, half unfolded as if it was offering itself for duty. Or shrugging. Conner thought this: Maybe it was shrugging.

by
MARK
CHIUSANO

It was all a long time ago, Conner reminded himself. He breathed. It'd been three years now. He had made it out of that cesspool, those minor league towns. Here he was in Milwaukee, finally. It was Sanchez Day at the ballpark, but it was the last of Sanchez's days here. Soon the park would be his, to make, to own.

Sanchez's big belly flopped out from under the T-shirt he was wearing, which was not tucked in. His arms opened like a split barrel. "Come on, rookie," he said. "No hard feelings today. It's a nice day."

Conner entered into that chest and those arms stiffly, like a little boy. He patted Sanchez once on the back and smelled the strange fragrance he was wearing.

Sanchez smiled as he withdrew. "Perfume," he said. "My good-luck charm."

"I've gotta do my thing," said Conner, pointing to the warning track.

"Of course," Sanchez said, "of course. You do you, you always do, and that's good, the way it should be. Gotta say, I'm gonna miss the little routines, the mornings at the ballpark, the first fans trickling down the grandstands…"

He trailed off. Conner smiled tightly and turned toward the wall.

He made a full arc of the warning track without looking back at Sanchez, and by the time he arrived at the left field pole and turned around, Sanchez was sauntering back toward the dugout, making marks on the exquisite dirt as he crossed the infield and waved to the groundskeeper. "Sorry, Joe. I'm real sorry.

I couldn't resist!" His voice floated over the expanse. By the time Conner had arrived back at the right field pole, Sanchez had grabbed a rake from the dugout and was smoothing out his steps, bullshitting with the groundskeeper, who went to hug him after they'd cleaned up.

Conner did his laps and let the annoyance drain out of him.

What he loved about the running was that he could let the wall guide him while his mind wandered. The wet dirt under his feet. The padded wall to his right and then his left. He envisioned the future unfurling. It was comforting to have the wall and the open field on either side, like he was sheltered from buffeting winds.

After five laps he went back into the clubhouse to stretch, to get a massage from his favorite member of the strength-and-training team, to change into his full uniform.

He wasn't slotted to pitch that day, but he liked to prepare for every game as if he were. They were using him in relief now; soon he would be a starter. His last few innings had been extremely successful. The Yankees were in town and he'd come in during the sixth, the Brewers' starter Louie was all out of gas and there were men on second and third and that monster Judge was hitting.

"All right," said Olafsen amid the tumult, "let's just get out of here with one or so." He handed Conner the ball.

But Conner was ready. He didn't even feel the emotions of the crowd or think about the men on base behind him. He attacked. He blew it by Judge, and then Stanton, and then the other Sanchez. He struck out all three.

They ran a little segment about it on ESPN that night, the rookie putting down Murderers' Row. And he had done it without craft or luck but with simple courage. Attacking with every weapon. It was his time, his time was coming. His dad texted later, said he'd seen it, just that.

Remembering the strikeouts put Conner in a good mood despite the inspirational Sanchez quotes blasting from the loudspeaker even then, half an hour before game time. How long before there was a goddamn book of them? Conner was en route to the bullpen, where he'd shoot the shit with the younger pitchers and visualize, visualize, visualize, when Olafsen stopped him and a few of the other pitchers and said with a smile, "You all can sit on the bench today, Sanchez's last day."

Like it was a gift.

No matter. He turned back to the bench, and he was there leaning against the railing as Sanchez walked behind the plate to catch the ceremonial first pitch. The stadium was packed now. Sanchez's young son was throwing, couldn't have been more than five. They set the kid up about ten feet from Sanchez. He fisted the ball almost directly into the ground. Sanchez sprang up, catlike as usual, grabbed it, and then he grabbed his son, swung him around, to the cheers and joy of the crowd.

"What a good dad," Olafsen said to no one in particular, shaking his head. The pitchers were all there, squeezed into the end of the bench, not used to it, nodding.

Sanchez brought his kid into the dugout. The kid was wearing a mini Sanchez jersey and a bucket cap. He kept one hand on Sanchez's dropped-down finger and the other on Sanchez's calf, so the kid kind of had to trot. It was pretty fucking cute, even Conner felt it. For some reason the kid ran right up to Conner.

"Are you—" he said before breaking off. He looked up at his dad again. "That's Conner Belthaldt," the kid said, pointing.

"That's right," Sanchez said, shifty-eyed. Conner had never seen him shifty before. "He's the one," Sanchez said in a strange voice, looking away.

"Wow," said the kid, drawing out the w's, staring up in awe at Conner. And then Sanchez smiled swiftly and swept his kid back up into the air.

Everyone in the dugout was studiously not looking at Conner. He was in shock. He had a sinking feeling, the kind you get only when you receive a compliment from an enemy: Is this a trap? Was I mistaken all along? And then the effect of the anointment washed over him. Suddenly he felt the air in the dugout turn, as if seconds ago he had been a rookie nobody and now he was the front-runner. He had a target on his back.

Was he ready for it? Sure, he might be. He hadn't known it would come so soon. It was all he'd wanted in life, but he didn't know it was going to be so oppositional, so rise and fall. He reached for his warm-up jacket and put it over his right arm even though he wasn't pitching.

The game started. The whispers had gone through the pitching staff (none of them talked to the position players—naturally, this would have been bad luck): Sanchez had two at bats, that was it. Then the old hero was going to go up into the broadcasting booth and have a little fete, get ready for a speech after the game, talk about the few contests they had left in the useless season, how he'd be smiling from the bench in early retirement.

Sanchez was up third in the first, as usual. Tony the shortstop had legged out a grounder in the hole for a single, stolen second. Conner sensed that the crowd knew Sanchez was going to bring Tony in. The sound of it was new to Conner—he'd been in a major league dugout only a few times: usually, unless you're pitching, you're out to pasture in the bullpen. And he'd never heard everyone on their feet like this— like a storm. It reminded him of the sound of the waves at Jones Beach in late September, when he'd been able to convince his dad to drive him there and watch the surfers, though his dad never let him surf. Conner stirred.

The crowd was indomitable. Conner thought he could feel the sound within his jaw. He saw two of the older pitchers talking closely and nodding at him. He felt the target, ignored it. It was a 0–2 count for Sanchez, and Conner knew that of course the next pitch would be high, it would be a ball, it wasn't his or Sanchez's first rodeo. He was hardly watching what was happening, because he knew it would be a wasted pitch. But maybe Sanchez was nervous, Conner considered, or overanxious, or just over-the-hill, because he took a hack at the high one up around his teeth. The mighty Sanchez barely got his bat around in time; the ball dropped and dribbled toward the pitcher. It didn't even get that far—Sanchez's counterpart, the opposing catcher, leaped up and nabbed it, threw him out easily. Sanchez hustled, you had to give him that.

As he turned toward the dugout, Sanchez waved, smiling at the crowd, shrugging. The cheers were deafening. It was just a joke. There was another at bat.

But Conner had a bad feeling rising. He saw that something was changing out there even if no one else knew it. He muttered under his breath.

"Come again?" Olafsen asked.

"He's not gonna get a hit," Conner said.

Olafsen laughed. "Okay, rookie, we'll see," he said. "Just you watch. You're about to see

some magic tonight at the ballpark, I guarantee you that. It's a magical business and there are moments of glory in it, you just better hope you have a moment like Sanchez is gonna get tonight."

Olafsen moved to the other side of the bench.

Conner waited. He was certain, and he felt dread. He knew he was to blame. He had a bad feeling. His heart was stuck on his spikes.

The game dragged on. Neither team was touching the other's starter much; there was only a ball or two hit hard. It was 0–0 going into the fifth. Sanchez didn't have a chance to throw down to first or second with a live runner, though he made a big flair of a warm-up at the top of the fifth, rearing up and gunning like there was nothing left in the world. And then it was the bottom of the inning and there it was, with their eight hitter on third after having drawn a walk and been bunted over. Tony with another liner up the middle. First and third, two outs, and here's the God again, Sanchez rising, someone must have brought the kid back out from the bowels of the stadium, because there he was, sitting on Olafsen's lap, chanting, "Dad-dy, Dad-dy," and it almost looked like the fresh meat that Cincinnati had sent to pitch up there was afraid of the moment, the crowd absolutely bonkers, or so it seemed to Conner. Maybe this was why they rarely let pitchers into the dugout. Conner thought about the origins of that word, *dugout*—like a war, hunkered down. But it was all positive for Sanchez and he stepped out of the box, waved to the crowd, allowed them to roar in response. "Dad-dy, Dad-dy," chanted his kid, and then the first pitch was a little low and Sanchez watched it go by, and now everyone was bloodlusting. Olafsen raised the kid up off his lap so he could address the rest of the dugout. "Men," he said, "what you're about to see here is a lesson," then he looked hard at Conner, glaring, the heir apparent, the kid following Olafsen's gaze toward Conner, too, and then the kid ran over to Conner, threw a hand against his knee, said, "Lift, help," and there was Conner, raising Sanchez's son. And then the pitch came in and Sanchez's arms flexed and the Midwest held its breath, the wrists, the swing, the connection, that defiant and national crack of the bat, the intake of air from fifty thousand throats as Sanchez popped out in foul territory around third.

by
MARK
CHIUSANO

* * *

Conner would remember it forever, the feeling he'd had in Sanchez's hotel room that long-ago spring morning, of freedom and a promise. Sanchez opening the door stone-faced and then erupting into a smile when he saw that Conner was carrying the yoga mat and the emptied, open fucking bag.

"Rookie," he said. He had a bath towel around his waist; his bare chest was denuded of hair. Maybe he'd shaved it. Conner barged in.

"Congratulations," said Sanchez. "You're the first one. Nobody's ever opened the bag before. And that's my first lesson to you: That if you want to be a real pitcher, if you want to get your name in the starlight, if what you're looking for is eternity and a Cy Young Award and the magazine covers, you have to break the rules, be a little nontraditional. You have to murder the opposition. This is a battle and the others are just drafted into it, you have to be the hero and the voice and the world."

He was dribbling on like that and there was nothing Conner could do to stop him.

"Now you can continue down the path laid for you," Sanchez was continuing. "All of your tools are in that bag. Here, let's begin: I'll show you the exercises that are necessary, the way to keep your body and mind sharp and fit over a long season, to make every five-star hotel room—yes, there will be five-star hotel rooms—your home and gym. I'm glad you made your choice so quickly, because I have a few years left in this league and in this earthly body, and I'll be here for you. I've noticed that you need some work on your change-up, by the way. We can put that together. I think it's gonna be a hell of a career for you, I really do."

Conner turned and walked toward the door of the hotel room, his knuckles grazing the frame. He turned around. "I don't need a father," he said to the great Sanchez, and then left him behind.

A FRESH START RUINED

by Chelsea T. Hicks

The Monday after Marie married her boss, she went into his office and told him supper would be ready at six. "Sales reports?" he asked.

She hesitated, the skirt of her dress swishing nylons. "Done."

"One more thing." Jim hung a cigarette from his lips and tapped the corner of his mouth.

Marie kissed him the way he liked, lips extra soft, no spit, then slid the keys off his desk. He said nothing, so she bit the smile from her cheeks and walked out of the office. No one ever drove Jim's Pontiac, but here she was, stepping into the parking lot an hour earlier than usual, tracing the creamy paint job, her new diamond ring reflecting sun off the hip bone curves of the hood. Her eldest son and his wife would be envious when they saw the car tonight. Meeting a new daughter-in-law on their own first night home as newlyweds was not ideal, but nothing about her life was ideal, except for Jim. She rolled the windows down like she didn't care and drove home to check on her seven-year-old.

He was supposed to come straight back after school, no more roaming the neighborhood, what with dirt-caked elbows and baseball bruises. This was Jim's new rule, delivered the same easy way he told her he'd lie and tell the county clerk he was Cherokee if they so much as eyed her funny. At Johnstone Avenue, she braked for the light and a teen boy clacked up behind her with the gusto of a horse cop. He walked by, swinging his hips in gabardine and dress shoes, pounding the sidewalk with a sound like doll-sized gunshots. His gait reminded her of her first son's father. The light went green and her thoughts moved away from her and seemed to occur on the windshield. An ache grew between her shoulder blades, the ghost of all her past and future selves. There was no one behind her, so she changed lamé pumps for loafers, took three aspirin, and sped away from the sense of unreality that was meant to stay on the before side of the marriage.

A white owl flew from a tall cedar and floated low over the lawns where sprinklers stuttered into tiny rainbows. She reached her dingy limestone, where the bike-free yard confirmed her latchkey kid was out, and went directly next door to ask the redhead nurse if she'd seen him. The door opened on the fifth knock, and the neighbor shook her head no, David John wasn't in the living room trading stories for pie. No one else even opened their doors. All down the block, women hid behind peepholes, mixed-bloods hating her the same as the whites they resembled, each identifying her as Indian divorcée. They saw her and thought of her dates with so many men—Marie What's-Her-Name from the Osage, an outcast in tight clothes and careful makeup. As if their town of Bartlesville wasn't for Osages—old Kawazhi Dawa, "Little Horse Town."

She turned onto Osage Avenue and went down that block, knocking with diligence, but still no one opened. Maybe this was punishment for turning from Mrs. Groves into Mrs. Haydon in the span of a year. She faced the yellow-blue sun-fade and went home to call her ex-husband, Frank.

His new wife answered and said they hadn't seen David John since July 4.

Marie thanked the severe lisp of a woman and hung up.

At her son's age, she'd had a dead mother, a disappeared father, and an aunt who hit her daily, but she hadn't run away. She went back outside and bellowed his name from the porch.

Wind blew the flush off her skin. Jim would be home any minute to reduce her to Future Mother, Incapable. He wanted a son of his own, badly, and she could see him rationing affection like ice into dinner party glasses, a kiss here, a hand-squeeze there. On the third date, he'd said he wanted to make so much money he could pay for a full tomb, like Jesus's. Jim said his mother's love was like a mink stole but Marie knew her love was even better. She felt love like water: it went everywhere—dispersed, evaporated, gathered overhead until it flooded everything. Currently, she was in love with her husband's on-time arrivals, combed hair, and steady sales quotas. Six dates in, she still wouldn't go home with him, because rejection made her more than secretary-flavored candy.

"Someone needs to oversee all this." That's what he told her when he proposed.

It was true that she was full of peo a^katha, as her grandmother called it. Know-how. In loving, keeping house, rearing children. She'd have to work harder to make up for being on her second time around, and a missing son on day one could start the fight that would begin the end of the marriage.

She descended the steps, walked the driveway,

A FRESH
START
RUINED

by
CHELSEA T.
HICKS

and slammed herself into the car seat, the cement whirling at her in a bout of vertigo. Clouds piled above the rooftops and a train screeched in the distance. She buckled, revved, and reversed toward a man in her rearview mirror. His car was parked in front of her yard, and he appeared to be fixing the inside of his truck door.

She got out to ask if he'd seen her son, but just then the telephone rang in the house and she ran back inside, leaving the engine running in the driveway.

It was her ex-husband.

"I haven't called the police yet. Have you seen him? Is he there?"

"No. And he's your goddamn responsibility."

Marie pictured the striped overalls she'd sewn for the baby that had turned out to be Vera—the second daughter, whom Frank had wanted to be a boy. It was usually Vera's job to find David John, but piano practice had spared her today.

The receiver crackled with a bop and a thud, the dropping of a heavy tool.

Marie made a fist and matched it to a pink rose on her wallpaper. "I married Jim."

"Marie, what in hell happened?"

"I took him to the Arkansas office, where they don't ask for a birth certificate."

"I mean, what happened to our son."

"You don't have to always treat me like a wad of crap."

"Call if he doesn't come back tonight." Frank hung up.

Marie nodded to the dial tone. She'd spent years plying his miser's smile with pie and chicken-fried steak, but she was done the moment Vera grabbed onto his supper chair at three years old and he shoved her. He'd justified it, saying, "It's too goddamn salty!," but Marie ripped off the locket containing his photo and dropped it into his gravy. When Vera was born, Frank had handed her back and said, "Is this mine?" He spoke in anger, all Neolithic brow bone, tall, angular, severe, mangled left ear, one-quarter Cherokee, three-quarters Irish, with a full frown deepening into early wrinkles.

She pulled the phone to the floor, dialed the police, and filed a report.

Then she called her half-brother, Billy.

He picked up on the first ring. "Marie?"

Her brother's voice was like a valve releasing her. She cried, sputtering out that David John was missing, the neighborhood women wouldn't help find him, Frank had insulted her, and now she was married to Jim, who didn't know David John was gone and would not understand, and on top of it all Roy was coming with his new wife for supper and she wasn't ready.

"I'll be damned!" Billy was the only person she'd told everything to, down to the very end, when Frank had insulted the smallness of her eyes, the freckle on her right foot, her hairless arms, the bridge of her nose, the shape of her breasts. "Well, how long's the kid been gone?"

"Hours!" Marie's stomach shuddered like a twitchy eye.

"Well. He'll come back. Ask me how my cattle been. Get your mind off things."

Marie pulled the phone cord tight along her leg. "How are they, Billy?"

"They've been asking the same thing about you."

Marie's laugh bounced in the receiver.

"I ran away at DJ's age. Wrapped cheese in a bandanna on a stick. Call when he's back?"

"Okay. Love you."

"You, too, kid."

They hung up and the living room filled with the ticking of clocks. Her son's head could be split open on the concrete, bike slid down into a gully. He might have tried to dodge a car and ended up smashed between a lamppost and a fender. The old sadness crawled up her shoulder blades, around her neck, and lodged itself in her mouth. It was the same feeling as ever: romantic in fall; hard in winter; worst in spring, except when she was in love; fullest in summer, when it wore her like a thick coat, crushing with heavy time. If she pushed all her attention into some object, the sadness would gather in her hand so she could wear it compact like a pretty brooch. A spiderweb shook on the sill. Marie gazed hard like she would become silk. She was still covered in a grief that laminated her from happiness and made her untouchable as a field of butterfly wings. Spiders could drop from the roof and carry her away and she would believe it was as unreal as everything else. That was better than crying until her eyelids were swollen and she had nightmares of child demons with round faces and slick skin. She stood as night bloomed with a power-sadness-rage in her.

A knock sliced the air and she jumped, hand-over-heart rattled.

She ran to the front door and yanked it open to her son and a tall bald policeman. She sank and hugged him with a low moan, but he was wet. Black asphalt imprinted them both like a fresh coat of spray paint. Her white dress was ruined.

The policeman offered her a handkerchief. "Mrs. Groves?"

David John grabbed her hand. "Her name isn't Groves! It's Haydon."

"Mrs. Haydon, then."

Marie stood. "David John, please." She accepted the hankie. "Thank you."

The policeman had caught sight of the Cassatt copy over the mantel, a painting of a mother feeding her baby, one breast uncovered. His gaze went to Marie's stained chest and he flushed. "Your boy here was out on Hillcrest, covered in fresh-laid road. Bike wreck. His sister cleaned him up. Her boyfriend banged his bike wheels back circular too."

"Boyfriend?" Neither of her girls had a boyfriend. Was Lora sipping tea off Hillcrest, a letter jacket pulled over her lemon-yellow sweater?

David John was still as a sentry, hands in fists.

Marie pulled him inside and thanked the officer again.

"Sure thing." He winked. "Runaways is regular. Don't take it too hard."

Marie nodded, said goodnight, and shut the door.

David John plopped onto the couch and shoved his hands between his legs.

The skin of his left arm was shades lighter than his right. Last night's bath had been so much splashing and this, the arm, was all that had been washed.

She gripped him. "What were you thinking?"

His mouth drifted open.

"You know what Jim says about mouth breathing!"

He closed his mouth with a look of hatred that pulled on her as if they were magnetized.

"Tell me," she said. "I feed you, clothe you, get you little presents, make sure you're taken care of, that you go to school, bathe, but do I get any thought from you?" She was unfurling out of the cocoon of her body, sending out heartbeats, but he just sat there squeezing his dirty forearm and then watching the handprint fade. "Look at me!"

He showed her eyes hard as metal and flattened his lips.

"You will respect me, and that is the first thing you will always do."

His eyes fell away from her.

"Do you know what it is to be Osage? It means to show respect."

"Great-Grandma said it means 'Name Giver' or 'Water People' or 'Perfect.'"

"Don't interrupt me." She walked to the mantel, where a portrait of David John in a suit sat beside a daguerreotype of her grandfather wearing a severe look after a council meeting. "Being Osage means things need to be done correctly. You didn't want to wear that suit, but that's what respect is." She tapped the frame of her son's picture for emphasis, but it fell and bounced onto the carpet.

"To step in the arbor, one's ribbon, beads, yarn, and pleats must fall just so. Perfect, or not at all. So with this house, so with you, so with our life. You will not run away again, ever, so long as you live. Roy's married and long gone, and Lora's one foot out the door. You think you're going to be all gone now too?" Marie stood tall with her words. "Don't shame me. Not in front of the whole neighborhood, just as we begin a new life. Now go to your room."

He obeyed, slump-shouldered and disorderly as a puppy.

She was doing her best by him, correcting where needed. For Lora, it might be too late. She was on track to go repeating after her mother. Infatuation, baby, dropout, move, marriage, divorce. No, Lora could not have a boyfriend.

The doorknob whispered with the near-soundlessness of Vera's touch and Marie stood, her bare foot crushing the fallen picture frame. Glass shards entered her arch and blood covered her son's image. The pain came last, like a thin needle.

Vera stood in the entryway, speechless, with piano books under-arm, pink sweater smooth as cotton candy and draped in angles over her hips. She looked down as Marie picked the glass from her foot.

Pressure moved behind Marie's eyes. Her vision edged in gray. "I need you to fry up some chicken."

Marie never let Vera cook but Vera nodded like this was normal.

"Fried chicken is page one hundred ten in the Lookout cookbook. Boil potatoes, beans."

Vera left the room in a silent glide. Marie had always liked this way of not speaking. Her

by
CHELSEA T.
HICKS

too-perfect second daughter, who hadn't uttered a word until she was four years old. There had been self-possession in it, breaking into fully developed speech at the last possible moment. David John would never be as composed as she or as responsible as Lora, but he would learn respect. Two men to leave her, one mother to die, and she asked for one thing: a son to love her. She ran her fingers along her leather belt, beaded in a beautiful chevron pattern of red, yellow, and blue with accents of white and black, and then slid it from her waistband.

He was facedown in the center of the bed when she walked in. She whipped him twice, hoping it would be enough, but he did not make any sound or movement, so she lifted the belt again and whipped him once, twice more. It was necessary that he cry, to show remorse, or else it just hardened the child. He wriggled as she lifted the belt for a final strike, and the master thread holding the beads broke in midair. Beads of red, white, yellow, black, and blue scattered across the floor. They caught in the blue folds of the quilt. She hesitated, the belt flopping back in the air, and then she lowered it with a final snap. David John began to cry and she released her breath. If only he had felt repentant sooner. Beads rolled into the baseboards and lined the windowsills. She dropped the belt.

Vera opened the door, trailed by the waft and sizzle of frying. "I did the chicken and boiled the vittles like it says. Can I go practice French at Ada's house?"

The bow on Vera's braid was undone. Marie retied it. "Fine. But be back for supper."

Vera closed the door and Marie sat on the edge of the bed and hugged David John.

He hugged her back weakly, not like her eldest son, who was clingy as lint but so strong. Roy and Julie would arrive soon. She had to wrap this up, immediately.

"You have your Echo's hair," she said, and rocked him like the other mothers did, correcting bad little boys and girls. "You're a little Indian boy. You be proud."

The choke of her Cadillac entered the driveway. Her foot was still bloody and she needed to change her dress. David John hugged her tighter and rubbed his sweaty black curls on her stomach.

"Why do you spell it *e-c-h-o*? We learned about long *e*'s. It should be *e-e-k-o*."

"Go and wash your face for supper." She pulled away from him and stood. Her dress was still covered in tar.

"Mom. Roy is coming tonight, right? With Julie too?"

"Yes," she said, and then shut the door to his room.

Jim was already on the entry mat, untying his shoes. "Why was my car on?"

"Oh." She got a sweater from the closet and buttoned it up before Jim stood. "I've been preparing for Roy and Julie. I'm so nervous."

Jim held her at arm's length and squeezed her arms three times, a code she didn't know.

"I'll make it the last time," she said, and tried to kiss him, but he held her back.

"Why are you crying?"

"I'm not," she said.

David John thudded in, still tear-streaked, but now in boots and holding a rubber lasso.

Jim released Marie and squatted to David John's height. "Hey, you."

David John smiled. "Hi. Want to see my drawings?"

Smoke singed Marie's nose. "Do you smell that?"

David John rolled his eyes. "Been smelling it forever." He dropped the rope and ran.

In the kitchen, Marie found the burner still on, the range hot, and all the thighs charred.

Headlights entered the kitchen through the sink window.

"Roy and Julie! Already." Jim cracked the window and aired the kitchen out.

Marie ran to hide his shoes. This was her first time meeting her son's wife, and she wasn't prepared. She squared her shoulders and tried to make her face seem relaxed. It was easier, following Jim in his lazy walk, three-piece suit still creased at the knees. He gave her a quick kiss by the door. "Why don't you teach Roy's new wife how to fry pork? As a wedding gift."

"Good idea." She kissed the stripe of white hair sprouting from his temple and they stepped out to catch Roy in the driveway, holding a casserole dish with one arm and his wife with the other.

The wife turned. Her purple skirt opened like an evening primrose. "Mr. and Mrs. Haydon!" She clasped Marie's hands and gently scratched the backs with pink pointy nails. "I made stuffed chicken divine," she said, and smiled a row of Cheerio-sized teeth.

Roy looked wind-tousled, hair an inch past the ears, shoulder blades arching with nerves.

"Aren't you going to hug me?" Marie asked him.

He presented the casserole dish filled with chicken and cheese and shrugged.

She took it. "You look well, Son."

Jim shook Roy's hand. "I assume the drive was good." He removed Parliaments from his jacket pocket. "Got your favorites."

Julie *ooh-aahed* the tea roses growing around the chimney stack while the men established themselves on the porch to smoke.

David John came out and flicked the rubber lasso over the landing. "Hullo, Sis."

Julie gasped. "You're David John!"

"Yes." He flicked his whip like a snake tongue.

"And where are my other new siblings?"

"Vera will be back for supper, and Lora is Daisy Mae in the high school parade."

"Your sister is in a parade?"

David John turned a devil's eye on Marie. "It's Sadie Hawkins. Not for married people." He flung the lasso at Julie's ankle.

Roy picked him up. "Watch it, Crockett. You hear?"

David John headbutted Roy. "Make us go to the parade! Please?"

Julie pulled her skirt down. "Let's go inside. I'm cold!" She led the way to the kitchen, guessing at where it was, turned the oven on, and put her dish in without waiting for it to pre-heat. Time was moving too fast for Marie to keep up, so she said nothing and situated herself in the corner of the kitchen, near the entrance. The wall and counter held her neatly. Roy passed them and went to his Echo's framed fan in the hall.

Julie watched with a keen eye. "Roy says you come from a chief? Your ancestors must've been so noble."

Jim came in last and pinched Marie's hip, then scooted into the kitchenette booth. He crinkled his cheeks in the salesman smile and gave Marie a look like she was a movie.

Julie giggled and took a seat across from him.

His smile deepened. "On our first date, I ordered Marie a gin and tonic, not knowing she doesn't drink. She said it smelled like juniper, drank it to be polite, and then she told me her ancestry. I couldn't believe it." Jim sat back, dragged on his cigarette, and blew some smoke in Julie's face. He crossed his long legs and cocked his head. "It's just one of those things."

Roy moved farther into the dark hall and stopped in front of a black-and-white picture of his dead Echo. He'd always lamented what he had never known: a departed grandmother, an unknown father. His silent stare made the air heavy, and Marie could feel Roy forming the question, once again, of who his father was. She usually deflected it, but with this new wife ruffling around like a pretty bird, Roy could corner her with the rules of politeness.

Marie looked to her daughter-in-law, expecting interrogation, but Julie folded her hands in the posture of confession. "Roy and I have news."

Marie covered her mouth with her hand like a scolded child. "You're not pregnant?"

Julie smiled toward the ceiling, cheeks dimpling. "I am!"

Jim put his cigarette out on a tea plate in the center of the table. "Well. Congratulations. Who could top this? We're married and now there's a new one coming into the family."

"Thank you," Roy said to Jim, his tone an inch short of *you're not my father*. He then looked at Marie and dragged a hand over his brow so that his hair appeared to recede. "And, Mother, my wife might like to know. Just how Indian will the baby be?"

Julie put a cigarette in her mouth and asked Roy to light it. Both of their chins turned orange from the lighter and Marie remembered the Osage word for "orange," *ze zhutse eko*, meaning "red and yellow, like that." Roy watched Marie from the corner of his eye.

"If you're asking about the baby's blood quantum, my mother was a quarter-blood, my Echo is a quarter-blood, her Echo was a half-breed, and her Echo was the daughter of Chief Pawhuska. Roy isn't enrolled. But he's Indian, and any children you have will be Indian."

Julie got up and nodded with a flounce of her skirt, then opened the oven. She found oven mitts in a drawer, took one out, and dabbed the gelatinous fat in her rubber chicken supper. Jim dusted off his hands and asked Roy how he'd proposed. Marie didn't hear the answer over the sound of David John entreating Julie to watch his skip jumps. She plated the food and lit six blue candles with a sulfuric rush of matches. They all sat and Marie said a blessing, which Jim tolerated in open-eyed silence. Everyone

by
CHELSEA T.
HICKS

ate without speaking until Julie commented on the prairie grass colors. Half of her plate was untouched and the other half was bone clean. Marie focused on chewing twenty-six times, so as not to rush. On the eleventh bite, she realized that Vera had never come home to supper.

"David John, go run and tell Vera we're eating. Hurry, before it gets cold."

"Is she in trouble?"

"No." Jim nodded at the window. "Go check first, Son."

David John ran to the drapes and threw them open. "It's dark!"

"That's right. And we never go out when it's dark." Jim gave a quick smile for everyone at the table. "Vera can enjoy dessert with us when she comes back."

Marie's chest burned with Jim's correction. She swallowed all her anger except a blush and forced a smile. Everyone was eating peacefully, anyway.

"It's very good," she said.

Julie finished, too quickly. Marie told David John to go take his shower when he was done, so that he'd set the house into a whir of hot-water pipes and drown them all out. The men asked each other questions about work for the rest of the meal, and once everyone was finished Julie began clearing the table. Jim invited Roy into the living room and closed the French doors separating the rooms like windows and Marie watched them open a box of chocolates. They wanted to be untouchable, a silent movie in Technicolor, but they were both cowards. Roy lifted a chocolate to his lips and Jim arranged logs in a tripod over a pile of smoking newspaper. Fool men, oblivious, caring only for food, comfort, control. Tonight they deserved exactly none of it.

She removed the clip from her twist, pulled curled tendrils around her shoulders, and pushed open the French doors with her toe.

Roy settled farther back into her favorite toile chair beside the first blush of fire.

Marie pinned him with her eyes. "You used your wife to ask, because you wanted to know, but I don't want you discussing it with her any more than you discuss it with me."

Jim deposited a round chocolate back into the box. "What are we talking about?"

Marie took a step closer to Roy. "You're an adult. Don't hide behind your wife."

Roy folded his arms tight around his middle. "What's his name?"

The fire settled in its first break. "I just can't talk about it," she said. A twinge curled in the middle of her head, as though her brain were rearranging itself. Pain entered her heart like small icicles.

Roy stood. "Please, Mother. We're here all the way from Texas. Who is he?"

"Why did you move so far away in the first place? Just to get away from me?" Wood popped in the fire, and the fallen picture by the mantel caught her eye.

"That's it. I'm not doing this."

"Wait," Marie said. "Please. Don't go."

Julie was blowing out the supper candles, smoke encircling her like a halo.

"Julie, let's go! This trip was pointless."

She entered the living room in a solemn walk and took Roy's hand.

Marie sat on a corner of the red couch. Her body felt so small, as if she were shrinking. If they made it all the way to the door, she might disappear.

"I'll tell you if you'll just stay," she said. She thought they wouldn't hear, but Roy turned.

He looked at Julie, and they waited.

"Jean. His name is Jean."

"Jean who?" said Roy.

"Tallman."

Julie and Roy went to the chairs opposite Marie and sat. "Tell me about him," said Roy.

"He was my tenth-grade teacher. I never told you, because he hit me. When I told him I was pregnant with you." Marie imagined Jean's hands on her, back against the bark of the tree, body exploding like a star until she was bruised by the rub and slide of right and wrong every night of her sixteenth winter. "I realize now that he took advantage of me. Aunt Cherie kicked me out. When I told him about you, he gave me pills to end it. I wouldn't take them, so he hit me."

Julie's face was blank as a doe's. Roy stood but he was so flustered he lost his balance and knocked the chocolates off the side table. A cherry cordial fell onto the picture of David John. Marie looked out the window and felt the emptiness of her head, hollow as potpourri. Out front, the same man was still parked by their mailbox, now with a woman in the Chevy, her hands moving like sign language.

"Can't we all just be happy?" Julie pleaded.

Marie turned back to Roy. "If you can't feel that winter in your blood, there's not much else I can say to you."

Julie moved to the edge of Roy's chair. "Should we go check in?"

Marie willed Lora to come home, act the Daisy Mae, flirt with everyone. Even Vera would be a help in this situation. The only good thing in all this was how Roy was Osage on both sides, not like Vera and David John and Lora, who instead had tribes she knew nothing about.

Roy was leaving again, getting his keys from the entry table.

"Don't go! I'll make up the sofa. I can make coffee. There's fresh pie; Lora made it." Marie's eyes filled with tears. "You have to stay until Lora comes home, at least. Please."

Roy opened the front door and cold air rushed in, along with Vera, holding the mail.

The red font of the BIA quarterly check matched the roses on her blue cotton dress.

"Bonsoir. Je rentre. Good evening. You must be Julie?" Vera extended a slim, icy hand to Julie, who complimented her dress and asked if she wanted a ride around the block in their car.

"We were just on our way. I'm sorry, we ate without you."

David John came out in pajamas. "Are y'all going driving? Roy, will you drive us out to Okesa? Then we can get some Indian paint pods that Lora won't get me and play Cowboys and Indians with face paint, but I don't want to be the Cowboy—you do it, Roy."

"Enough," said Roy. "We're going. Vera, it's nice to see you."

"Going where?" Lora crested the porch steps in singsong. When she saw Julie, she laughed. Julie reciprocated and they embraced like long-lost sisters. Vera stepped back like an interrupting acquaintance, and David John groaned. "Let me in!" he said.

Lora gave David John a quick squeeze and then picked him up.

"How was the parade?" Julie asked.

"Good," Lora said. She took a small brown rock with a bulge on the tip from the pocket of her skirt and offered it to David John.

"My paint pod. Where did you get it?"

"That boy from the football team finally went fishing." She turned to Julie. "Our ancestors used to break it open and use the powder in here for face paint."

"How exotic!" Julie said.

David John offered the rock to Roy, but he ignored it. Julie clutched Roy's hand like she was afraid of them all. Roy looked hurt, though Marie didn't understand why. She couldn't keep up with the chaos this family spun.

"I'll boil water for tea," Marie said. As soon as she left them, Julie began talking, free and easy. Roy said something about the Phillips Mansion, and everyone erupted in laughter. She didn't even know what they were talking about. Why had it become a real party the second she'd left? David John followed her into the kitchen and begged her to try coffee, but she said nothing.

Vera came up behind him, and David John drew an invisible arrow from an imagined quiver and strung it back. "Your chicken was burned! But don't worry. You smell good. How are you so shiny? Shiny, and doing nothing."

Vera started lecturing him. "I did all your jobs today, DJ. Why are you even awake?"

Marie gripped the sink and ignored them. She needed to think of something happy. Jim had told her that morning, while she stood over the same sink, that she was like the best mood of his life, warm weather making a second spring at the end of fall. She'd had no idea he was so poetic. They could be a better family with new ways. Here was Vera cutting the pie, Lora joining her to plate it, and David John suggesting different-sized forks and napkins and a kind of tea that Marie didn't have. None of them knew that she had been looking for David John all day, racing the sun, combing the neighborhood, spitting into the creek that was her life until it became a goddamn waterfall. She wanted them to get out of the kitchen.

Then she remembered Roy and Julie. "Are my children staying?" she said.

"They went outside with Jim," Lora said. "Can we eat in bed? I need to study."

Marie didn't answer. The sound of an engine bobbed. She ran to the front porch as Roy was backing his car out, staring at the rearview mirror like there was nothing else in the world. Marie chilled like a quick breeze on sweat. The ground seemed to pull at her. She had to grip the window frame for strength, but Jim grabbed her around the waist, turned her, and held her face to his. She touched his head carefully, like a pot

on a clay spinner, and let him pick her up, hands pressing her into a tighter, more manageable self, one that held together and fit him. He took her into the house, and she hoped the children would see that she had a good man, but they had already retreated. Jim pushed his mouth onto hers and put her on the bed and she let him struggle off every bit of her clothing down to her stockings, still caked with the blood from David John's portrait. Jim's kissing was quiet as a swim in a cold pond and she cried because she wanted him so. When they separated, her lips opened and she slept with the old dream of her mother's funeral, burrowing under trade blankets to the sound of Echo's talk.

"Mina," she said, over and over. "We are not Ganitha. We are not of chaos."

by
CHELSEA T.
HICKS

A LITTLE LIKE GOD

by Molly McCloskey

In the mornings, my bed was littered with skin. It was like sleeping with a molting thing, or a being that had passed the night evolving. I thought of tails or fins abandoned in the bedclothes. After he left, I'd shake the sheets out the window and send flakes of him over the brick patio, where they were carried on the breeze into the grass quad adjacent to my house. There were students down there—there were students everywhere, flawless and blank-eyed, plumped on fructose and a feeling of entitlement to they weren't sure what—and I loved the thought of it, the runoff of last night's friction, the acid rain of middle age drifting down on them.

The first time he stayed the night, I couldn't tell what was happening. I don't mean the sex; I mean after. He slept vehemently, violently, as though he were undergoing something, electroshock or the return of buried memories. One minute his breathing sounded like a small motor, then silence, then a sudden snorting. He would kick, shudder, flip himself over suddenly and completely, as though someone had turned him with a spatula. It looked exhausting. In the midst of all that action, I slept hardly at all, and rose the next morning bleary-eyed, while he awoke rested and refreshed. Apparently, it was not exhausting.

He was a year back from Afghanistan when we met, one of those wars Americans had begun to lose track of, so that people sometimes forgot whether we were still fighting it or just advising others who were fighting, or pretending to advise them while we fought it, in secret, ourselves. He had just turned fifty, which seemed old to me for a deployment, but he'd been on the medical side of things—gathering intel on threats, everything from snakes and fungi to weaponized chemical agents—more than on the front line. Not that there was a front line, as such. Or maybe there was. What did I know about how battles were fought? I was an English professor who'd spent my entire adult life abroad. I had once worked with a colleague in England designing what she'd called a "vet-friendly curriculum," which had prompted me, for a time, to think about the mental lives of people who go to war and about what literature might owe or could offer them. But that wasn't like knowing them. It wasn't like finding flakes of one in your bed, having him flop like a fish next to you all night long.

He said that when he came home from Kabul, they'd put his unit in some anonymous hotel in a flyover state to decompress. He'd lain on his bed with the AC maxed, drinking beer after cold beer and watching the Shopping Channel, where an ad for doggy stairs showed elderly and disabled pooches ascending to luxurious beds.

"Fucking doggy steps," he said, and laughed with a strange sort of joy. "I knew I was home then."

I wasn't long home myself when we met. I'd been gone twenty-five years. I had left for graduate school, then gotten a teaching job in Dublin. I had just taken a one-year visiting gig at a university in DC, and I was half hoping they would offer me something permanent. A ten-year relationship in Dublin had ended. Every winter had felt drearier than the last. And I'd grown tired of being foreign, tired of the performance of my foreignness, which consisted largely of trying to underplay it without seeming apologetic or too imitative of the locals.

I was given a house in Foggy Bottom for the year. It was the tail end of August when I arrived, and the city felt tropical and fetid and buttoned-up. I couldn't get a sense of it. Some mornings I walked the length of the Mall, and monuments appeared in my path as though I were living in a pop-up book. My neighborhood sat at the city's lowest elevation, where the heat hung like in a bayou and the rats were bold. One night I watched two of them fighting on the sidewalk outside a restaurant. They rolled and tumbled like cats, like cage fighters. I couldn't tear myself away. It seemed the most savage thing I'd ever seen. On our first date, I described it to him, in exaggerated detail. I was trying to impress him. I wanted him to think of me as someone who wasn't easily fazed, who would look squarely at whatever was in front of her.

We met on the internet. A photo of him in cammies dripping medicine into the mouth of a young boy in Kandahar. Another of him dancing at an embassy party, solo, with obvious abandon. One smoking a cigar. One in uniform, looking crisp as a cracker. I knew immediately it was going to go one way or the other: either I would loathe him or I would be in deep, fast. His specialty, here in the civilian world, was continuity

by
MOLLY
McCLOSKEY

in emergencies, which I knew must mean something very specific but which suggested, in its broader application, a person one could count on.

At dinner, after the rats, we talked about science fiction, which we both loved. About free will, and human engineering, and computer-generated pleasure—whether believing you were having a pleasurable experience was in any way distinguishable from actually having one.

He said, "What pleasurable experience are you imagining right now?"

Dear god, I thought, and rolled my eyes. We were halfway through the meal and I was teetering in a big way. On his left pinky he wore some kind of signet ring, and his hand flamed shyly with psoriasis. I felt sorry for him, and then for myself. I thought of calling it a night as soon as the plates were cleared, but something tugged at me to wait.

Over dessert I said, "Tell me something about you that I'd never think to ask."

He smiled. He liked the question. "I'll tell you something about being with me."

"Okay," I said.

"You'll always be safe, and you'll never be bored."

It had the sound of a line he'd used before, but somehow that didn't bother me. "Quite a guarantee," I said.

He leaned back in his seat and held my gaze for a long moment. "How is this going?" he asked. It was clear he meant our date, and it was also clear the question was rhetorical. He'd sensed the shift in my attitude.

"Well," I said, "I'm not bored."

He laughed. "Then we're halfway there."

The restaurant was a few blocks from where I was staying, and by the time we finished our coffees, I had decided to invite him back for a drink. When we reached the steps leading up to my front door, he cocked his head. "Is it crooked, or has one beer done me in?"

He was right. The house was on the historic register, and to save it from demolition, it had been moved from another location and reassembled, which accounted for its slightly drunken look: the door jambs were at a tilt; the upstairs floors were raked like stages.

I got two beers from the fridge. It was mid-September, unseasonably temperate, and we went out back to the brick patio, where we sat in the gentle roar of the AC units, which

seemed to come, at all hours, from everywhere and nowhere.

He clinked his bottle against mine and said, "Nice place, kiddo."

It was, actually. It was the nicest place I'd ever lived. Even the great *whooshing*—it was like living next to a waterfall or a stormy sea.

I took a swallow and put my beer on the cast iron table and turned in my chair so I was facing him. He was sitting with his legs splayed and the beer bottle held loosely in two hands, resting atop his crotch like a little rocket he was about to launch. He saw me taking him in and I caught the twitch of a smile. Without looking away from me, he put the bottle on the table, slipped a hand around the back of my neck, and, with a quick tug on my hair, kissed me.

It is said that every novel educates us about its own conventions, teaching us how to read it as we go along. The same, surely, can be said of people. They teach us how to desire or love them, schooling us in themselves. Those oddities and predilections that at first seem so alien and off-putting slowly work their way into us, until one day we realize we've crossed a line without noticing.

I'm not referring to anything horrific. We agreed on virtually nothing, but he wasn't evil. Even his life in the military—which I sensed had sometimes bled into realms of intelligence shadier than snakebite serum and gas masks for the troops—seemed as concerned with protection as destruction; he'd gone to Aceh after the tsunami and Haiti post-earthquake. I mean, he had a way of eating that was somewhat savage—very fast and almost with an air of panic. As though he hadn't seen food for days, or as though he were an animal hunched over some prey, trying to get his fill before a larger beast appeared. I'm exaggerating. But it could certainly be said that he *wolfed* his food. It repelled me at first, then I grew fascinated, and finally, on occasion, aroused. That naked display of appetite. Not that he was rough around the edges; in fact, he was quite presentable. He loved Thomas Pink shirts and a good hand-stitched leather. To see him fingering ties at Brooks Brothers, you'd think he was a different kind of man entirely.

As for his skin, there was so much more to the story than the small red blotches I'd spied at

dinner that first night. On his elbows and knees were patches of psoriasis that were raised and rough as coral. When I ran my hands over him, I thought of those relief maps we had in elementary school, mountain ranges like blisters on the page. But the condition, like so much about him—his nocturnal tortures, the framed photos of right-wing heroes on his wall, his shadowy past in various trouble spots—came to seem normal. He said to me once, of a certain West African change of government (smiling slightly as he said it, half to get a rise out of me and half because the memory actually did stir in him a warm glow), "It was a good coup." I grew used to it all, and with a speed that surprised me, as though I had only ever known such skin, such men, such true believers.

My students amazed me, with their complicated traumas and their hungry innocence. One had a sister who'd overdosed on a drug I had never even heard of, and another's father had run off with his sixth-grade teacher, who was a man. At least two were in recovery from cutting. They worked these things into their assignments with an inventiveness I had to admire. They had all been born after I'd left the US, and I had the feeling, sitting with them, that I'd been asleep for two decades and had awoken to a changed world.

One afternoon in class, a few weeks into my affair, we were reading "The Lady with the Dog," reading it through the lens of totalitarianism. I was talking about the value of secrecy, the inviolability of the private and the unshareable. I wanted them to think about the political dimensions of the inner life, even—or especially—if its particulars were never spoken. A student raised an index finger. He said, "Okay, fine, but between two people in love, nothing should be unshareable." When it came to his own girlfriend, he wanted to know everything about her, every thought and fear, every shame and desire. He said, his eyes narrowing, that if you didn't want that, that unabridged knowledge, if what you wanted instead was to know only what was convenient or attractive, then how could you say you really loved someone?

I laughed nervously, unsettled both by his sudden declamation—he was not one of my more vocal students—and by his desire to take

ownership of his girlfriend's mind. I said, "Not only can't you know her to that extent, but why would you want to?"

I waxed rhapsodic, then, on the enigma of the other, the mystery that keeps us coming back and that we want both to breach and to keep sacrosanct. I said that we weren't rejecting someone by allowing them their privacies.

I said, "We don't even know ourselves that well," and the whole class looked at me like I was deluded, or middle-aged.

I thought of my own romance, how the secret corners of his psyche were given literal boundaries by a high-level security clearance. For a moment I thought of posing the scenario to the class, without naming the protagonists, as a thought experiment. What better way to concretize the abstract, to make the metaphor explicit?

Thankfully, the impulse passed.

When I got out of class, there was a text from him. *You & me, 7pm.*

On the phone or in person, he was large, expansive, gob-smacked, as though life—for all its violence and misery—were one big hoot. But his written communiqués were terse. Their very succinctness thrilled me, as though I were taking instructions in an emergency. Oh, I was high as a kite those days.

I texted back, *Yes*, and looked around, feeling illicit. There I was, bedding a Republican, and not just any Republican but an officer, one who did a sideline with Homeland Security, who disappeared the odd weekend to an underground bunker somewhere beyond the Beltway to monitor existential threats to America.

We met that night in Georgetown. He wolfed his beef adobo. We went to a movie in which some Navy SEALs battled some Taliban fighters and hardly anyone survived. A few times during the carnage-making, he jerked in his seat, as though he'd been shot. Afterward, he was unaccountably cheerful, while I felt peevish and queasy. "It was like watching porn," I said, and he gave me that loopy smile of his, and said, "I thought you'd never ask."

We stayed the night at my house. The following morning, after he left, I found such a sea of flakes on my bedroom floor that I had to get out the vacuum cleaner. It was strange, hoovering him up like that, as though he had actually disintegrated right there beside my bed.

A LITTLE
LIKE GOD

by
MOLLY
McCLOSKEY

I imagined that one day I might bid him good-bye at the front door and go back upstairs to find an entire epidermis lying crumpled on my floor, still holding the shape of him. Later, when he called me from his office—he was looking out at the Potomac, updating an anthrax response plan—I told him what I'd been thinking. I said I liked the idea. "I could inflate it and have a blow-up doll of you."

He laughed, one of those great big laughs of his. But the image of the shed husk stayed with me. I thought of tails and fins again; I thought of different kinds of men. I wondered whether he wasn't the sort of man whose time has been, and been and been, and was finally up, and I worried about that. I looked around me at the boys in Adams Morgan, with their shopping bags and their skinny jeans, and thought: Who will stay steady through our wars? Who will shepherd us through our emergencies?

I became fascinated by soldiering. I read a book about the surge in Iraq in which a young marine said that to be in a platoon on active duty was to fall in love, over and over again. Another guy said there was no sexier feeling than coming under fire. I began to envy the intimacy of men, and to pity them that, too, because they didn't know what to do with it after, with all that big, big love. And so they sat there in shambles in those bleak towns, full of grief and guilt, shocked by what they'd seen or done but also by what they hadn't seen coming: the wreckage they'd become after war.

On the surface, he was not a wreck. He was robust, punctual, direct. He had a way of arriving at my house that made even the most mundane of assignations seem urgent. He would knock—two short, sharp raps—and I would open the door and before he was even over the threshold he'd take my face in his hands and kiss me; then, all business, he would slip off his overcoat, hang it on the coat stand, and stride into my living room, where he would collapse into the armchair and unlace his brogues and fall back as though he had traversed continents to reach me and had to catch his breath. Everything with him was large, declarative, certain of itself. He entered my house with the air of someone planting a flag. To witness such conviction filled me with awe, as though I were in the company

of a man incapable of concerning himself with alternatives. I imagined a mind of planes and angles, surfaces that held up under the fiercest strain. My own mind is all curlicues and shadows, the impossible staircase, the Möbius strip, everything circling, each choice containing its own negation.

One evening when he was over, I was watching the news, and a story was on about two police officers beating a guy up in Queens.

I shook my head.

"You don't approve," he said.

"Do you?"

"Of that? Probably not." But, he said, he had no problem with the cops giving a few kicks to a rapist or a kiddie fiddler.

I said, "What about the rule of law, presumed innocent and all that? What if one day you're the kiddie fiddler?"

He made a face.

"The *suspected* kiddie fiddler. You think the cops are infallible?"

"I think we're too worried about being nice," he said.

"I see," I said, then upped the stakes. "Should we torture people?"

"Not for fun," he said, "or revenge. But if it's going to save lives, it should be on the table. You can't tell me that if banging some dirtbag's head against the wall a few times would save your mother's life, you'd vote against it."

I thought for a moment. "Maybe I'd recuse myself from the vote."

He laughed. "Liberals are such hypocrites." When it came down to it, he said, to saving our own skin, we'd do exactly the things we professed such horror about. "But you don't have to make those decisions. You have the luxury of outsourcing them."

"To people like you."

"I've never tortured anyone."

"Bravo!" I said.

"And I don't want to." He ran a hand through his hair and looked at me. "Would you want me to? To save your life?"

I got up from the sofa and went to get beers from the fridge. He followed me. I popped the caps and handed him one, and he took a swallow, then said, "I'm not a bad person. Believe it or not. But you're not as saintly as you think."

"I don't think I'm a saint."

He put his bottle on the counter and took

mine from my hand and set it on the counter too. "Okay," he said. "I'm sorry." Then he pulled me to him and wrapped his arms around me and whispered in my ear, with what sounded oddly like sadness, "Let's talk about something else."

His own place was an eighth-floor apartment across from the National Cathedral, and we could see from the big kitchen window the clock towers rising up out of the treetops, like a lost city emerging. We could hear the church bells, which pleased us both, though atheism was one of the few things we agreed on.

The bedroom had a smaller window that slid open to the night, and I used to imagine, lying under it, some wild urban nightmare teeming beneath us. The trill of the cicadas and the tree frogs' squawks, and all those sirens. I had never lived in a city in which signals of distress were as common as birdcall; it was as if we were in the midst of a perpetual communal crisis. I tried to tell him once how sirens used to make me feel, in the days when I lived in cities of moderate alarm. I said they reassured me because they meant someone was in control; someone was in trouble, yes, but someone else was dealing with it, and the call-and-response of distress and succor was deeply comforting to me. Here, though, the relentlessness of the sirens was overwhelming. Police cars, ambulances, security details, and the motorcades that blared and hurtled up Mass. Ave. as though the very world were ending.

He said, "I learn what to tune out." He meant he sorted all stimuli, every hour of the day, into threat and non-threat.

I said, "It's not about tuning out. It's about the emotional resonance. It's about what it does to our lizard brains."

He pointed two remotes at the television and did something complicated. We were stretched out on his king-size bed, watching end-of-days stuff, which he liked almost as much as war movies. Earthquakes. Tsunamis. Biological attacks. Toxins in the water supply. An electromagnetic pulse detonated by a nuclear weapon that would wipe out the grid. His favorite show was *Doomsday Preppers* on the National Geographic channel. He had his own bug-out bag, a stack of Spam in the cupboard, a pair of bolt cutters. There were jerry cans of water in the

bathroom. I wavered between regarding it as a charming quirk and worrying about my own lack of preparedness. Something in me resisted the very ethos of it all. On TV, anyone prepping for doom looked like a Hells Angel, only angrier, and not a single one seemed possessed of a communitarian spirit. It was all about having enough guns, keeping your neighbor from stealing your freeze-dried food or your woman.

I said, "I'd rather die than live in a world populated only by those people."

"Trust me," he said, "when the time comes, you won't be saying that."

We watched an episode where millennials in the Bay Area were reduced to animals after two days without water, a story line he found particularly gratifying.

"Three square meals from chaos, kiddo."

It was as though he lived there already in his head, in the aftermath, at a level of honesty about human nature that was bracing. In a cold, clear air free of delusion and sentimentality. Sometimes I thought it was our only hope, and other times it sounded like martial law waiting to happen.

Later that night, rutting on his sofa, I looked up and noticed a framed photo of him shaking hands with someone I considered a criminal, and I thought: Who am I? Have I no compass? He owned a gun, probably several, and though I'd never seen him hold one, I thought of him with his gun, and I felt the most distressing sense of safety.

I began to see everything differently. When I turned on the tap, I thought of water wars. A beach scene led to visions of rising seas. I read *Homeland Preparedness News*, which focused to a surprising degree on pathogens and biohazards, all the more alarming for their stealth and invisibility. That the internet should survive one more day without succumbing to a super-virus astonished me, that the trains ran on time, that there was food on the shelves—all of it seemed primed to implode. How could it not? I watched drone footage of a cliff slowly collapsing on the California coast, chunks of it sliding into the ocean, the edge moving closer and closer to a line of houses. Because there was no audio—no screaming, no thunder as the earth met the sea—the scene looked both

by
MOLLY
McCLOSKEY

cataclysmic and mundane, as though it were happening after our extinction and therefore didn't matter. I felt a little like God watching it.

I was sharing these thoughts with him one Sunday evening as we headed out for dim sum. He had just come back from the bunker, about which he told me very little. I pictured him sitting in a swivel chair, all night long the trail of threats across a screen, picked-up chatter, infrared footage. However it all got monitored, it was out there. The only thing he'd say was "You have no idea."

When we got to the restaurant, he took note of the exits. He said, just by the way, that in an emergency I should always text, not keep trying to call, because when the network came back the texts would be delivered. "You know that, right?"

I didn't know that, though it seemed obvious once he'd said it. "I should text you."

There was the briefest beat of silence, and though his hesitation had little to do with us and everything to do with the homeland, whatever I needed to know was in that silence. It hadn't occurred to me—and this was foolish, of course—that if something happened, he wouldn't come for me. He had a higher calling.

"I'd try to contact you," he said. "But I could be anywhere."

Feeling irked, I said, "You'd like it, wouldn't you? If something happened."

He turned the page of his menu and, still scanning it, told me about all the chemical-weapons sensors in the city, all the unseen ways I was being protected. My naïveté was becoming a theme with him. Something in his tone made me feel ashamed, like when I was a child and my mother would remind me, in moments of exasperation, how hard she worked for my pleasures and my privileges, how oblivious I was.

"I've been there when something happened," he said. "It isn't a thing you can like." Then he closed his menu and dropped a hand under the table, wedged it between my thighs, and said, "The pork ribs here are amazing."

One week later, as if on cue, two small bombs exploded in DC. The Metro shut down. We were asked to stay indoors, out of the way of the police.

Initially, it felt unreal. Like one of those simulations he worked on to test the system's preparedness. Was I ready? Of course I wasn't. My refrigerator was its usual unstocked self: organic condiments, a bag of triple-washed arugula, two slices of leftover flatbread. Had the water been cut, I'd have been left drinking olive oil.

The first bomb, in a garbage can at Union Station, had caused a fire; though no one had been killed, several people had been hospitalized. By the time the second one ignited, at Gallery Place, about a mile from my house, the Metro system had been emptied of people. On top of this, two men had been shot near the Convention Center, and no one seemed to know whether or not this was related to the bombs. On the news, there was a lot of talk about very little information, and much back-and-forth about whether these were amateur bad guys or the advance guard of something far more serious.

I locked my doors and emailed family and friends in other places to tell them I was safe. Then I wandered around my house, not knowing what to do with myself. We were the capital, we were the nerve center, there was a chance that something big was happening. I pressed my head against the upstairs wall beside the window and stared out at the street. A few times, squad cars rolled purposefully by. The throb of helicopters was constant. I heard sirens coming from various directions.

I made tea and tried to read a novel, as though it were a normal evening, which only made me more jittery. Shouldn't I be keeping my eye on the ball? Doing my citizen part? I gave up on the novel and scoured the internet, then turned on CNN again, which made me feel less isolated, in a way the internet did not, but all of it was unsettling. The city was right outside my door and yet suddenly it was a place I couldn't wander into; it was as though it no longer existed in any concrete sense but only as a broadcast simulacrum. A journalist so flawlessly good-looking he was disconcerting to behold reported from a deserted street lined with cop cars, on the periphery of the city. I couldn't understand why the media was there—surely the bombers could see what I saw? But maybe that was the point; maybe it was a ruse cooked up by the cops, and the real stakeout was taking place in another neighborhood entirely. The scene, I now noticed, had a

hyperreal quality to it. There were a few trees behind the journalist and their leaves shivered dramatically in the wind, like props in a children's play. The journalist's face was a strange hue, and because of the unusual circumstances and the need for quiet, he was standing too close to the camera, as though in an amateur YouTube video. A man in a police uniform materialized in a headlight and then vanished again in the dark. I marveled at my mind's ability to turn a straightforward city street into something mildly hallucinogenic. Oh, I didn't think, *really*, that the airwaves or the internet had been taken over and that these feeds had been concocted to distract me while a military coup unfolded or everyone of a certain kind or color was rounded up, but wasn't my very skepticism about the possibility of such a scheme a necessary condition for its enactment?

They were looking for two young men. As soon as they put a number on them and posted those furry images, I glanced around me in a new way. No longer were they incorporeal, an *idea* of violence; now they were bodies moving about the city. I went around and checked the door locks.

The archetypal fears were queueing up.

And still I didn't hear from him.

Around midnight I went up to bed. I lay there stricken, less with fear now than with longing. I wanted him with me, rather desperately. I had been glib about our affair, I had regarded him as a curio, and yet alongside that attitude—of which I felt ashamed—I had watched this other thing form, independently of whatever I might will or reason: attachment. I thought of him out there in the city, or in a bunker, or in some office, in a tank rolling through the streets—I had no idea of the role he was playing. I had texted him an hour ago. Even then, I'd thought: Don't be needy.

On the afternoon of the second day, one guy was arrested in Baltimore; by evening, the other had been found in his sister's house in Hyattsville, hiding in the boiler room. Their faces were all over the internet. They had the sleepy, tousled look of teenagers. No one had said yet to what, if anything, they were connected. The shooting, it seemed, had been just another shooting.

* * *

Two days after normal life resumed, he texted me. *That wasn't a test*, he wrote. And then a squinch-faced emoji that managed to convey two things: he knew I knew it wasn't a test, and he was stressed-out and tired. *Want to see me?*

That Friday night, he came over to my house. He didn't arrive with the usual flourish; he didn't *exclaim* himself. There was instead an intensity about him, something peremptory. He pushed me up against the wall in the foyer and kissed me hard, and I wrapped my leg high around his thigh and pressed into him for all I was worth. We stayed like that for a minute, grinding into each other, until he took me by the hips and backed me into the living room, where we fucked on the sofa, the curtains wide open behind us.

Afterward, I had to stop myself from weeping. There was some kind of need in me, something I wanted and that I knew I was never going to get from him. I don't mean his heart, or his devotion. What I needed was so much bigger and more complicated than that, and I didn't even know if it existed anymore.

With what felt strangely like sorrow, as though all that heat and ravenousness had occurred under the cloud of a bereavement, we reassembled ourselves in silence. Once we were dressed, he gave me a wan half smile and said with a lightness he clearly didn't feel, "Are we hungry, kiddo?"

Dinner was an already-roasted chicken, and while I made a complicated couscous dish—the elaborateness of it suddenly embarrassed me, as though I'd overdressed for some occasion—he loitered in the kitchen, watching me, his mind somewhere else entirely.

While we ate, we talked about what had happened, or at least aspects of it. He didn't tell me where he'd been during those two days, or what he'd been doing. He wouldn't say what he knew about the two young men. He told me about a woman in Southeast who'd started firing out her back window at what turned out to be a cat.

He said, "Any excuse to lose it."

I didn't answer. I thought every reaction could seem laughable in hindsight. Finally, I said, "When people don't know what's happening, they get scared."

"People are better off not knowing."

"Why?" I said.

"Most people don't actually want to know. They say they do, but they don't. What they

by
MOLLY
McCLOSKEY

really want is to feel safe without having to think about what's keeping them safe."

"What's keeping me safe?" I said.

He looked at me and cocked his head. Without smiling, he said, "Do you feel safe?"

I shrugged. "Relatively speaking, I suppose I do."

"Good," he said. "Then live your life."

Around eleven he said he needed sleep. I didn't ask him to stay the night, partly because I didn't think he would, but also because I didn't believe whatever it was I was feeling: there was something ersatz about my longing for him. It felt skin-deep, even as it tormented me. While he finished the beer he was drinking, I watched him intently, without pretending I wasn't. He didn't squirm, or even say, *What?* He just looked right back at me. I had never seen him more defiantly himself than at that moment. I had never liked him less, or understood more clearly the divide between us. We both knew, in our own way, the world we were living in, and we knew, too, that if the time came—I mean, if something truly horrific befell us—he would be part of an apparatus that swept aside the concerns of people like me in order to preserve a structural order, and that once that was accomplished, my world, if I was still around to see it, would look very different indeed.

Before he left, we said we'd get together the following weekend. But when we spoke a few days later, it was clear something had shifted. I couldn't say why for him, but for me it came down to the fact that I had begun to dislike myself for wanting him, and to blame him for that. We agreed that we would take a breather, which I think we both knew was a euphemism for calling it quits. When we hung up, I felt foolish and liberated and very alone.

In a novel, I read: "We have all kinds of ways to talk about life and creation. But when guys like me go and kill, everyone's happy we do it and no one wants to talk about it." The character who's speaking is a Vietnamese man who's spent the war killing Vietcong. Every Sunday, before the priest talks, he says, a warrior should get up and tell people who he's killed on their behalf. He says listening is the least people can do.

When I read that, I thought of him. I wanted to phone him up and read it to him, to ask what he made of the idea, of people being forced to hear about the killing done in their names. I remembered a morning he strode out the door in his shined brogues and crisp button-down and said in a tone of sardonic affection, "I'm off to protect an ungrateful nation." I remembered him, one evening, pausing on the corner of R Street and Florida Avenue. He took a deep breath and looked around him as though he were standing on a mountaintop, and said, "I love this country. *Pathologically.*" It was in response to some comment of mine; we'd been having the sort of quarrel that had become a feature of our date nights, endless variations on the question of what forms caring about your country could take, and of the relationship between what was moral and what was legal and who got to decide that. Our own relationship was becoming one long, running argument, the particulars of which are mostly lost to me now. That line I won't forget, though. You'd think there might've been menace in it, a whiff of patriotism about to run amok. But what I heard in his tone was something sensual. I saw the gleam of the erotic in his eyes. He had done things that could only be hinted at—things, he would remind me, that safeguarded my freedom to stand in judgment of him; things I had no doubt would appall me. And yet—does it sound strange?—I envied him. I looked at that love of his and it seemed a comic-book kind of love, all boldfaced caps and a belief in superheroes. But I couldn't deny it: it was a love that moved me.

I didn't get the job I wanted, but I got another job, and I stayed. I think I decided to stay during those hours I'd spent locked in my house. Something in me fell for the city then. Something in it felt human, and mine. I had drifted fretfully through the rooms of my house, imagining people all over the city moving about their own homes, imagining it all in great detail: what they were cooking, what they said to one another, whether they were afraid. Back then, there was no one here I was close to, apart from him, and so I had no hierarchy of concern or attentiveness; every unseen person in the city had the same claim on my curiosity, and my fellowship. Never had I felt so isolated and yet so deeply a part of something.

Now I have a small apartment. From the roof of my building, where I sometimes go at dusk, I can see the curved concrete flank of the Hilton, the one where Reagan was shot. The city,

unfurling low-rise before me, feels oddly muted, as though it's been reduced to a smoking ruin. I like to watch the planes floating into view as they descend toward National, looking, in the deadness, like they're ferrying supplies to somewhere cut-off and in trouble.

I had a fantasy once: to be with him in some malarial war zone, making sweat-slicked love inside a mosquito net while death pressed in all around us. I wanted him to call me from unexpected places; I wanted a mental map with colored pins in it. But he never called me from anywhere surprising, just his sixth-floor office with the big window overlooking the Potomac.

To be honest, the best times of our affair were moments we weren't even together. It was the aftermath I liked, that odd repose that followed an encounter, as though I had survived something perilous and demanding. Weekday mornings I'd leave him at his bus stop, then take the 31 home, down Wisconsin to the low-lying neighborhood, where I lived, journeys far sweeter in my memory than the crude dawn couplings that preceded them. There was something intensely pleasurable, and also melancholic, about being on the bus at that hour with all the commuters, the smell of him still on me, the morning fugginess of the crowd, the vehicle's slow, spasmodic lurch. Being delivered back to humanity like that, after the dire isolation of sex. I have heard of people who claim to feel connected to all of creation when in the act, but I'm not one of them. I feel like the last person left alive, or someone flung to the far reaches of the galaxy. But then I'd board the bus and I *would* feel it, everything rushing to meet me, each one of us teeming with worlds. I felt enveloped, in the throes of an indiscriminate love, as though I had traveled a great distance and seen many things and was home now, and earth, I can tell you, had never looked so good.

A LITTLE
LIKE GOD

The experience of being so fully immersed in a story that it activates a cinematic sequence in the mind's eye is what makes reading such an engaging and fulfilling experience for me. As a photographer, I am often inspired by real-life events and by the indelible and filmic memories that remain in their aftermath. As I read through the eight stories featured in this issue, each one projected its own beautiful and brilliant short film, and I embarked on the humbling experience of creating photographs to accompany these stories, according to my interpretations. I found inspiration in the quiet moments between main plot points, in the presence that characters leave behind after they've left a space, in objects that carry emotion, and in photographic perspectives that situate the viewer within the scene. —HOLLY ANDRES

HOLLY ANDRES is a photographer known for her stylized cinematic scenarios often inspired by her childhood experiences. Her work has appeared in major museum exhibitions as well as prominent editorial publications; viewers are drawn to her often dark and mysterious or bright and witty photographs.

MARK CHIUSANO is the author of *Marine Park*, which received an honorable mention for the PEN/Hemingway Award. His fiction and essays have appeared in *Guernica*, *ZYZZYVA*, *Harvard Review*, and online at *Tin House*, NPR.com, the *Atlantic*, and the *Paris Review*. He is a columnist and editorial board member at *Newsday* and was born and raised and lives in Brooklyn.

NEAL HAMMONS graduated from the University of Florida's MFA program for fiction. This is his first published short story.

CHELSEA T. HICKS is an MFA fiction scholar at the Institute of American Indian Arts in the creative writing MFA program. Her writing has appeared in *Yellow Medicine Review*, the *Rumpus*, the *Believer*, and elsewhere. She holds a master's degree in creative writing from the University of California, Davis, and has taught writing there and at the University of California, Santa Cruz. She was a 2016 and 2017 Writing By Writers Fellow, a 2016 Wah-Zha-Zhi Woman Artist featured by the Osage Nation Museum, and a recipient of a 2009 University Achievement Award at the University of Virginia and of a Double Hoo Research Grant in sound-driven creative writing for UVA's Office of Undergraduate Research. An enrolled member of the Osage Nation, she lives in her tribal district of Pawhuska, Oklahoma, where she works in language and cultural revitalization at Daposka Ahnkodapi, or "Our School," the Osage Nation Immersion School.

AFABWAJE KURIAN was born in Jos, Nigeria, and immigrated to the US at the age of seven. She is a graduate of the Iowa Writers' Workshop and is currently at work on her first novel.

MOLLY MCCLOSKEY is the author of five works of fiction and nonfiction. Her latest novel, *Straying*, was published by Scribner in 2018. She lives in Washington, DC, where she works as a freelance editor.

MAI NARDONE is a Thai and American writer. His fiction has appeared in *American Short Fiction*, *Electric Literature*, *Guernica*, the *Iowa Review*, *Kenyon Review* online, *Ploughshares*, and elsewhere. He lives in Bangkok.

LEIGH NEWMAN's memoir about growing up in Alaska, *Still Points North* (The Dial Press, 2013), was a finalist for the National Book Critics Circle's John Leonard Prize. Her stories have appeared in journals such as the *Paris Review*, *Tin House*, and *One Story*, and she is the cofounder of the book company Black Balloon, an imprint of Catapult, where she now serves as an editor.

SANTIAGO JOSÉ SÁNCHEZ is a Colombian American fiction writer at the Iowa Writers' Workshop. Their stories have been published or are forthcoming in *Subtropics*, *Joyland*, and elsewhere.

ALSO AVAILABLE *from* McSWEENEY'S

FICTION

The Domestic Crusaders	Wajahat Ali
The Convalescent	Jessica Anthony
Emmaus	Alessandro Baricco
Mr. Gwyn	Alessandro Baricco
Arkansas	John Brandon
Citrus County	John Brandon
A Million Heavens	John Brandon
A Child Again	Robert Coover
Stepmother	Robert Coover
One Hundred Apocalypses and Other Apocalypses	Lucy Corin
Fever Chart	Bill Cotter
The Parallel Apartments	Bill Cotter
Sorry to Disrupt the Peace	Patty Yumi Cottrell
End of I.	Stephen Dixon
I.	Stephen Dixon
A Hologram for the King	Dave Eggers
Understanding the Sky	Dave Eggers
The Wild Things	Dave Eggers
You Shall Know Our Velocity	Dave Eggers
Donald	Stephen Elliott, Eric Martin
The Boatbuilder	Daniel Gumbiner
God Says No	James Hannaham
The Middle Stories	Sheila Heti
Songbook	Nick Hornby
Rerun Era	Joanna Howard
Bowl of Cherries	Millard Kaufman
Misadventure	Millard Kaufman
Lemon	Lawrence Krauser
Search Sweet Country	Kojo Laing
Hot Pink	Adam Levin
The Instructions	Adam Levin
The Facts of Winter	Paul Poissel
Adios, Cowboy	Olja Savičević
A Moment in the Sun	John Sayles
Between Heaven and Here	Susan Straight
The End of Love	Marcos Giralt Torrente
Vacation	Deb Olin Unferth
The Best of McSweeney's	Various
Noisy Outlaws, Unfriendly Blobs...	Various
Fine, Fine, Fine, Fine, Fine	Diane Williams
Vicky Swanky Is a Beauty	Diane Williams
My Documents	Alejandro Zambra

ART & COMICS

Song Reader	Beck
The Berliner Ensemble Thanks You All	Marcel Dzama
It Is Right to Draw Their Fur	Dave Eggers
Binky Brown Meets the Holy Virgin Mary	Justin Green
Animals of the Ocean:	Dr. and Mr. Doris
In Particular the Giant Squid	Haggis-on-Whey
Children and the Tundra	Dr. and Mr. Doris
	Haggis-on-Whey
Cold Fusion	Dr. and Mr. Doris Haggis-on-Whey
Giraffes? Giraffes!	Dr. and Mr. Doris Haggis-on-Whey
Unnecessarily Beautiful Spaces	Int'l Alliance of Youth
for Young Minds On Fire	Writing Centers
Celebrations of Curious Characters	Ricky Jay
There Are Many of Us	Spike Jonze
Be a Nose!	Art Spiegelman

The Clock without a Face	Gus Twintig
Everything That Rises	Lawrence Weschler

BOOKS FOR CHILDREN

Here Comes the Cat!	Frank Asch; Ill. Vladimir Vagin
Benny's Brigade	Arthur Bradford; Ill. Lisa Hanawalt
Keep Our Secrets	Jordan Crane
This Bridge Will Not Be Gray	Dave Eggers; Ill. Tucker Nichols
The Night Riders	Matt Furie
We Need a Horse	Sheila Heti; Ill. Clare Rojas
Stories 1, 2, 3, 4	Eugène Ionesco
Hang Glider & Mud Mask	Jason Jägel, Brian McMullen
Symphony City	Amy Martin
Crabtree	Jon and Tucker Nichols
Recipe	Angela and Michaelanne Petrella; Ill. Mike Bertino, Erin Althea
Awake Beautiful Child	Amy Krouse Rosenthal; Ill. Gracia Lam
Lost Sloth	J. Otto Seibold
The Expeditioners I	S.S. Taylor; Ill. Katherine Roy
The Expeditioners II	S.S. Taylor; Ill. Katherine Roy
Girl at the Bottom of the Sea	Michelle Tea; Ill. Amanda Verwey
Mermaid in Chelsea Creek	Michelle Tea; Ill. Jason Polan

NONFICTION

White Girls	Hilton Als
In My Home There Is No More Sorrow	Rick Bass
Of Color	Jaswinder Bolina
Maps and Legends	Michael Chabon
Real Man Adventures	T Cooper
The Pharmacist's Mate and 8	Amy Fusselman
Toro Bravo: Stories. Recipes. No Bull.	John Gorham, Liz Crain
The End of War	John Horgan
It Chooses You	Miranda July
Black Imagination	Natasha Marin
The End of Major Combat Operations	Nick McDonell
Mission Street Food	Anthony Myint, Karen Leibowitz
Indelible in the Hippocampus	Ed. Shelly Oria
At Home on the Range	Margaret Yardley Potter, Elizabeth Gilbert
Half a Life	Darin Strauss

VOICE OF WITNESS

Throwing Stones at the Moon	Eds. Sibylla Brodzinsky, Max Schoening
Surviving Justice	Eds. Dave Eggers, Lola Vollen
Palestine Speaks	Eds. Mateo Hoke and Cate Malek
Nowhere to Be Home	Eds. Maggie Lemere, Zoë West
Refugee Hotel	Juliet Linderman, Gabriele Stabile
Patriot Acts	Ed. Alia Malek
Underground America	Ed. Peter Orner
Hope Deferred	Eds. Peter Orner, Annie Holmes
High Rise Stories	Ed. Audrey Petty
Inside This Place, Not of It:	Eds. Ayelet Waldman,
Narratives from Women's Prisons	Robin Levi

Out of Exile: Narratives from the Abducted and Displaced People of Sudan	Ed. Craig Walzer
Voices from the Storm	Eds. Chris Ying, Lola Vollen

HUMOR

The Secret Language of Sleep	Amelia Bauer, Evany Thomas
Baby Do My Banking	Lisa Brown
Baby Fix My Car	Lisa Brown
Baby Get Me Some Lovin'	Lisa Brown
Baby Make Me Breakfast	Lisa Brown
Baby Plan My Wedding	Lisa Brown
Keep Scrolling Till You Feel Something	Eds. Sam Riley, Chris Monks
Comedy by the Numbers	Eric Hoffman, Gary Rudoren
The Emily Dickinson Reader	Paul Legault
All Known Metal Bands	Dan Nelson
How to Dress for Every Occasion	The Pope
The Latke Who Couldn't Stop Screaming	Lemony Snicket, Lisa Brown
The Future Dictionary of America	Various
I Found This Funny	Various; Ed. Judd Apatow
I Live Real Close to Where You Used to Live	Various; Ed. Lauren Hall
Thanks and Have Fun Running the Country	Various; Ed. Jory John
The Best of McSweeney's Internet Tendency	Various; Ed. Chris Monks, John Warner

POETRY

City of Rivers	Zubair Ahmed
Remains	Jesús Castillo
The Boss	Victoria Chang
x	Dan Chelotti
Tombo	W. S. Di Piero
Flowers of Anti-Martyrdom	Dorian Geisler
All That Is Evident Is Suspect	Eds. Ian Monk, Daniel Levin Becker
Of Lamb	Matthea Harvey; Ill. Amy Jean Porter
The Abridged History of Rainfall	Jay Hopler
Love, an Index	Rebecca Lindenberg
Fragile Acts	Allan Peterson
In the Shape of a Human Body I Am Visiting the Earth	Various; Eds. Ilya Kaminsky, Dominic Luxford, Jesse Nathan
The McSweeney's Book of Poets Picking Poets	Various; Ed. Dominic Luxford

COLLINS LIBRARY

Curious Men	Frank Buckland
Lunatic at Large	J. Storer Clouston
The Rector and the Rogue	W. A. Swanberg

ALL THIS AND MORE AT
STORE.McSWEENEYS.NET